Victorian Majolica

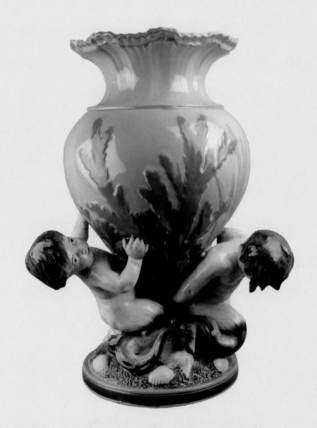

LESLIE BOCKOL

77 Lower Valley Road, Atglen, PA 19310

Bockol, Leslie.
 Victorian majolica : with price guide / Leslie Bockol
 p. cm. -- (A Schiffer book for collectors)
 ISBN 0-99740-953-9 (pbk.)
 1. Majolica -- English -- Collectors and collecting -- Cata-
logs. 2. Majolica -- 19th century -- Collectors and collecting
-- England -- Catalogs. 3. Majolica, American -- Collectors
and collecting -- Catalogs. 4. Majolica -- 19th century -- Col-
lectors and collecting -- United States -- Catalogs. I. Title.
II. Series.
NK4320.G7B63 1996
738.3'7--dc20 95-45611
 CIP

Copyright 1996 by Schiffer Publishing

This book is meant only for personal home use and
recreation. It is not intended for commercial applications
or manufacturing purposes.

Printed in Hong Kong
ISBN: 0-88740-953-9

Published by Schiffer Publishing Ltd.
77 Lower Valley Road
Atglen, PA 19310
Please write for a free catalog.
This book may be purchased from the publisher.
Please include $2.95 for shipping.
Try your bookstore first.

We are interested in hearing from authors
with book ideas on related subjects.

CONTENTS

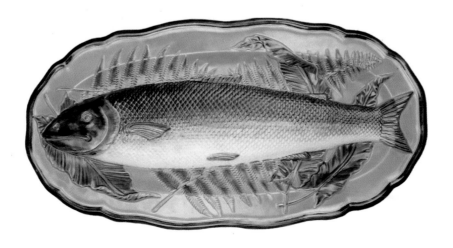

ACKNOWLEDGMENTS

This project would never have been possible without the generosity of those collectors and dealers who allowed to me photograph some of their most cherished pieces. My gratitude goes to Rita and Ian Smythe, whose shop Britannia, in London's Grays Antique Market, is a majolica-hunter's fantasy; to Marilyn Karmason, who can always find the most striking piece in town; to Michael G. Strawser of Majolica Auctions in Wolcottville, Indiana; and to Joseph Conrad Antiques and Dearing Antiques in Atlanta's Miami Circle, which is turning Atlanta into one of the best American cities for majolica lovers.

Also indispensible were staff members of the library at Winterthur, of the University of Pennsylvania's Van Pelt Library, of the Philadelphia Free Public Library, and of the Library of Congress. My thanks to all.

An 11"-long George Jones game pie dish, dating from 1869, with a seal mark on the base. Courtesy of Britannia, Gray's Antique Market, London.

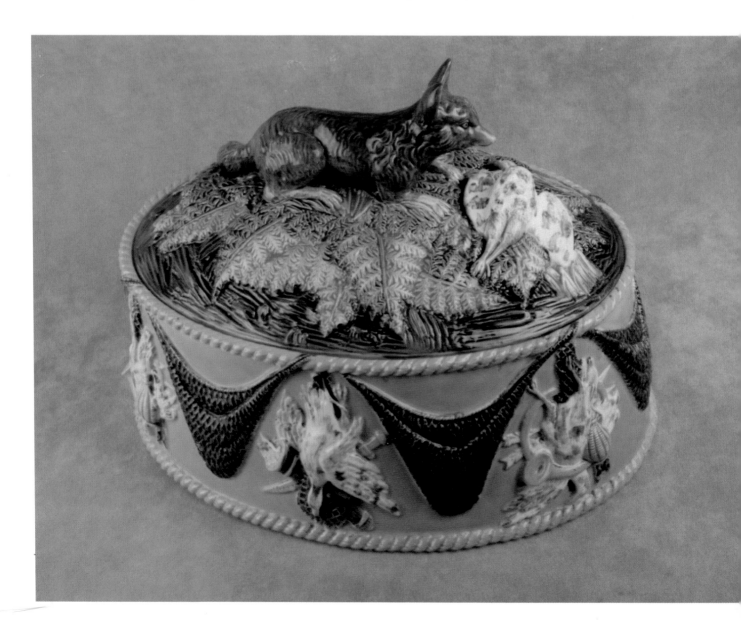

MAJOLICA: A STARTING POINT

In 1851, the English pottery industry hosted a great convergence of technology, artistry, and popular culture: an exuberant explosion of color and vitality that came to be known as Victorian majolica, a popular earthenware decorated with bright lead glazes. Times were changing rapidly, and the art and industry of pottery changed with them, much to the benefit of the avid majolica collectors who today span the entire world.

During the Victorian era, the English and American economies were expanding dramatically, prompting tremendous social change and increased consumption of mass-produced goods. The middle class grew in number and in overall wealth, and were eager to furnish their new homes in lavish styles they hoped would evoke upper-class wealth and culture. While museum-quality antiques were well beyond their means, their rooms were nonetheless rich with dark colors, draped in luxuriously heavy velvets and silks, crowded with countless knickknacks of insurmountible fussiness.

They were in dire need of the bright colors, whimsy, and wit that majolica would soon provide.

Potters in England had long since mastered the art of earthenware production. In the mid-nineteenth century, they began to perfect Mediterranean glazing techniques for their own purposes, adding brightly colored oxides to tin and lead glazes for use on earthenwares. Most glazed English ware from earlier eras had relied upon different colored clays for polychrome decoration, since the flat tin glazes of delftware had a limited color scheme and unembellished lead glazes offered only a pale yellow tint. The addition of oxides like cobalt, manganese, and copper opened a world of new possibilities, allowing vivid, translucent colors to be applied in the vibrant designs that make majolica so appealing.

At the same time, the population of England was becoming better-educated about the arts. Journals on the fine arts proliferated, and collections of artifacts and artworks toured the country in traveling displays. Prince Albert's Royal Society of Arts was in full swing, and was busily organizing the first of the great international exhibitions of industrial works, to be held in 1851 at London's Crystal Palace. The 'new money' middle class, aspiring to the long-established elegance of the 'old money' set, looked to these as lessons in culture for instruction. One historian summed up their motivations as follows:

With the knowledge of historic styles, what we might call artifactual literacy, came a heightened ability to 'read' objects for the accuracy of their historic reference and for the statements about social class, affluence, education, and values made by their owners when they brought them into their homes.[1]

For the upwardly mobile, it was crucial to be able to tell elegant from crass, authentic from imitation—or, more to the point, expensive-looking from the rest of the *hazerrai*.

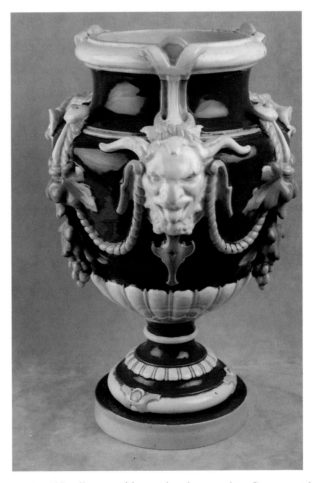

An ornate 13"-tall vase with ramshead gargoyles. Courtesy of Britannia, Gray's Antique Market, London.

Even as the English art scene was flourishing, the French was in an uproar. The Revolution of 1848 set the country aflame, and Louis Napoleon Bonaparte declared himself emperor in 1851. A brutal class war ensued, killing over ten thousand people. Industries catering to the wealthy disintigrated, and many French artists and craftsmen fled to safer countries, many to England. They brought a Continental artistic sensibility with them, and exerted considerable influence on the expanding English design community.

Majolica was the perfect culmination of these social, technological, and artistic changes in Victorian England. Majolica's initial incarnations, made by Minton & Company, were impressive imitations of the antique Italian pottery called *maiolica* collected by wealthy art-lovers and museums (see page 11). They were well-received in 1851, when they were introduced by Minton at London's "Great Exhibition of the Works of Industry of All Nations" (a.k.a. the Crystal Palace Exhibition). Later pieces, abandoning *maiolica*'s style but retaining the name, were revivals of other Renaissance and historical styles. Minton's creations were a hit with English consumers, who were thrilled by the elaborate designs of French exiles like Minton's art director Léon Arnoux (1816-1902) and by the prestigious look that could be achieved by pieces of relatively inexpensive earthenware.

Majolica grew immensely popular. Minton's competitors throughout England (and on the Continent) began manufacturing their own versions, further expanding the market and the array of designs. By 1860 majolica was considered very popular, and through the 1870s nearly every English pottery produced at least a limited line of the ware. A report in "The Pottery and Glass Trades' Review" from June, 1878 states that

> Judging from our experience we should say that Majolica ware is now the most popular class of decorated pottery. The taste for this class of wares appears to be rapidly on the increase and is spreading itself through every branch. Designs to suit majolica are in demand and everything in the way of novelty stands the best chance on the market of ultimate success.[2]

Potteries like George Jones, Wedgwood, Holdcroft, Lear, and Sarreguemines produced wares of good, and sometimes excellent, quality. Successive international exhibitions—Paris (1855 and 1867), London (1862, 1871, and 1874), and Vienna (1873)—kept every visitor up to date about new lines of majolica, at the same time keeping designers and manufacturers up to date about new styles, new historical and foreign inspirations, and new technical developments. As the years passed, majolica responded with remarkable creativity to every new Victorian trend—some revelling in good humor, others glistening with sophistication, and all awash with gorgeous majolica glazes in shades of red, brown, purple, blue, green, gold, pink, lavendar, turquoise, and orange. Bright green bowls shaped like lettuce leaves appeared on dining-room tables, along with pitchers that looked like iridescent gray and green fish standing on their tails. Parlors sported cobalt blue pedestals that were encrusted with three-dimensional rams' heads and flowers in rich shades, or crowned with a ring of brown and gold gargoyles called "grotesques." Sweetmeats could be gingerly selected from the lavendar interior of tazzas molded as huge white scallop shells, supported on the backs of naiads and water-babies with strands of seaweed entwined around their soft, pink legs.

Majolica's immense popular following encouraged (and even demanded) greater and greater mass-production, and more potteries began producing the ware in quantity. These ranged from respectable firms with decent enough standards down to fly-by-night potteries that produced low-quality wares, which they saw no reason to burden with a trademark. As more companies began to cash in on the trend, the quality of majolica as an entire class began to decline. Small companies bought the used (and retired) molds from better companies' most popular pieces, and used them to produce versions that were inferior to the originals in the clarity of the molded details. Painting too became sloppier, as majolica's fashionability trickled down to lower classes with less money to spend and fewer aspirations to aristocratic home decor. In 1878, a trade journal wrote that such a high demand "is not without its evil side which seems to be in sacrificing in many particulars good form to the merely catchy. However we hope that the exuberance will sober down and that we shall have elegance as well as colour and that the chaste in design will be studied as well as the novel and surprising."[3] But for better or for worse, this was not to be the case—better for those of us who have yet to tire of the exuberant and the surprising, worse for those potters whose profitability depended on a continually enthralled contemporary market. During the mid- and late 1870s, majolica's popularity waned among England's well-off middle class, and the English market for high-quality wares began to shrink.

Fortunately for the Staffordshire potters, another exhibition was about to be held—this one in Philadephia, in celebration of the United States' 1876 Centennial. A few pieces of English majolica had been displayed at the New York Crystal Palace Exhibition in 1853 to little effect, but by the time of the Centennial Exhibition the American public was ready to embrace the splashy forms and colors of the imported ware. In 1876, English potters sent their majolica over to the New World, and opened a brand new market.

The Centennial's timing was perfect; Continental exhibitions had ceased providing a strong venue for English majolica sales. Wedgwood's London agent at the 1878 show in Paris found the minimal presence of majolica in either English or European displays remarkable. He was moved at the time to suggest to Godfrey Wedgwood that all new designs should be decorated in any way *other* than majolica glaze, fearing that "bringing them out in majolica we shall get them disliked at starting."[4] Upon his further wanderings through the Exhibition, he observed that the only English firm to show majolica in quantity was Brown-Westhead, Moore & Company, which seemed to be targeting the recently-emerged American market. By the mid-1880s, English majolica production had trailed off, with most of the production geared for, and shipped to, the United States.

American consumers had begun avidly purchasing majolica just as their English predecessors were abandoning the ware; ironically, in many cases the ware's prestige stemmed from its English origins, as Anglophile Americans were enthusiastic to embrace what they imagined was the epitome of English fashionability. In addition to the issue of stylishness, Americans were notorious in their belief that English dishware was of higher quality than even the best-made domestic wares. Nevertheless, American potters jumped into the fray, willing to fight for a share of their own home market. American potters like Griffen, Smith & Company in Pennsylvania, along with a large number of pot-

teries in New Jersey, Ohio, and Maryland, began their own lines of majolica. Often their forms and designs (and sometimes marks) mimicked those of English pieces in order to combat the American preference for English imports. Eventually, protectionist tariffs and the growing quality of domestic pottery won the American audience over, at least in part, and many U.S. firms did a thriving business in majolica.

Sadly, majolica followed the same path in the United States as it did in England; popular demand encouraged mass-production at a furious pace, but allowed for a diminished quality. The poor quality reduced the market price, and majolica became unprofitable. Maufacturers began to skimp on glaze and on labor, and quality declined further. Majolica was even used as a give-away 'premium' by the supermarket now known as A & P!

By 1900 majolica's day had passed on both sides of the Atlantic, not to be revived for nearly a hundred years. In recent decades, however, antique Victorian majolica has been brought down from the attic, unwrapped from its yellowed tissue paper, gently dusted with a soft cloth, and set proudly on the mantelpiece. After years of neglect and disparaging accusations of being 'tacky', 'garish', and 'gaudy', Victorian majolica is once again appreciated for its lightheartedness, its entertaining designs, and its elegant vitality. It can instantly bring a glow even to the most somber of rooms, and it can set a sun-filled room positively ablaze with glory. Today, savvy collectors have confiscated just about all of the majolica that was hiding unrecognized in flea markets and garage sales. Majolica now belongs in the realm of fine antique stores, some of which specialize in it almost exclusively, and in auctions. But there are still bargains to be found by those who are familiar with market values and those who can recognize quality when they see it.

Of course, the right piece of majolica can fill you with lavendar, turquoise, tangerine, gold, and pink shades of joy, and can make you laugh with delight unknown even to frolicking putti. No matter what the backstamp, majolica is priceless!

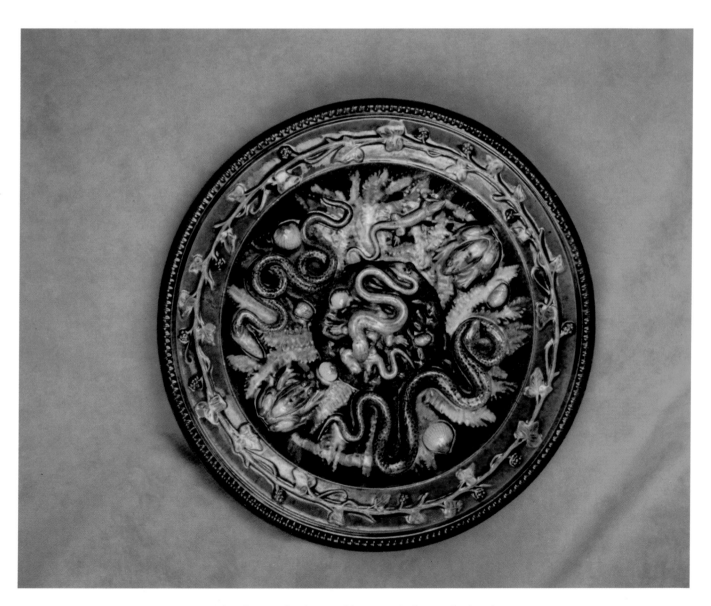

A colorful Palissy-style platter with an atypical smooth-glazed surface, 17" diam., unmarked. Courtesy of Britannia, Gray's Antique Market, London.

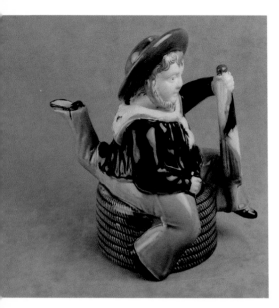

A whimsical 9"-tall teapot, marked "W. BROUGHTON / DOUGLAS / ISLE OF MAN." Courtesy of Britannia, Gray's Antique Market, London.

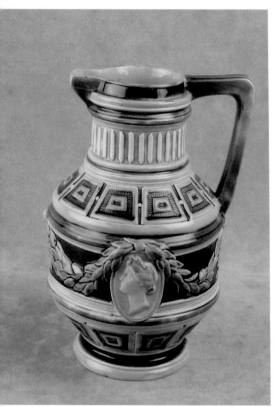

An unmarked 8"-tall pitcher with a classical motif. Courtesy of Britannia, Gray's Antique Market, London.

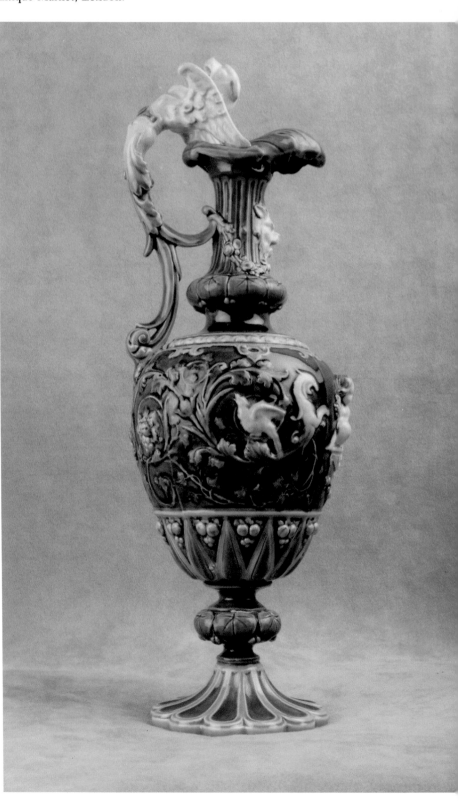

A 13"-tall ornamental pitcher in a classical Palissy style, made by Minton in 1872. Courtesy of Britannia, Gray's Antique Market, London.

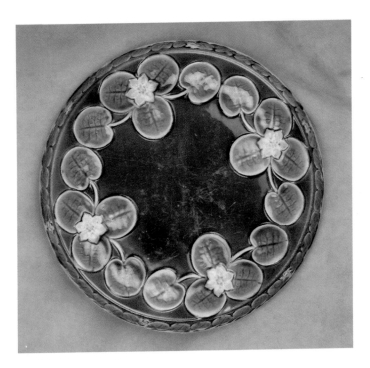

A 12" bread plate with a water lily pattern and a brown mottled back, unmarked. Courtesy of Britannia, Gray's Antique Market, London.

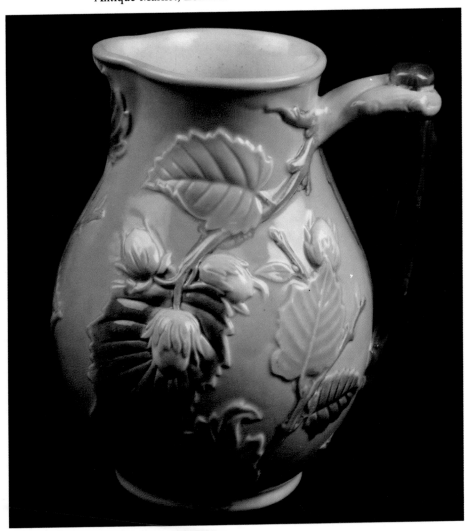

A Holdcroft pitcher, 7". Courtesy of Dearing Antiques, Miami Circle, Atlanta

An unmarked English fish pitcher with nice detail in the modelling, 10" high, c. 1860. Courtesy of Joseph Conrad Antiques, Atlanta

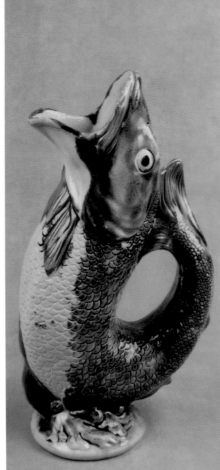

An unmarked English fish pitcher with nice glazing, 9" high, c. 1860. Courtesy of Joseph Conrad Antiques, Atlanta

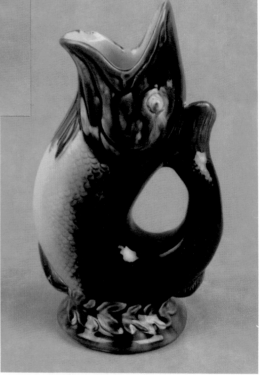

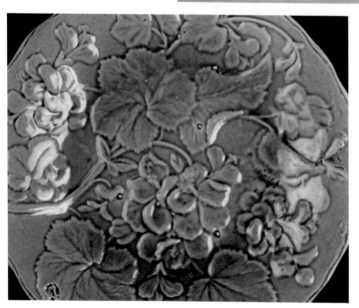

This English plate shows three marks from 'stilts', which were used to separate items when they were stacked in the kiln to be fired. The marks on the back are found frequently, the marks on the front less so. Marks like these (especially on the front) cannot be found on better quality wares.

MAJOLICA & ITS INSPIRATIONS

Majolica pieces were manufactured to reflect the many interests and infatuations of Victorian society, and thus can be found today in a wide array of styles. In any shop specializing in majolica, you will see pieces with naturalistic foliage designs, traditional English ceramic motifs, ornate baroque grotesques, and stylized Art Nouveau patterns.

Each of these styles can be traced to recognizable origins, and their connections to Victorian majolica are interesting to establish. In the following sections, three major influences on majolica are featured: rustic Italian *maiolica* from the Renaissance, for which majolica was named and from which the glazing techniques originated; French *Palissy-ware*, the inspiration for majolica's sculptural aspects and many of its naturalistic elements; and *chinoiserie* and *japonisme*, influences from the Far East that swept Europe and America after majolica was already well established.

These discussions trace the roots of Victorian style, showing how majolica came into being to satisfy a popular taste for antiquities, and how majolica designers thereafter strove to incorporate every new passing fancy (particularly those too expensive for the middle class to indulge in). Majolica addressed the public's taste for a variety of styles admirably, while maintaining its own character completely; individual pieces were not mere imitations of other styles or types of ware. Victorian majolica designers made the most of their medium, using the glossy, bright glazes and soft-bodied earthenware to add touches of whimsy and delight to heavy early styles, and to make light of the self-seriousness that often accompanied the new styles of high culture.

A portrait of *maiolica* artist Luca Della Robbia, from a Victorian journal. Other etchings in this chapter, also from Victorian journals, show the Renaissance *maiolica* and Palissy-ware with which nineteenth-century readers were familiar.

ITALIAN MAIOLICA— "BOOTY & SPOIL"

One of the most significant precursors of Victorian majolica is the ware from which its name was derived, a bright tin-glazed ware from Renaissance Italy called *maiolica*, first made in the fourteenth century. *Maiolica* had drawn its name in turn from the island of Majorca, which at that time was a melting pot of influences from northern Africa, Persia, and southern Europe, and was the source of Hispano-Moresque tin-glazed wares exported to Italy. Popular Italian legend tells this story of Majorca-wares' introduction to their shores; keep in mind that the nineteenth-century journalist who reported it called it "surmise only":

> The men of Pisa once upon a time undertook to clear the Tyrhene Sea from all Mussulman corsairs. There was at that time an infidel king, Nazardeck by name, who busied himself cruelly about the coasts of France and Italy. Twenty thousand Christians were said to be imprisoned in his dungeons. In the year 1113 the Archbishop of Pisa preached a crusade against Nazardeck, exhorting the people to open ther prisons of their Christian brethren and to deliver them out of the power of the infidel. It was not however until two years later that Majorca was taken, the king was killed, his son made prisoner and carried with great spoil and booty to Pisa. Among the spoil were many plates of Moorish pottery, which the Pisans stuck into their church walls as trophies and ornaments. For two hundred years this pottery was regarded only as a thing of beauty and to be venerated as a religous symbol and it was not until the beginning of the 14th Century that the Italians began to make an imitation ware which they called majolica.[5]

Less dramatic (and more reliable) histories record that Italy and Majorca enjoyed a healthy trade relationship, in which pottery was a major commodity. It is generally accepted that Hispano-Moresque wares in Italy were transported there as exported merchandise, not as "spoil and booty."

There is no doubt that Italian potters soon set to work in imitating the splashy Hispano-Moresque wares. Italian-made *maiolica* was made of a buff clay body, over which an opaque white, tin-based glaze was applied. Bright colors were then added, using metallic oxide glazes: first green (from copper) and purple (from manganese), then blue (cobalt), red (iron), and yellow (antimony). The earliest designs incorporated some Middle Eastern patterns—to be expected, since the Hispano-

Moresque glaze technology, and hence decorative styles, were imported primarily from that region.

Maiolica artisans soon abandoned Middle Eastern patterns in favor of Greco-Roman acanthus leaves, armorial devices, and mythological figures like sphinxes, putti, grotesques, and griffins.[6] Like their successors in Victorian England's majolica design-shops, Italian potters departed from historical precedent to suit the needs and tastes of their times. Their wares began as mere imitations, but quickly assumed their own character.

The forefather of artistically significant Italian *maiolica* was the Florentine sculptor and potter Luca Della Robbia (1400-

1482), whose high-relief work in tin-glazed terra cotta was commissioned by the Medici. While he did not actually originate the technique of tin-glazing in Italy, a nineteenth-century historian wrote that "it is certain he made such a decided forward movement as to give him the same position in Italy that Wedgwood occupies in England, Palissy in France, and Böttger in Germany."[7] Much of Della Robbia's work (in the Urbino region) consists of bas-relief scenes or flat medallions surrounded by three-dimensional wreaths of fruit, putti, and scrolls.

Other craftsmen continued this tradition through the 1500s, 1600s, 1700s, and 1800s, notably in Venice and Faenza. It was the artisans of Faenza who introduced the techniques of *maiolica* to France, Spain, and the Netherlands, from whence England learned of it. This route of cultural exchange is the main explanation for the English term "faïence" to describe wares decorated with metallic-oxide glazes, though it may also derive from the French town of Faïence, oddly enough known for a similar art.[8]

As the years passed, most Italian *maiolica* potters abandoned the sculptural aspirations of Della Robbia, focusing more on large, flat chargers and jars with small bits of sculptural ornament. By the early 1500s most styles were in the *istoriato* tradition: "the central part of the ceramic surface, and later the entire surface, was covered with a narrative scene."[9] These scenes were taken from the Bible, history, mythology, or stock genre scenes,

and were quite realistic in contour and perspective. These pieces were decorative, not utilitarian, and often served a commemorative function:

> For weddings, potters were ordered to select from the fables or from the thousand metamorphoses of Jupiter, an appropriate incident to reproduce. On the occasion of a birth a large vase was specially modelled and beautifully ornamented, to be handed to the mother as she lay in bed, . . . represent[ing] the birth of gods or heroes.[10]

By the end of the sixteenth century, however, the overall quality of these wares had begun to decline. While the tradition continued in Italy through the next three centuries, one had to look elsewhere in Europe—primarily in France—for high-quality pottery and artistic innovation.

Visitors to Italy still carried newly-made *maiolica* home with them, some just as bright and cheerful as sixteenth-century *istoriato* work, but the wares had fallen into disregard among the art-conscious. No matter how well-executed, they were considered mere "imitations" of antique *maiolica* from the days of Della Robbia and his immediate successors, rather than as modern manifestations of a continuing, vital tradition. "Time was," wrote one visitor with nostalgic memories of *maiolica*, "when tourists in Italy, if they were wise, always brought some home; but now you cannot obtain anything good, and must be on your guard for forgeries. I am frequently asked to look at so-called Maiolica and faïence which I can see at a glance is a forgery."[11] Too many tourists were bringing cheap, poorly made souvenier *maiolica* home to England, and too many Italian manufacturers capitalized on their notoriously uneducated taste.

Even the earliest antiques were considered with suspicion by some, who supposed that the best specimens could be as easily imitated as the more common variety; "Who knows," wrote a sceptic, "whether specimens of it, now held up to our admira-

tion, are any older than yesterday? Nothing is easier of reproduction than these articles, upon which the hand of genius has not bestowed its princely touch."[12]

While this commentator's editor wrote that he and his staff did "not admit the easy imitation of this faïence" and asserted that "no collector could be deceived by such copies," a good number of tourists and casual collectors were duped on a regular basis. Granted, they had generous assistance from some of the sellers, who specially sought out unmarked wares. These pieces

> have barely issued from the potter's hands before they are carried off by the brokers, or, more properly speaking, the 'swindlers'. The first thing they do is to put them in a dungheap to rot; then they expose them to a hot sun, or else they boil them in greasy, dirty water, to give them the smell of antiquity; they scrape the enamel with emery paper in order to rub the betraying varnish off, and make ingenius cracks and chips in them. These freebooters sometimes purposely break the piece and put it clumsily back together again. It is seldom that with one or other of their frauds . . . they fail to deceive a credulous amateur, a novice in this branch of art . . .No tribunal exists for the punishment of these frauds, and indeed what judge could decorously keep his countenance when a victim's sole complaint to him was that he has purchased a genuine Luca della Robbia for only thirty francs . . . [when really it was merely] a vulgar modern moulding which would dishonour even the memory of the great master?"[13]

ENGAGEMENT PLATE.
(Pesaro ware.)

When Herbert Minton, father of Victorian majolica in the mid-1800s, decided to make revivalist pieces in the style of Italian *maiolica*, how did he fit into this hodgepodge of cheap copies and unfavorable opinions? How did he keep his ware from being classed with the horde of shabby imitations that had become increasingly available during his century?

First of all, it must be remembered that for museums and serious collectors, distinctions between authentic antique *maiolica* and newly-made *maiolica* had not been lost; indeed, they grew increasingly crucial. Despite the declining reputation of new, tourist-grade *maiolica*, antique pieces with the proper credentials could still fetch "incomparable prices,"[14] from those in the know. One report stated that the South Kensington Museum bid 30,000 francs for an antique *maiolica* item as late as 1869.*

However, Minton's Victorian majolica was not marketed to those educated collectors who could afford thirty-thousand-franc antiquities; it was intended (and priced) for the newly-moneyed middle class, those novice world travelers and souvenier-hounds who were the regular marks of shysters hawking "Genuine Della Robbia!" for only thirty francs.

This is not to say that Minton's best marketing strategy was aiming for an ill-educated market; his new products had a great deal to recommend them. While casual collectors may have been scared off from purchasing *maiolica* while abroad, the mid-1800s saw a boom in art education (inspired by new government schools of design, circulating collections, and art magazines), and the public was gradually exposed to the glorious old *maiolica* from which the imitations had sprung. There were few who could not appreciate the inherent magnificence of the fourteenth and fifteenth century originals. Before these pieces were displayed to the huge crowds in attendance at the first international exhibition in 1851, the reputation of fine *maiolica* began to restore itself. The general public knew only that the rarest and best antique *maiolica* could be found in repositories like the South Kensington and the British Museums, and on the estates of the wealthy—and Victorians being Victorian, they coveted it. Beginning in 1851, these pieces made appearances at exhibitions throughout Europe. One attendant at the Paris exhibition in 1862 wrote that

* The editor also noted that the bidder in question was *not* the South Kensington Museum, but a collector from the nobility instead. It is not known whether or not the bid was successful.

In the Trocadero were massed probably the richest series of selections from the cabinets of private collectors of pottery and porcelain and from public museums ever brought together in one place. The rarest treasures of antiquity were laid before the public with a generosity beyond all praise . . . the most noteworthy objects were the Italian maiolica, the Hispano-Moresque vases and plaques and the faiences of Palissy.[15]

The pieces remarked upon at this exhibition included some made at Gubbio, Urbino, Deruta, and Faenza, sites of *maiolica*'s finest accomplishments.

One well-heeled collector of antique *maiolica* was the Duke of Buckingham.[16] In the late 1840s, when pieces from his collection fell into the hands of Herbert Minton, the time was right to provide the English audience with an alternative to the tourist-ware versions of maiolica that had been circulating so widely, and with such ill effects. Minton's first glossy, magnificent pieces of Victorian majolica provided the upper and middle classes with replicas of the very best antique *maiolica,* a significant improvement over the shoddy, hackneyed imitations of mediocre *maiolica* designs that were to be had in Italy. Suddenly the middle class could afford Renaissance revival *maiolica* that resembled the high-end pieces in museums or palaces, instead of Italian street-fair imports that imitated the lowest class of rustic *maiolica* pottery.

Minton, like all craftsmen who hope to bring life to styles of the past, knew that strictly copying old forms would soon make his wares stagnant and dull, just another degraded branch of the old *maiolica* tradition. Not everyone thought that his initial offerings helped to revitalize the tradition; one of Minton's contemporaries wrote that "at the present day Italian majolica has been revived with success—but without originality—by Minton, in England." The same writer continued

> The art of Majolica . . . can no longer content itself with the mere reproduction of pieces, even of the finest specimens of Italian art. We might as well ask our poets to write nothing but tragedies. Our sideboards, carved out in kinds of wood which were then unknown, with different outlines, and made to supply new wants, cannot be burdened with spurious imitations which are dimmed and extinguished the moment an original, even of the same period, is admitted among them.[17]

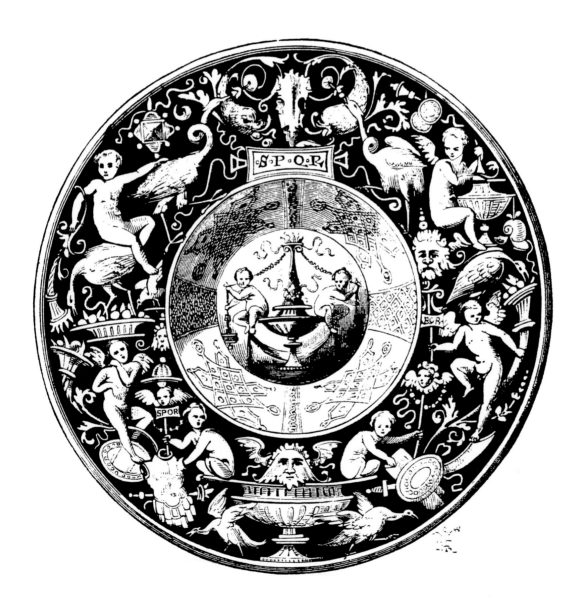

To remain a vital art form, Victorian majolica had to adapt preceding styles to its own audience, to the needs, tastes, and technologies of its own time—it must, he wrote, "transform itself as all other arts have done."[18] Herbert Minton was very much aware of this, and the following decade saw an amazing transformation of maiolica-style majolica into a wide array of styles, some revival and some thoroughly new, and many fascinating combinations of both.

Another commentator, discussing the similarity of Italian *maiolica* to its Victorian namesake, wrote that "similarity is the optimal word because although a few early pieces . . . were imitations of 15th century Maiolica the vast majority were not."[19] Within just a few years, 'majolica' came to mean earthenware decorated in any style with colorful, semi-translucent lead glazes, often not the slightest bit reminiscent of *maiolica*. The Italian ware had lent its prestigious name, its aura of elegance and antiquity, to a new line of pottery, providing an invigorating start to an exciting era of design and technology. From this auspicious beginning, a generation of potters in England, America, and the Continent began a wonderful and diverse tradition of their own.

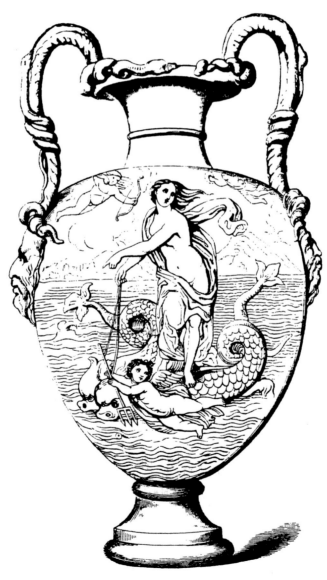

PALISSY WARE

*"Who has not lingered
with a feeling of enjoyment in some great museum
or exhibit, over a collection of ancient and modern pottery,
in doubt whether to admire most some quaint piece with its
lizards and newts, direct from the hand of the great Palissy,
or a specimen of modern china from one of the great
European hives of industrial art....Who has but read of the
struggles of Palissy, with a faith so sublime that the doors,
the very furniture of the house, go to feed the kiln?"* [20]

Another root of Victorian majolica is the Renaissance ware called Palissy-ware, made during the 1500s in France. A variety of styles fall under this category, most notably a geometric classicism featuring mythological monsters and deities, and an organic "Rustic" style featuring haut-relief plants and animals molded with unappetizing realism. Most important, Palissy-ware used deeply-colored lead glazes, more lustrous than any seen before in Europe.

While imitators abounded in susbsequent centuries, genuine Palissy-ware was made during the mid- to late 1500s by French potter Bernard Palissy. His career was dramatic, to say the least. Born in 1510 into the family of a poor glass-painter, Bernard was a voracious student of the world, independently studying chemistry, botany, geology, history, and mythology. When he encountered a piece of remarkably fine enameled ware—glossy, rich, and lovely—he was entranced, and became determined to master the techniques of its manufacture. Though he knew nothing of basic pottery, let alone of advanced glazing methods, he began to experiment.

He struggled for years, much to the disadvantage of the wife and children he acquired along the way. One historian from the Victorian era tells Palissy's story thus:

His friends and neighbors looked upon him as a madman. Often his wife and children went supperless to bed, the last penny spent to purchase the wherewithal to pursue his investigations. In vain his wife pleaded; the kiln with its capacious and unrelenting maw swallowed up everything and the direst poverty stared them in the face. For nearly sixteen years he struggled on, enduring the reproaches of his wife, the death of his children, the pathetic look of hunger in the faces of those spared to him, and the revilings of his neighbors.

Surely even the most avid potter would have resigned himself to the mundane life of a wage-worker at this point, or at least have begun producing marketable wares in some quantity. But Palissy continued with his experimentation—certain, after sixteen years, that the small piece of enameled ware from so long ago was about to yeild up its secrets to him. Though he had exhausted his credit with the townspeople and could no longer purchase fuel to fire his kiln, he found a way make one final attempt:

Success he felt was within his grasp, and undaunted by failure, he sacrificed his furniture for fuel. One by one the few domestic articles disappeared in the kiln, his wife and children hungry and ragged, in vain imploring him to desist. If this failed, it was of necessity his last experiment.

The situation was indeed dire. But Palissy was sure that he had at last struck upon the proper combination of ingredients, and that the secret would be his.

The very last stick of furniture had been thrust in the kiln, the house had been stripped of every vestige of woodwork, and who shall attempt to portray with what emotions Palissy awaited the result....With trembling hands he drew the few pieces from the kiln—for a moment he dared not trust his senses—he looked again— *the enamel had fused.* [21]

Thereafter, Palissy began to enjoy tremendous success, and was patronized by Catherine de Medici; he was "courted by those who had previously reviled him as a madman."

The first wares he made with his fantastic new glazes were simple, unembellished, but aglow with the colors of his brilliant enamels.

Around 1548, Palissy undertook a new sort of ware now known as "Rustic." Platters, urns, ewers, and other items were encrusted with naturalistic portrayals of plants and animals, sculpted in high relief and glazed in realistic color schemes with the potter's famous lead glazes. His wares from this period are startling, crawling with insects, reptiles, and crustaceans, and it is with them that Palissy is most familiarly associated today. These wares, journalists would later explain to collectors, were molded upon natural models, "not designed for domestic uses but to adorn the 'dressoirs', which it was the custom among the rich to have filled with vessels for show, however splendid the service of the table might be besides"[22]—not a far cry from their use today.

In his third period, Palissy focused on classical and geometrical works, featuring smoother surfaces than his Rustic ware did. These wares often had pierced borders and a mythological motif.

It is impossible to guess whether Palissy himself, in a final reckoning, considered success to have been bought at too great a price—"a row of tiny graves, a neglected wife, a desolate home"—but some clue may be found by the curious in his autobiography, entitled *L'Art de terre.*

According to Palissy's own account, he was aware throughout his sixteen years of misery that the enamel he sought so fervently was in common use in Italy, and was manufactured in Rouen as well; the secret of its manufacture could have been learned in a workshop in either place. Historians have asserted that only working independently could Palissy have accomplished work that is considered far superior to the wares made in Italy or Rouen, enamels "so pure, so brilliant, so rich and deep in tone, that they have never been equalled since, and admitedly rank amongst the most wonderful production of human industry." It may be wondered if this was any small consolation to the famous potter's beleaguered family. One guesses not, since as Palissy himself reported, after each failure he would come into the house in the wee hours of the morning, "with not a dry thread about me . . . as dirty and drenched as one who had been dragged through the ditches and slums of town . . . stumbling and knocking up against things like one intoxicated," only to meet "with nothing but reproach and blame; instead of consolation," he wrote, "I only received abuse."[23]

Palissy's life, which began with such hardship, was to end in distress as well; during the French Reformation he was sentenced to the Bastille. Though he was granted a reprieve by the

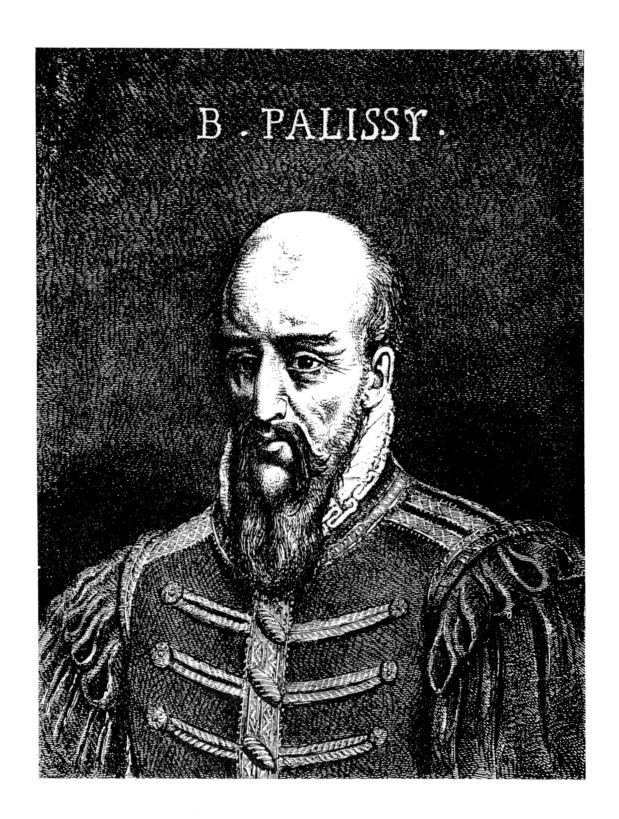

B . PALISSY .

admiring king, he was later sentenced again—this time to death. Palissy died before the execution, however, at the age of eighty. There is no record of what became of his family.

Wares made by Palissy and by his immediate successors made their way to England during the 1500s as luxury items, largely souveniers or as gift exchanges among the nobility rather than as trade goods.[24] An archaeological excavation in London's Black Friar's Lane unearthed an elaborate French Palissy-style tazza decorated with an allegorical scene:

> The design has three concentric zones: medallion, border, and flanged rim, defined by yellow bands. The inner border is a series of concave ovals in brown, defined and linked by raised yellow strapwork in grey, over a background of green acanthus leaves. The rim has a raised strapwork design of linked open trefoils, and acanthus leaves. The center is an allegorical scene, Minerva in a plumed helmet, cape and skirt, with a spear and grotesque-masked sheild. Cupid, hovering, carried a quiver or arrows . . . six figures (muses?) are under palm tree.[25]

This piece is thought to have been brought to England between 1570 and 1650, and "could be contemporary with the Palissy output." It is of very high quality, and thus is thought to have been a presentation piece given to an English nobleman by a member of the French nobility, or brought home as a memento by a travelling English nobleman. "Either way," writes the archaeologist, "is was owned by a household of some status, probably with strong foreign and/or courtly connections."

Apparently, even at the time of Palissy-ware's initial introduction to England, it had a high degree of exclusivity and prestige. There is documentary evidence, however, that by the mid-1600s there was an outlet in London for the sale of Palissy-type wares. The most respectable of these imitations in later years were made by Victor Barbizet, a Parisian potter; Georges Pull, a German potter living in Paris; Charles-Jean Avisseau, in Tours; Alfred Renoleau; and Calder, in Portugal. There was no consensus about how they compared to the originals, or even if the style in general was worthwhile; one critic from the Philadelphia 1876 Centennial Exposition called the antique Palissy ware he saw in the French exhibit "striking, but repellent in the mass."[26] Another critic from the nineteenth century was similarly repulsed, and speculated that

> Perhaps . . . it is we who look too closely at things which were intended to be seen at a certain distance and produce a general effect. It is possible, too, that these basins were not intended to be the ornament of dressers and shelves, but rather to be placed flat on a table, and filled with water.

Victorian etchings of Palissy-wares from the sixteenth century.

Nonetheless, there is no argument that Palissy Rustic wares and those made by his imitators struck a chord with the mid-century Victorians. Scientists in that era were making tremendous strides, particularly in the fields of biology and botany, and Palissy's detailed examinations of animal anatomy—to be seen only in the ancestral homes of the upper elite and in museum galleries—captured their imaginations like nothing else.

"Rustic" dish with reptiles, shells, &c. Enamelled ware of B. Palissy. XVIth century. Coll. Soltykoff.

PALISSY FRUIT PLATE.
(In M. Dutuit's collection.)

Etchings of Palissy-wares like these were found in many Victorian journals, inspiring a taste for detailed ceramics in an organic motif.

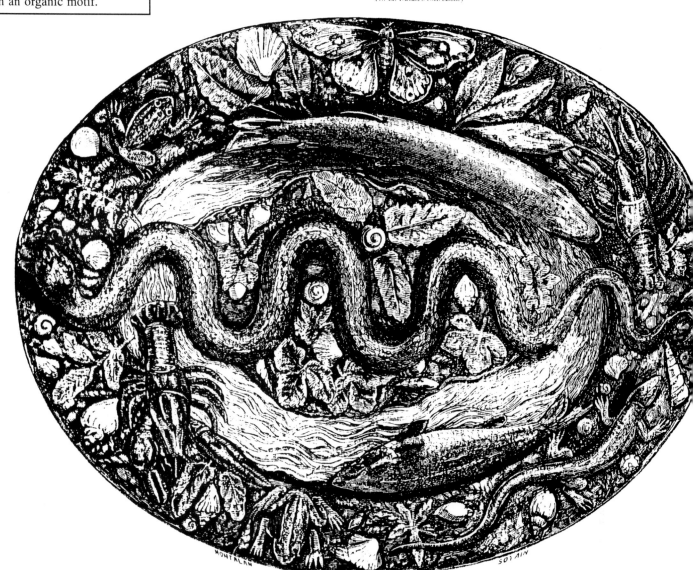

AL PALISSY DISH, WITH REPTILES.

(Collection of the Marquis de Saint Seine.)

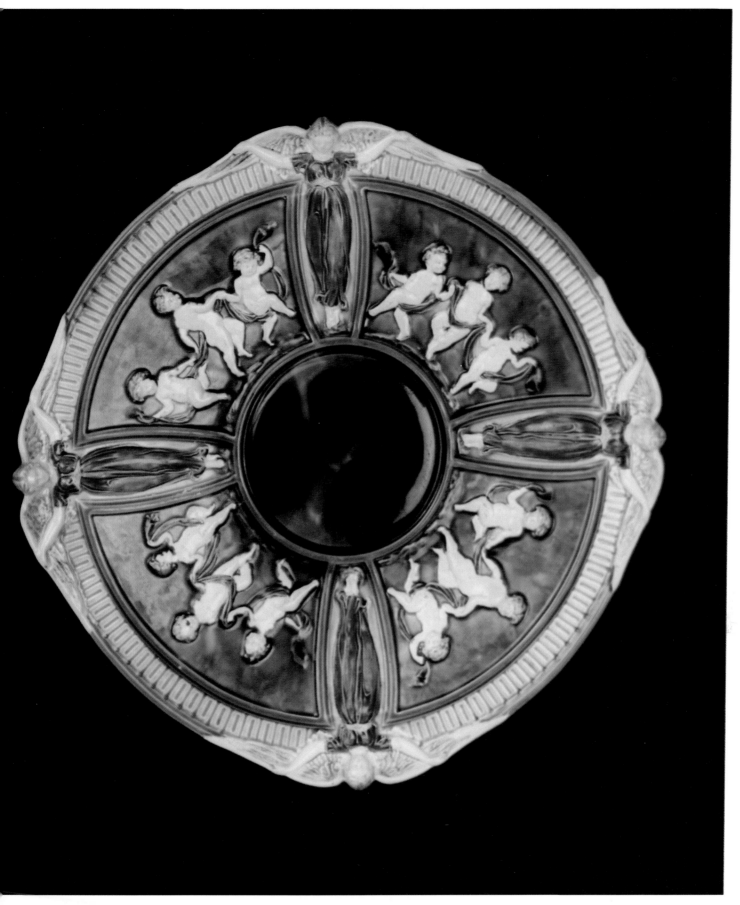

A pedestal plate with a Palissy-style classical tray and dolphin
feet, 3" high x 11.5" diam. Made by Wedgwood, with a British
Registry Mark from August 1865. Courtesy of Britannia,
Gray's Antique Market, London.

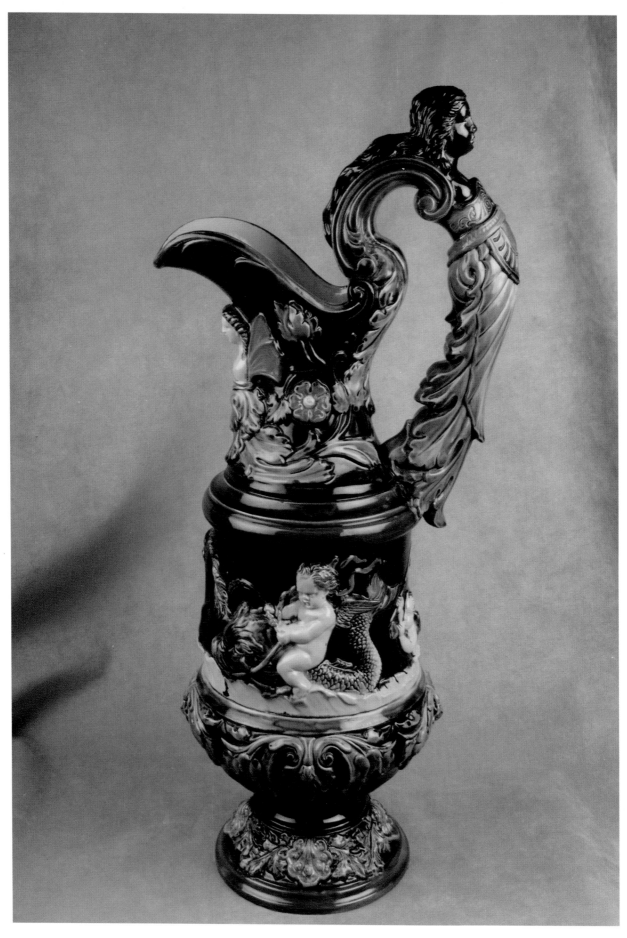

A 23"-high piece reminiscent of Palissy, possibly Austrian.
Courtesy of Joseph Conrad Antiques, Atlanta

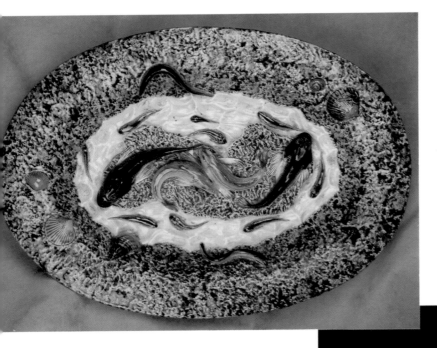

A large Palissy-style platter with fish, shells, and a 'pebbled beach' rim, 24.5" x 17". Marked with two diamond-shapes placed end to end. Courtesy of Britannia, Gray's Antique Market, London.

A pedestal plate with a Palissy-style classical tray and dolphin feet, 3" high x 11.5" diam. Made by Wedgwood, with a British Registry Mark from August 1865. Courtesy of Britannia, Gray's Antique Market, London.

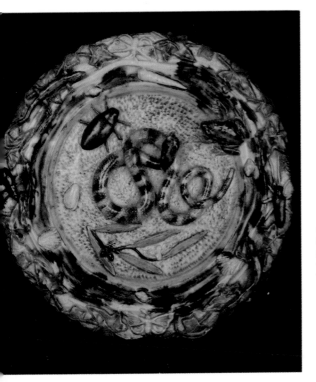

An 8" Palissy-style plate, featuring a snake, a frog, lizards, and insects. Courtesy of Britannia, Gray's Antique Market, London.

MAJOLICA AND THE FAR EAST

During the 1700s, England and the Continent were struck by an overwhelming fascination for all things Chinese, down, writes historian Jonathan Spence, "even to the pigtail."[27] In a wave of enthusiasm known as *chinoiserie,* pagodas were scattered through shady public gardens, imported silks clung to the figures of ballroom beauties, and Nanking dishware graced the tables of all who could afford it. Two generations of English potters strove to recreate this Chinese blue and white porcelain, or at least to come up with an earthenware substitute. By the end of the century the quality of Chinese and Chinese-styled dinnerwares had declined, and the followers of high fashion turned their attention elsewhere.

Then, in 1854, while Victorian England was just beginning to appreciate majolica styled after traditional Palissy or maiolica designs from France and Italy, Commodore Matthew Perry and the United States Navy successfully oversaw the opening of Japan to the Western world. Japanese porcelain, not yet corrupted by the lower standards of an undiscerning and immense foreign market, was hailed far and wide as superior to the sloppy Chinese exports of the day, which often verged on caricatures of their predecessors. In a market swamped with revivals of familiar styles from the past, "Japanese art came as something of a revelation," wrote one historian, "with its delicacy and pure, bright colors"[28] in arrangements never seen widely in the West before. The Western interest in Asian aesthetic standards was rekindled, this time called *japonisme.* From this time hence, beginning with the 1862 South Kensington exhibition, every major exposition featured a broad range of Asian artifacts, with special recognition often going to the exquisitely fine traditional crafts of Japan. A report from the Paris Exposition in 1867 notes that

> a survey of the entire field shows some curious things: England and France hesitating between originality and imitation, Palissy retarding the development of the national art he helped to create; Italy aping the manners of its youth; China rapidly nearing dissolution; and modern Japan rising upon the ruins of old Japan.[29]

Japanese items found eager markets in England, and after the Centennial Exhibition in Philadelphia in 1876, in America as well. The style's exoticism captured the imagination of mainstream consumers everywhere. Into parlors already crowded with knick-knacks of every stylistic denomination came what has been called "a new and even more disastrous treasure-house of art [from] the Far East. Soon," the critic wrote,

> Japanese gewgaws and the spindly furniture received a rapturous welcome in every home from Tulse Hill to Belsize park. However, it must not be supposed that the new arrivals disposed any of the existing ornaments; . . . the artistic little snuff-bottle from Yokahama shared a corner of the mantelpiece (now tastefully draped with a fringed green plush) with the shell-work lighthouse from Shanklin.[30]

Little regard was given to the actual intent of Japanese aesthetics, and any token recognition paid to Asian design's ideals of simplicity was quickly lost in the clutter.

Among artistic circles, however, authentic Japanese artifacts were valued not just as exotic novelties, but as examples of the handcraft tradition quickly dwindling in the West, which in their opinion could not be replaced by any amount of manufacturing ingenuity or precision. These art-lovers often criticized mass-produced ceramic wares that drew heavily upon Western tradition for their charm, rather than drawing upon the kind of originality and individuality so apparent in Japanese works.

Ironically, this sentiment prompted Western manufacturers to start drawing on Eastern tradition as well, in an attempt to establish a reputation for artistry. They began producing their own imitations of Asian wares, in majolica no less than in any other form. A observer at the Paris Exhibition wrote that

> the widespread taste for Oriental art has induced many to look to China, Japan, and Persia for models. But the difficulties to be encountered in such a path deterred many from attempting to cope with them, and these, falling to a lower plane of imitation, have contented themselves with reproducing forms that originated among the [European] porcelain makers, and with copying the majolica of Italy or the wares both early and contemporary of their own country.[31]

From the quantity of Asian imitations produced in the West during this era, it may be questioned how many manufacturers really were "deterred" from attempting their own versions, including clocks cased in bamboo-style frames, silver tea sets etched with plum blossoms and exotic birds, jewelry decorated with cloisonne and shakudo metalwork, and paper fans to no end. Japanese art "in all its efflorescent glory"[32] could be found everywhere; American artist James McNeill Whistler "dotted the walls and even the ceiling of his [London] dining-room with the brilliant Japanese fans which now constitute so large an element in the decoration of many beautiful rooms." His drawing-room featured fifteen large panels of Japanese pictures—each measuring five feet by two feet!

One may presume that the Asian artifacts used so courageously by Mr. Whistler were genuine, not Western-made imitations. But for most consumers in the middle class, authenticity was no issue, nor, really, was it important that their Asian-style decorating elements be true to Asian style. Western imitations and genuine imports could be tossed with equal effect into the melée that was the Victorian drawing-room. One typical monstrosity of a room is described thus:

> The Blessed Damozel was yearning down from between pendant Japanese fans; the cast-iron mantelpiece, tastefully incised with sunflowers by Mr. Walter Crane, supported two Chinese ginger jars and a vase of Satsuma ware in which a solitary lily bore witness to the high regard in which the oriental ideals of flower arrangement were now held; and the Queen Anne furniture, so lately restored to the drawing-room, had to share the honours with chairs and sofas whose spiky frailty was assumed to be oriental in inspiration if not in actual origin.[33]

Into the mix, of course, was added majolica, which an outside observer might consider a medium ill-suited for copying the delicate lines and colors of Japanese porcelain wares. The soft modeling of earthenware does not hold the detail for which porcelain was prized, nor could majolica ever aspire to porcelain's legendary translucence. An American magazine writer in 1879

recommended Japanese wares to his readers, stating that "to one who has a passion for soft and refined tints, they are an unceasing delight"[34]—but it was seldom that majolica's vivid colors could restrain themselves to being anything approaching "soft and refined"!

Still, majolica's forays into Asian styles were not without success, and certainly not without admirers. Minton's designers drew upon Asian theater motifs, nature scenes, and metalwork for inspiration,[35] with exquisite results as always. Wedgwood produced magnificent pieces in the Asian style as well, and was followed by other firms such as Holdcroft and Fielding.

American potteries also produced a wide range of Asian-style majolica, though it is possible that these were based as much on early English *chinoiserie* and later *japonisme* as they were on genuine Asian pieces.[36] Most notable among American makers of Asian-style majolica are Griffen, Smith & Company and the Eureka Pottery Company, although they were far from alone in the field.

A great deal of Asian-themed majolica was made into Argenta ware, since the cream-colored background of Argenta complemented the spare designs and less imposing color schemes of Chinese and Japanese art. On both sides of the Atlantic, look for majolica with Asian motifs including prunus (plum) blossoms, chrysanthemums, bamboo and reeds, exotic birds, monkeys, dragons, and fan shapes.

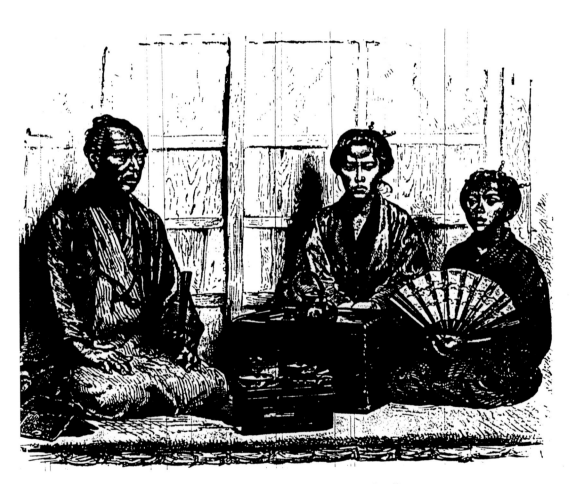

A Victorian etching of a Japanese family.

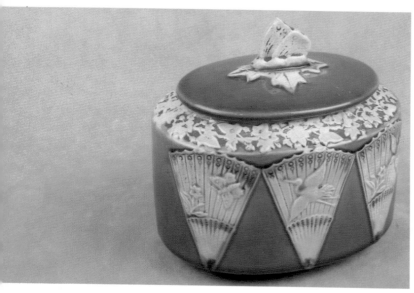

A 4.5"-high English canister, unmarked, c. 1860. Courtesy of Joseph Conrad Antiques, Atlanta

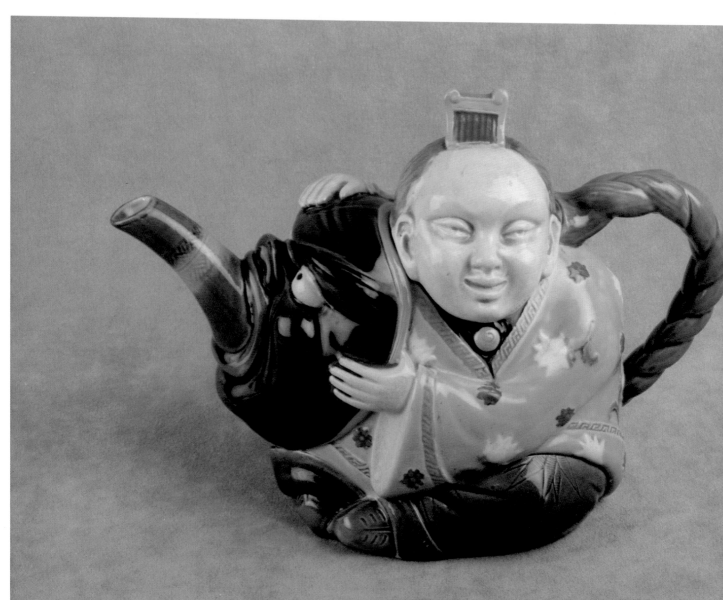

The Minton "Chinaman" teapot, 7" tall. Courtesy of Britannia, Gray's Antique Market, London.

A 12"-long platter, impressed
"WEDGWOOD." Courtesy of Dearing
Antiques, Miami Circle, Atlanta

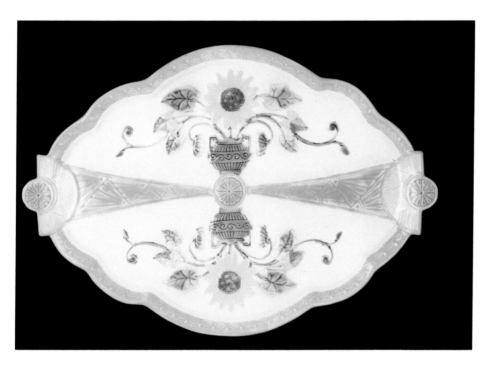

A platter by Lear, 18.5" x 13", with a
British Registry Mark. Courtesy of Dearing
Antiques, Miami Circle, Atlanta

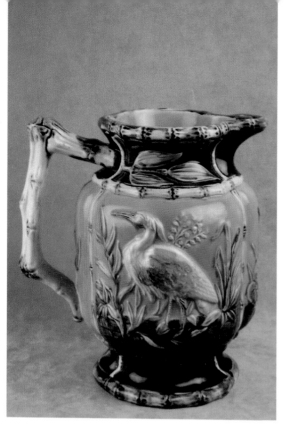

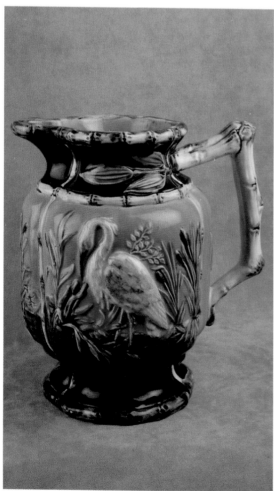

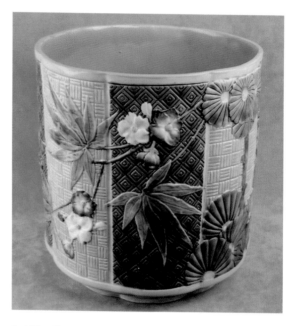

A 10"-tall geometrical 'japonisme'-style jardiniere by Wedgwood. Courtesy of Britannia, Gray's Antique Market, London.

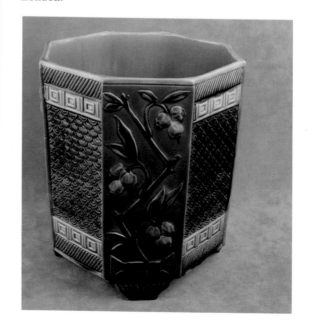

A 9.5"-tall pitcher with a bird design, unmarked. Courtesy of Britannia, Gray's Antique Market, London.

A 10.5"-tall 'japonisme'-style jardiniere by Wedgwood. Courtesy of Britannia, Gray's Antique Market, London.

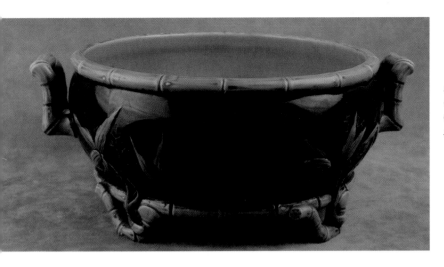

A 5"-tall Minton jardiniere from 1873, in cobalt and robin's-egg blue with bamboo details. Courtesy of Britannia, Gray's Antique Market, London.

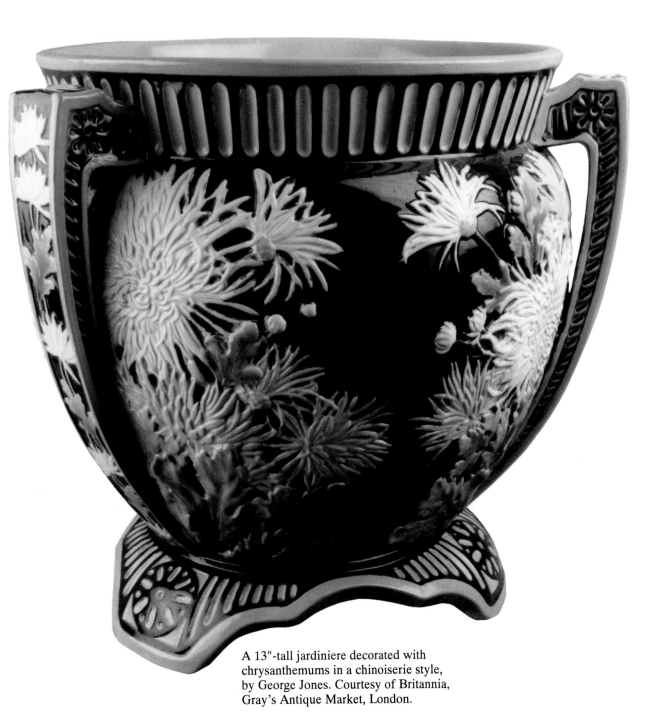

A 13"-tall jardiniere decorated with chrysanthemums in a chinoiserie style, by George Jones. Courtesy of Britannia, Gray's Antique Market, London.

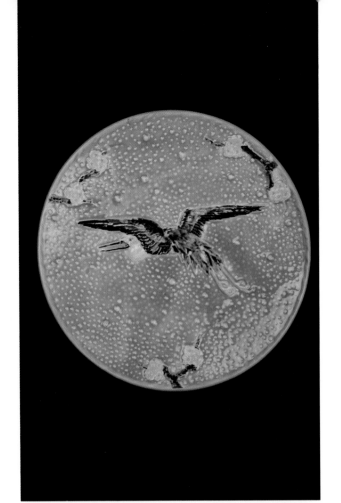

An 8.25" plate with a nubby texture and a heron design, unmarked. Courtesy of Britannia, Gray's Antique Market, London.

An 8.25" hexagonal plate, with a British Registry Mark from February 1, 1883. Courtesy of Britannia, Gray's Antique Market, London.

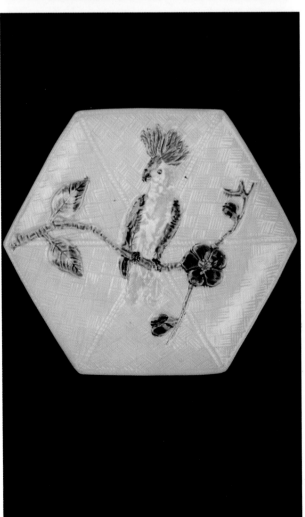

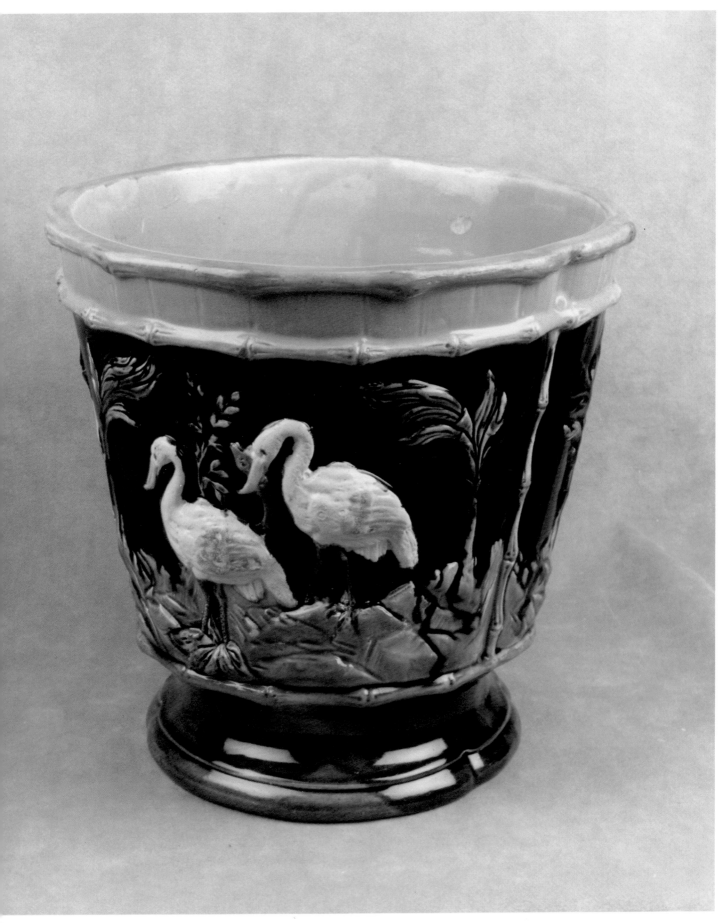

An unmarked English jardinere, c. 1860.
Courtesy of Joseph Conrad Antiques,
Atlanta

A 14" tray, 1860, English. Courtesy of
Joseph Conrad Antiques, Atlanta

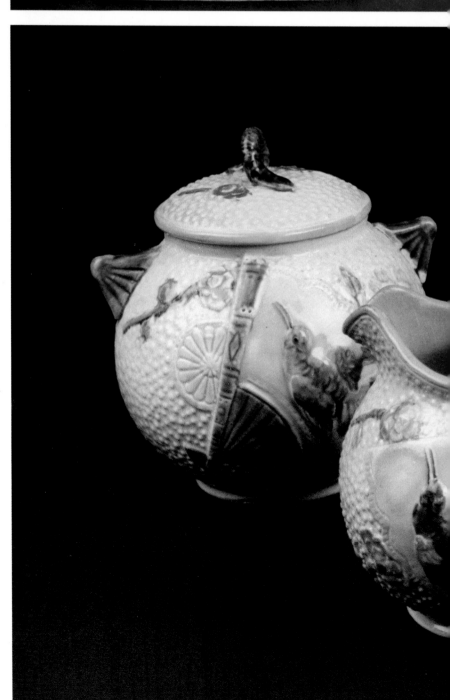

An unmarked tea set, possibly from
Fielding, c. 1860. The pot stands 7" high.
Courtesy of Joseph Conrad Antiques,
Atlanta

Two small dishes, 5.5" ea., American, unmarked. Courtesy of Joseph Conrad Antiques, Atlanta

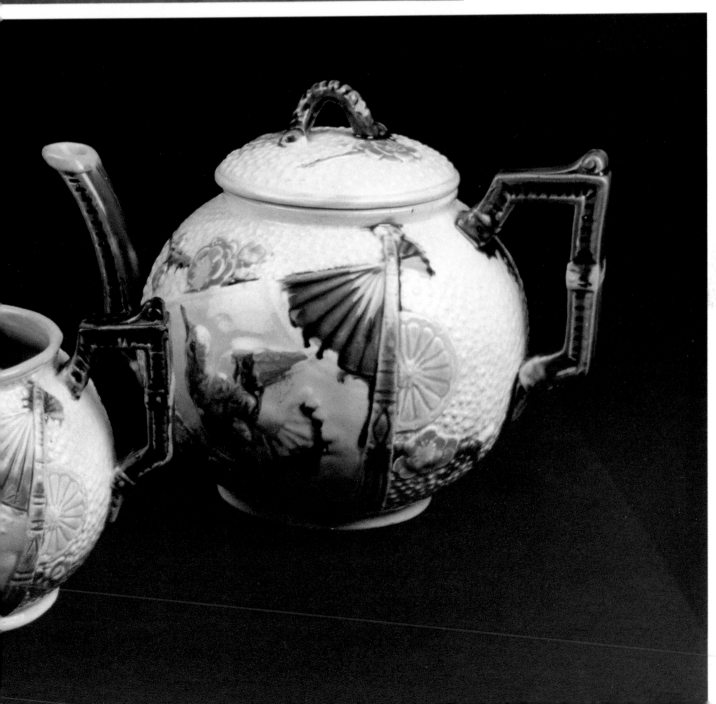

MAJOLICA FOR THE VICTORIAN ERA

The Victorian era spanned from 1837 through 1902, and it was witness to some of the most rapid change that the world had ever seen. To understand the evolution of any artifact, especially one with as many facets as majolica, it is necessary to understand something of the time from which it came. In the case of the splashy, colorful pottery we now know as Victorian majolica, it is necessary to investigate the people who created it and the people who purchased it. This chapter focuses on the wide range of influences exerted on majolica from both sides—from the potters in Staffordshire, Trenton, East Liverpool, Phoenixville, and elsewhere; from the changes in society and in global politics that dictated the evolution of style; and from the consumers who used majolica to add touches of elegance and good cheer to their dining rooms, drawing rooms, conservatories, and kitchens.

"**MAJOLIST:** A craftsman who makes majolica or similar ware."

STAFFORDSHIRE: BIRTHPLACE OF MAJOLICA

In the Potteries you have an active,
thoroughly employed, and well-regarded
population, earning ample wages, and yet not
banished in the depths of overgrown cities
from those rural sights and sounds which are
so dear to the hearts of man.[38]

Neolithic pottery specimens dating from the New Stone Age (2500-1900 B.C.) have been found in England, as they have been found elsewhere around the globe. These early English pieces, and the later wheel-thrown examples from the time of the Roman occupation (A.D. 43-450), are simple, functional, and solid—indistinguishable from primitive pottery from other regions of the world,[39] and a far cry from the elaborations of Victorian majolica.

English pottery advanced from this primitive state rather more slowly than that of the Far East, Near East, and Continent, for a number of reasons. First, until recent centuries the British Isles' geography isolated them from the influence of the rest of the world. Continental potters were constantly experimenting with materials, methods, and styles adopted from other regions, including Northern Africa, the Middle East, and Asia. They de-

veloped new techniques of clay-throwing and decoration, with glazing methods that would eventually prompt some of majolica's most important predecessors. Exposure to these technological and stylistic developments would have helped English potters advance more quickly.

To make matters worse, England was plagued domestically with political divisiveness throughout the country, wracked by devastating local conflicts between secular and religious leaders. This unrest prevented extensive domestic trade (and exchange of ideas) beyond narrowly-defined local borders, and precluded the kind of stability needed to nurture a steadily developing community of craftsmen.[40]

In this hostile climate, pottery remained rough, suitable only for the peasants and for kitchen use, while the upper classes dined on metal wares.[41]

Though the country settled down during the Norman occupation (beginning in A.D. 1066), pottery was still a trade worked by isolated craftsmen in poor, scantily-equipped workshops. By the thirteenth century, however, increased stability allowed English potters to communicate both among themselves and with

their Continental counterparts, and techniques from the mainland began to take root. French, Dutch, and Flemish glazing techniqes were in use by the end of the sixteenth century, and potters were striving to imitate Chinese blue and white porcelain.[42]

In the late seventeenth century, Staffordshire began to distinguish itself as a major English pottery center, and by the eighteenth century the industry was in full swing. All the necessary ingredients could be found in the outskirts of the region—coal, wood, water, clay, and flint[43]—and there was no shortage of man (or woman) power. The area soon became known as "The Potteries."

homewares to heavy, industrial-use cast iron. Daily necessities were flooding the market at reduced cost to the consumer, and there were plenty of factory jobs for energetic men, women, and children. A middle class grew in number and so did their general quality of life, as the population shifted away from subsistence farming in rural areas to join the industrial labor force in swiftly growing urban areas. As a result, England's national income increased thirty-fold between 1815 and 1839.

Soon, however, the problems of industrialization became obvious. As one nineteenth-century journalist wrote,

VENETIAN POTTERS AT WORK ABOUT THE YEAR 1540.
(From an engraving by V. Biringuccio, called the "Pirotechnie.")

Staffordshire is about one hundred and fifty miles northwest of London, covering an area nine miles long by three miles wide.[44] Six main pottery towns emerged—Stoke-on-Trent, Hanley, Burslem, Longton, Fenton, and Tunstall—in addition to Cobridge, Lane Delph, Longport, and Shelton, which also boasted some ceramic production. Burslem was considered the mother of the Potteries.[45]

Potters like Thomas Whieldon, the Wood family, and Josiah Wedgwood began to improve the quality of the region's production, and expanded their repertoire of ceramic styles. Their wares began to set the standards for ceramics throughout England. When a canal transportation system was implemented in the area and the Liverpool and Manchester Railways opened in 1830, Staffordshire was ready to export its goods *en masse* to London and the rest of England, and from there, to the world.

The Growth of Industry

This industrial boom of the early 1800s was not limited to the Potteries; it spanned all of England, in many fields of production, and brought with it almost as many new concerns as it solved old ones. The mechanization of production methods with hydraulics and steam engines made everything cheaper and easier to produce in quantity, from textiles, furniture, and ceramic

There are few who do not contemplate the commercial and manufacturing greatness of England with very chequered feelings. We are proud of the wealth; we are proud of the skill; but . . . there is much to abase our pride and to chasten our national exultation when we go behind the scenes.[46]

While the middle class was growing in prosperity, the rush of working class laborers to urban areas created crowded, shabby neighborhoods. There was a great influx of women, children, and immigrants into the labor pool, allowing factory managers to reduce wage standards and extend working hours, and to neglect the safety and comfort of their employees to a shameful degree. Increasingly, workers were becoming mere tenders of machines, instead of the skilled, respected craftsmen and farmers they had once been.

The increased consumption of mass-produced luxury goods by the upwardly-mobile middle class during this period is misleading; England's standard of living was not improving across all social strata. The mass-production of fine housewares made elegance accessible to the middle class, instead of just to the elite (who had always been able to afford the highest-quality hand-made goods). But this improvement for the middle tier of society did little to improve the plight of those at the bottom. As one commentator wrote,

Out of a dry and hard necessity comes still the beauty of the world. Behind out tinted Salviati glass, our painted Sèvres china and Minton majolica and shining silver plate, are the long rows of pallid faces inhaling poison in stifling rooms, breathing death that they may live.[47]

Despite the inclusion of the prominent Staffordshire company Minton in this list of offenders, it seems that the Potteries managed to evade many of the the problems faced by other manufactories. The journalist troubled by "chequered feelings" about England's industrial greatness was relieved to find, upon a visit to Staffordshire, that

there is a great national staple, at once the most ancient and one of the most beautiful and curious of all our arts, which is pursued among pleasurable circumstances, as we were most happy to find in a recent visit to the Potteries . . . The Ceramic art thrives and extends without the hideous adjuncts of our other manufactures.

Notwithstanding the smoke and grime from the ovens and furnaces, there is a marked absence of epidemics, the potters' worst foes being asthma and lead poisoning, but thanks to strict government supervision, the better ventilation and greater cleanliness of the workshops, these diseases are markedly on the wane."[50]

To protect (or placate) these workers, the amount of lead used as flux in the glaze was reduced by the end of the nineteenth century. Borax was used as a substitute.[51]

In another effort to improve the lives of the working class and to ensure the education of their children, the government ruled that children under thirteen could work only half-days, the remainder of which they must spend in school.[52]

In other aspects of the work environment, the potters were exempt from many of the unpleasantries their comrades in heavy industry were subjected to.

WORKSHOP OF PICCOLPASSO.
(A Durantine potter of the sixteenth century.)

He observed that the ventilation in the rooms was good, and that they were kept at a comfortable, cool temperature. "The industry," he reported, "generally is a healthy one, though there is a certain irritation to the lungs from the dust and dryness, and finer particles of flint and clay."[48]

The worst problem in Staffordshire was lead poisoning, or plumbium. Most at risk were the painters of majolica-glazed wares, who used their lips to pinch the tips of their brushes into points, and the kiln-workers, whose lungs were exposed to lead fumes during firing.[49] An American visitor to the Potteries described some unavoidable problems, but conceded that conditions were still better than expected:

There are none of the noisome adjuncts and deafening sounds of the huge cotton or woolen factory, where hundreds of hands are working together, and have to feed the giant machinery which dwarfs them all, and on which they are a sort of attendant imps. Pottery is pursued in a much pleasanter way and in a manner much more conducive to the personal comfort and the moral improvement of the operatives. Each potter works independently. There is a great demand for fineness of touch, sense of form, and manual dexterity."[53]

In the potting industry, machinery was at a minimum. Each employee was able to maintain a certain independence of craftsmanship, harkening back to the days when pottery was work for

a single family in a small workshop. The quality of the final product depended on the talent and attention of each worker—not merely on the efficacy of the machine.

Financially, the potters fared well compared to workers in many other industries. In 1871—in the midst of majolica production—it was reported that the best workers in various departments of potting earned the following weekly wages (average workers, of course, earning less):

clay mill men	30s.
throwers	50s.
plate-makers	30s.
dish-makers	40s.
hollow-ware pressers	40s.
turners	40s.
dippers	42s.
ovenmen (placers)	30s.
firemen	50-60s.
men gilders	30s.
women gilders	20s.
painters	35s.
paintresses	18s.
warehouse men	24s.
packers	30s.

In training for any of these positions, boys would spend seven years as apprentices. Girls would spend only five years in this stage, but both sexes began receiving good wages early in their apprenticeships.[54]

In a Parliamentary discussion of industry and the workers' condition, Lord Shaftesbury held the Staffordshire potters up as a shining example:

If we turn to the Potteries, we there see a large body of intelligent men, who, by their own act, by their own thrift and industry, have raised themselves to the possession of the suffrage. There are in that district about 9,000 potters, men in receipt of high wages, and I am told that very nearly 3,000 of these, by their own industry and care, have purchased their own freehold, and are now living in their own houses.

And quite a fine place to own a house it was, too. By the 1870s, there were 150,000 people working for or dependent on the Staffordshire pottery industry, with 120,000 living in the Stoke-on-Trent borough itself. Despite this high concentration, Staffordshire avoided the bleak urbanity of other manufacturing regions, like Birmingham, Manchester, and Leeds. A visitor wrote

The stranger does not enter a dreary and interminable town, where he feels himself shut out from the face of nature, and doomed to converse only with bricks and mortar in their dullest and meanest shapes . . . [rather he finds himself] at the end of nearly every street, in the cheering presence of nature's living green—of meadows, hills, and woods.

The region was laid out in long, thin strips of habitation, to maintain "a happy combination of the two influences, nature and art."[55] With its fine rolling hills and lovely vistas, Staffordshire's landscape was so bright and cheering that the lightheartedness of majolica is less to be wondered at, if no less to be admired.

The outskirts of the region were even more pleasing; indeed, "no district [had] a brighter border land . . . Remnants of vast forest that at one time covered the district . . . and the park and woods are free to all." On holiday Staffordshire residents visited the Moorlands at Leek, or the historic ground beyond Newcastle, which "open up wide fields of enjoyment . . . the potter at his leisure explores them all."

Known as avid sportsmen, the potters often fished and hunted in their home towns and in their vacation sites. Athletic sports were encouraged, and "plenty of cricketing on the greens and open spaces outside the towns" was to be seen. The area's healthy landscape, its residents' outdoor life, and the invigorated economy conspired to make the people of Staffordshire a hearty bunch. One longtime observer of the region even noted, during the 1870s, "that the *physique* of the population is visibly improved"![56]

The minds of Staffordshire residents were hardly neglected, either. In addition to the national ruling mandating at least a half-day of school for all children under thirteen, Staffordshire benefited from the art schools that began to spring up. "One would naturally expect to find schools of art flourishing in this district, and so we found it to be. The Art schools are said to be good and many," wrote one commentator, who noted that these schools were having a positive effect on the quality of pottery leaving the area. "It is most pleasing," he wrote, "to observe how the art is every year making more ambitious efforts. It is invading with increasing success the realms of both painting and sculpture"[57]—exactly what majolica is so renowned for.

These schools were noted for their positive influence on the adult community, as well; while beer is noted as the residents' favorite beverage, a historian noted that "of late years, thanks to such institutions as the Wedgwood Institute and the Schools of Design, of which each town boasts one, the present generation is more sober and better educated, whilst losing nothing of the kindheartedness and hospitality for which they have always been celebrated."[58]

In the wintertime, when they were not constantly busy with their "beloved patch[es] of garden," Staffordshire residents were avid followers of politics. Even in the pottery facilities themselves, newsmongering was happily indulged:

In many workshops it is the custom, winked at by employers and managers, for the workmen to read aloud in daily turn each morning's news.

Ardent politicians, they were most concerned with compulsory education rulings, the Permissive Bill, and non-intervention. Another pet issue was fostering cordiality with the United States, which was fast becoming Staffordshire's best customer. The potters kept on top of these and every other issue, leading one visitor to note, "Pity the sorrows of the unfortunate candidate who at a parliamentary election appears before the potters of Staffordshire displaying an imperfect acquaintance with his political catechism"![59]

No matter how widely Victorian majolica spread around the world, Staffordshire remains its point of origin. The designers and potters of that eminent region called upon the resources surrounding them, as well as the resources of world history, to

maintain the freshness and spontaneity of majolica's bright colors and motifs in a rapidly changing culture. The Staffordshire potter's vibrant life was an exemplary merging of countryside freedom and liberality with the ambition and excitement of modern production demands; similarly, majolica is a glorious example of optimum collaboration between human creativity and the potentials of mass-production. On this subject, what was once said of the potters can be said equally about the majolica they produced with such exuberance:

> It is pleasant to find this close contiguity of aristocratic splendours and of amplitude of domain with a swarming seat of industry like the Potteries. What an image does it give of our complex social condition! It may be safely said that the more closely these two opposite conditions of the social scale are brought together, the greater the mutual respect and kindness.[60]

Technology and artistry; urbanity and humanity: as intervening decades have proven, persuading either of these sets of opposites to cooperate in an industrious collaboration is a rare stroke of luck. The interests of labor, of management, and of the consumer seldom concur. Similarly, it is no easy task to combine these conditions in the design of a product, evoking the best artistic techniques and the best advantages of technology all in one. The years spent by Staffordshire potters creating majolica designs in glorious colors and forms, producing them in great quantity, and distributing them around the world, represent a harmonious culmination of efforts and traditions rarely seen even today.

THE DECOR OF VICTORIAN ENGLAND

Nowhere more than in the homes
of the great middle classes is there need of beauty . . .
The pressure of business sends every man engaged in it
home fatigued, and yet it is only when he enters that home
that his real life, his individual and affectional life,
comes into play.
On the exchange, in the office or shop, he has been
what commerce and the world determine; he has been but
perfunctory; but now he shuts the door behind him and his
own bit of the day is reached. What is the real
requirement for this person? Does a house that
furnishes his bed and board suffice him? or,
which is of greater importance,
does so much alone suffice others
who dwell habitually in it?[61]

Take away all that has been added to our homes by art,
and we all become naked savages living in mud or log huts.[62]

The economic expansion of the nineteenth century brought social and cultural change to all walks of life. New styles could be seen on the street, at the workplace, and perhaps most of all, in the heavily-curtained homes of the prosperous middle-class. This group's recent ascent into affluence made them voracious consumers, and they reveled in the trappings of luxury. "The present age is one of multiplied toys for grown-up people," wrote Lady Blanche Murphy in the 1870s, continuing

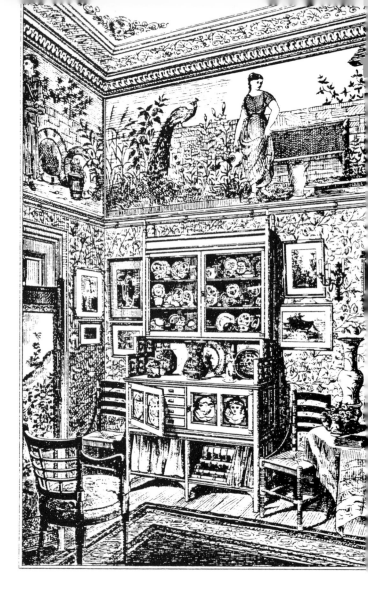

"Perhaps one country is just as much overrun with knick-knacks as another, but certain it is that England is by no means behindhand in this industry....in this kaleidoscope which is fashionable London one might lump together in one word the many whims and fancies that govern the sliding of one pattern into another, and call the whole brilliant, shimmering, frivolous, funny, evanescent system by the name of 'knickknackery,' [which] may touch art on one side and perverted ingenuity on the other."[63]

Victorian consumers were in raptures over many different styles, stretching across history and around the world—from classic Greco-Roman designs to the ghastly naturalism of French Palissy-ware, from bright Mediterranean maiolica to solid English Tudor ware, and from heavy, baroque grotesques to light, spare Asian imports. This wide range allowed for any number of decorating options (and fatal decorating errors). Home-owners began to seek help from a proliferation of books about decorating.

For the first time, too, they sought out the services of interior decorators. Such were the Misses Garrett, sisters and professional decorators who targeted the moneyed middle class. An interviewer reports that the Garrett sisters "have recognized it as a want that a beautiful decoration should be brought within the reach of middle class families, who are not prepared or dis-

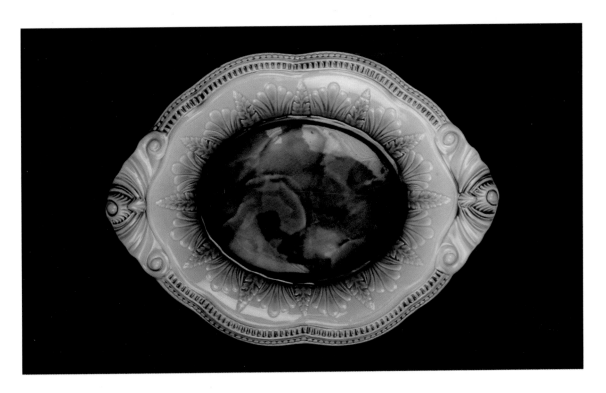

A platter with a mottled center, 14" x
10.5", unmarked. Courtesy of Britannia,
Gray's Antique Market, London.

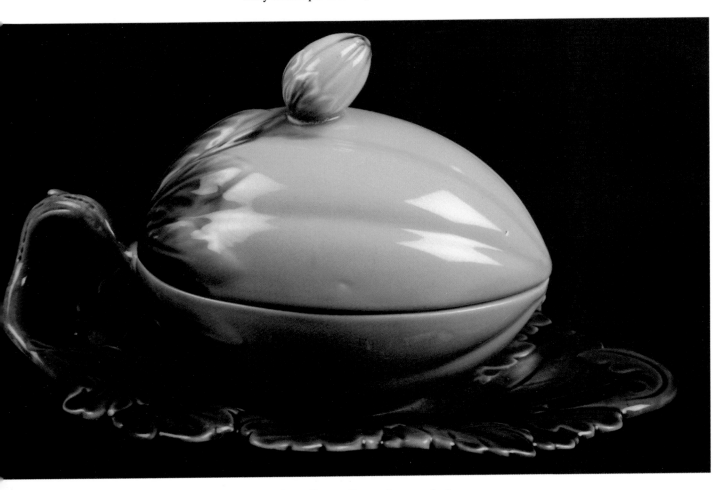

A 9"-long George Jones piece marked
with his initials in a double-circle.
Courtesy of Dearing Antiques, Miami
Circle, Atlanta

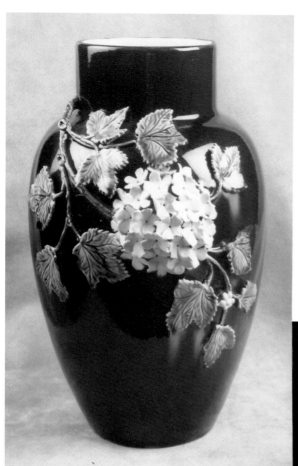

A signed Forrester vase, 13" high. Courtesy of Dearing Antiques, Miami Circle, Atlanta

A 7"-high vase with delicate modeling, made by the Worcester Royal Porcelain Company, c. 1867. Worcester did not make much majolica. Courtesy of Dearing Antiques, Miami Circle, Atlanta

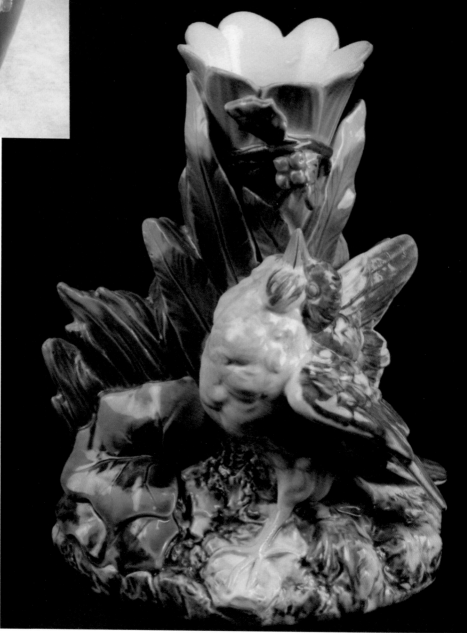

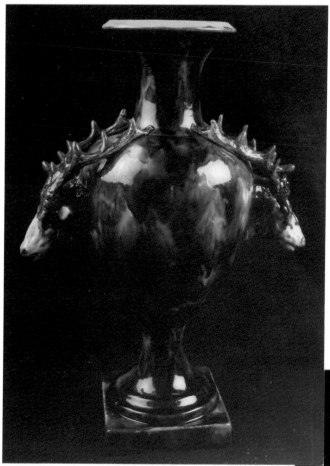

A rare George Jones vase, 14" high. Courtesy of Dearing Antiques, Miami Circle, Atlanta

Pompeiian Drinking Vessel.

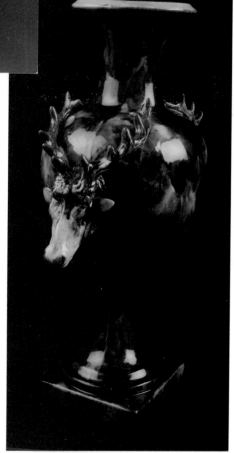

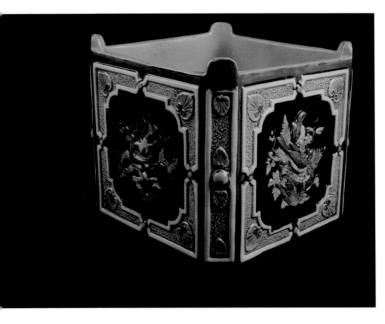

A Holdcroft jardiniere, 8.5" high.
Courtesy of Dearing Antiques, Miami
Circle, Atlanta

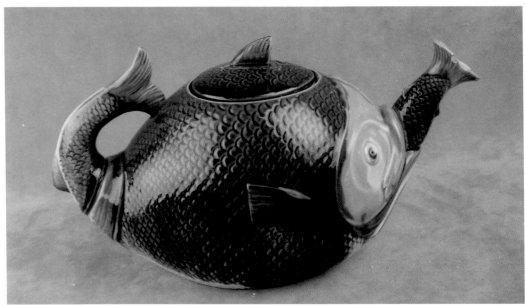

A whimsical fish teapot. Courtesy of
Britannia, Gray's Antique Market, London.

A 7" frog-and-melon pitcher, presumably
by Minton. Courtesy of Britannia, Gray's
Antique Market, London.

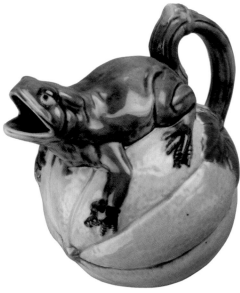

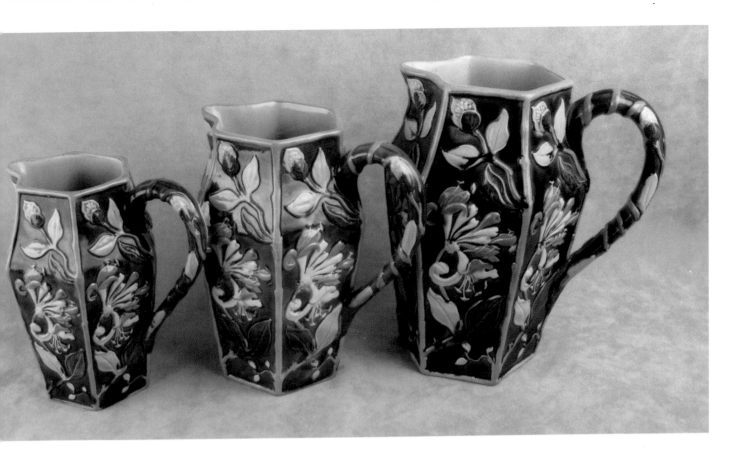

A trio of unmarked pitchers. The largest
stands 9" tall. Courtesy of Britannia,
Gray's Antique Market, London.

Marked "MINTON," 6" high. Courtesy
of Dearing Antiques, Miami Circle,
Atlanta

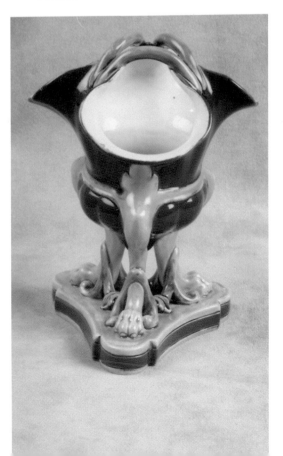

This cobalt saucer is by Moorcroft, which continues to sucessfully produce hand-painted art pottery even now, a hundred years after majolica faded from its initial popularity. The saucer is 5" in diam., and the back bears an impressed "MOORCROFT" mark. Courtesy of Britannia, Gray's Antique Market, London.

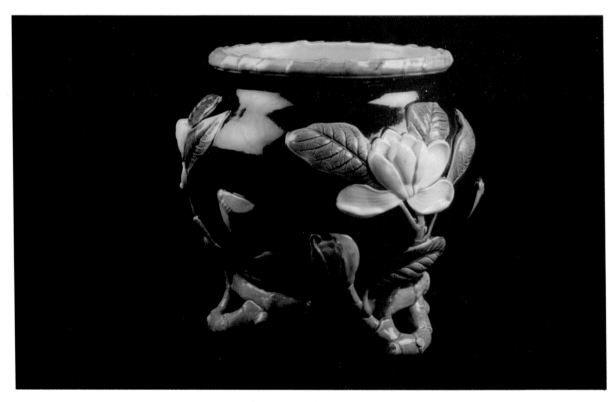

A cobalt jardiniere with a 9" mouth. Courtesy of Dearing Antiques, Miami Circle, Atlanta

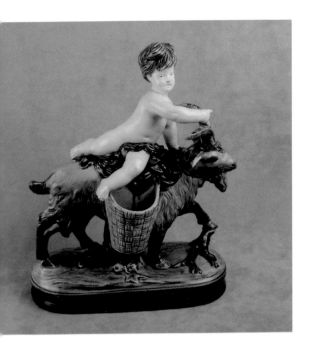

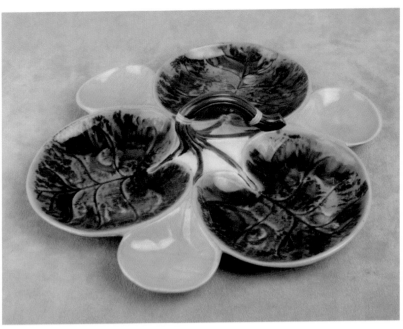

An 11"-tall putti figure with a goat and a basket, made by Holdcroft in 1878. Courtesy of Britannia, Gray's Antique Market, London.

A 9"-diam. serving dish with three large sections in mottled glaze, three small sections in robins-egg blue, and a stem-shaped central handle. Courtesy of Britannia, Gray's Antique Market, London.

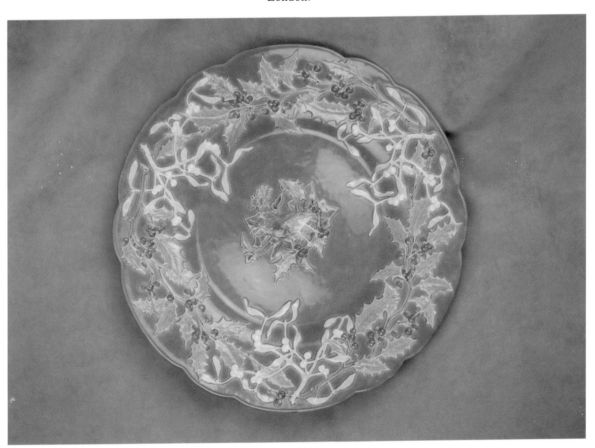

A 17" round Christmas platter, with a mistletoe and holly border surrounding a robin in the center. Made by W. H. Kerr, Worcester, c. 1861, with a round Worcester mark. Courtesy of Britannia, Gray's Antique Market, London.

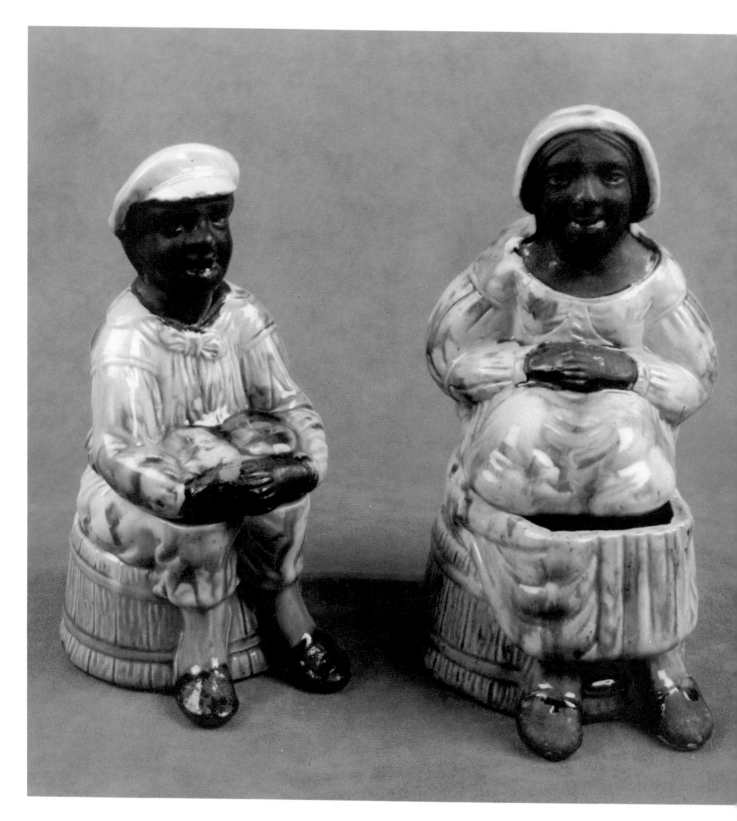

A two-piece smoking set, unmarked, 7.5"
high. Courtesy of Byron Hamilton, Atlanta

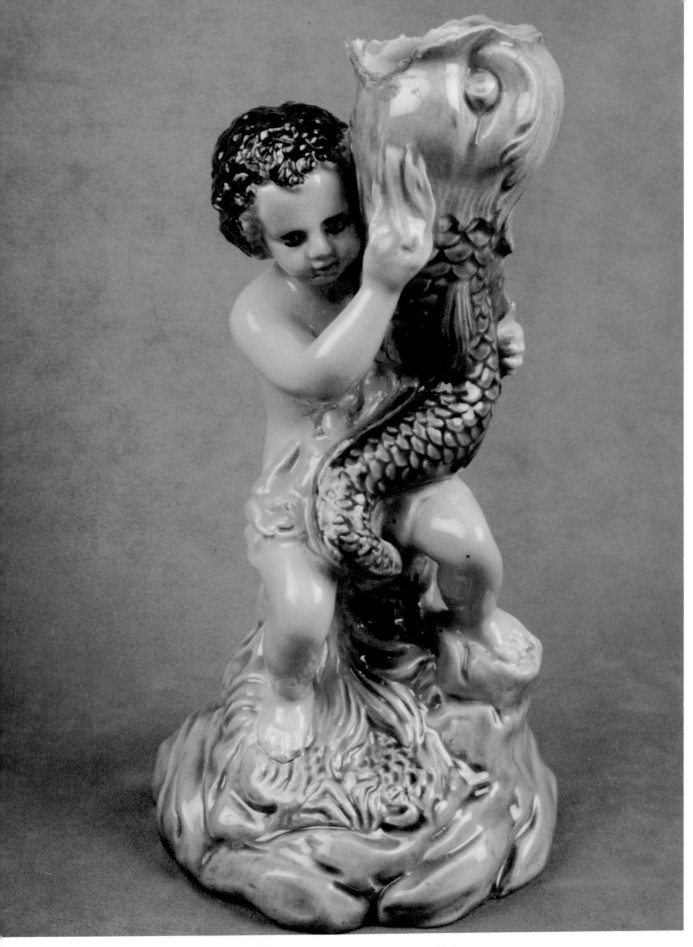

An unmarked vase (broken at top), 9.5" high.
Courtesy of Byron Hamilton, Atlanta

ENGLISH MAJOLICA

The years 1837 through 1901 marked Queen Victoria's reign in England, one of the most glorious eras of English history. In both domestic affairs and colonial interests overseas, it seemed that everything was steadily improving, and Victorian lifestyles grew commensurately more elaborate. Out of the increasing hodge-podge of English culture that resulted came the delightful majolica products of pottery workshops like Minton, Wedgwood, George Jones, and others. While countless manufacturers made majolica, they varied in quantity and quality of production. The aforementioned firms produced much of the best majolica, which is easy to distinguish from the rest and today fetches the highest prices. These firms were often the groundbreakers for innovative fashions and distinctive styles, after which the lesser manufacturers modeled their own productions.

MINTON & COMPANY

No matter what success [Herbert Minton]
achieved, his energies never relaxed;
there could be but one watchword for him,
"Forward."[70]

Herbert Minton, the creator of Victorian majolica, was born into a family already well-known for its talent with pottery manufacture. The Minton family had been working in the Staffordshire ceramics industry since the late 1700s (Herbert's father Thomas actually designed the original Willow pattern for blue and white dishes), when the Minton works opened in Stoke-on-Trent. The family tradition of innovative design and outstanding execution continued with Herbert, who took the helm when his father died in 1836. At this time, the Minton pottery was the most significant firm in Staffordshire, and under Herbert's direction it only improved.

Minton's production leading up to the mid-century was focused on reproductions and revivals of antique styles. Herbert's designers drew inspiration from the Italian *maiolica* and French Palissy-ware collections of the South Kensington (later Victoria & Albert) Museum and from the Minton family collection of eighteenth-century Continental porcelain and Chinese wares.

One firm, Minton & Co., are engaged in artistic work. It is said that they copy and imitate everything worth imitating in the old works of other nations, the majolica of Italy, Palissy ware of France, the famous inlaid Henri-deux ware, the Italian Capo di Monte, parian marble, and the cloisonné enamel of China and Japan,

wrote one contemporary journal. In doing this, the company maintained the outstanding reputation it had earned during Thomas Minton's supervision.

In 1849, Herbert Minton secured the services of designer Léon Arnoux, in exile from the upheaval in France. Arnoux, "a gentleman who had long enjoyed the reputation of being, perhaps, more profoundly versed in the mysteries of ceramic manu-

facture than any other *savant* in France,"[71] introduced new materials and techniques to Minton's factory. In his role as art director, he also contributed a more sophisticated aesthetic sensibility, which helped to raise Minton's products to a level higher than that of mere replication of historic styles. Delving into the past served as the primary inspiration for Victorian designers in every field and in most companies, often resulting in "incongruous or poorly conceived application[s]" of earlier styles onto new items, or at best a stagnation of creative innovation. Fortunately for Minton, Arnoux was able to take inspiration from the past and use it in innovative, contemporary ways. His supervi-

A Victorian etching of a Minton majolica
vase modeled by Albert Carrier-Belleuse.

sion kept Minton & Company's staff on the high side of the "distinction between designers who exploit historicism and those who understand and interpret it."[72] It was this understanding that allowed Minton to adapt *maiolica* and Palissy-ware into the dynamic ware known as Victorian majolica without falling into the trap of merely aping the past.

Majolica broke onto the scene in 1851, at the Crystal Palace Exhibition in London, with Renaissance-inspired wares updates with Arnoux's modern production techniques. Minton

52

majolica from this era had not yet taken advantage of the luminosity of lead glazes; they still relied on opaque tin glazes for their color and detail. Pieces featured mythological figures and genre scenes, much of it painted in an antique manner reminiscent of Della Robbia's maiolica, a style from which the company would soon depart. Many of these pieces feature *istoriato* painting—with the realistic look of oil on canvas—on platters' central medallions or on the flat surfaces of three-dimensional ware. Among these is the famous four-foot-tall "Prometheus Vase" (debuted at the Paris Expo in 1867) shown in an engraving here, and another is a platter portrait of Queen Victoria. The painted scenes on these required tremendous artistry and could not be mass-produced, and as a result very few were made. The Prometheus vase, for example, is thought to have been made in six versions, intended for display at the international exhibitions of the day. Other early pieces were heavily sculpted, incorporating gargoyle and grotesque motifs, garlands, rams' heads, masks, and other Renaissance forms, as well as Greco-Roman, Byzantine, and Islamic elements.[73] Palissy-style wares were made, some almost exact replicas of their predecessors.

At the Crystal Palace Exhibition, Minton's majolica created quite a stir, both positively and negatively. They faced a similarly mixed reaction at the early Paris shows, as majolica continued to expand its market. Many spectators were excited by the vitality Minton's glazes had lent to antique forms, as well as by the accessibility and relative affordability of modern versions. One report from the Paris show in 1855 says that

> The British section shared with the French and the Japanese the admiration due to living art—living, as opposed to that given up to exhuming the dead.[74]

while another reports that

> Messrs. Minton, of Stoke, in Staffordshire, manufacture pottery, porcelain, and majolica. By this latter, that massive ware, of bold design and bolder ornamentation and positive colours, principally blues, yellows, and greens, Minton's at the Paris Exhibition of 1855 created quite a sensation, and won universal admiration.[75]

A newspaper picture of Minton's famous Prometheus vase, along with a magnificent peacock designed by Paul Colomera.

Others considered Minton's display to be far from vital or sensational, as did the critic who wrote that "At the present day Italian maiolica has been revived with success—but without originality—by Minton, in England."[76] Others were less upset by the lack of originality evinced by Minton's replicas than by what they considered the relative inferiority of new to old:

> While science, as regards machinery, electricity, chemistry, and every other 'istry', has advanced with rapid strides, taste, beauty, refinement, elegance of form, outline, and colour—art itself, in fact—have retrograded This was strikingly evident at the Paris Exhibition Beautiful as the modern Wedgwood, Minton, and other pottery, to the true lover of art they bear no possible comparison to the work of other days.[77]

The talents of Herbert Minton, Léon Arnoux, and other Minton designers (notably Thomas Kirkby, Hugues Protat, Paul Colomera, and Albert Carrier-Belleuse) were not to let such criticisms stand unanswered. Their creative initiative soon told them the same thing some critics were:

> The art of Majolica . . . can no longer content itself with the mere reproduction of pieces, even of the finest specimens of Italian art. We might as well our poets to write nothing but tragedies. Our sideboards, carved out in kinds of wood which were then unknown, with different outlines, and made to supply new wants, cannot be burdened with spurious imitations which are dimmed and extinguished the moment an original, even of the same period, is admitted among them . . . It must transform itself as all other arts have done.[78]

In short order, Minton's majolica began to evolve. Indeed, while its initial popularity was based upon its ability to invoke the prestige and glamour of antiquity, the wares' lasting appeal came from "deviating, almost immediately, from historical autenticity to meet popular demand."[79] Minton's forms soon became more streamlined, more whimsical, more naturalistic, and more modern.

A Victorian etching of a Minton ewer.

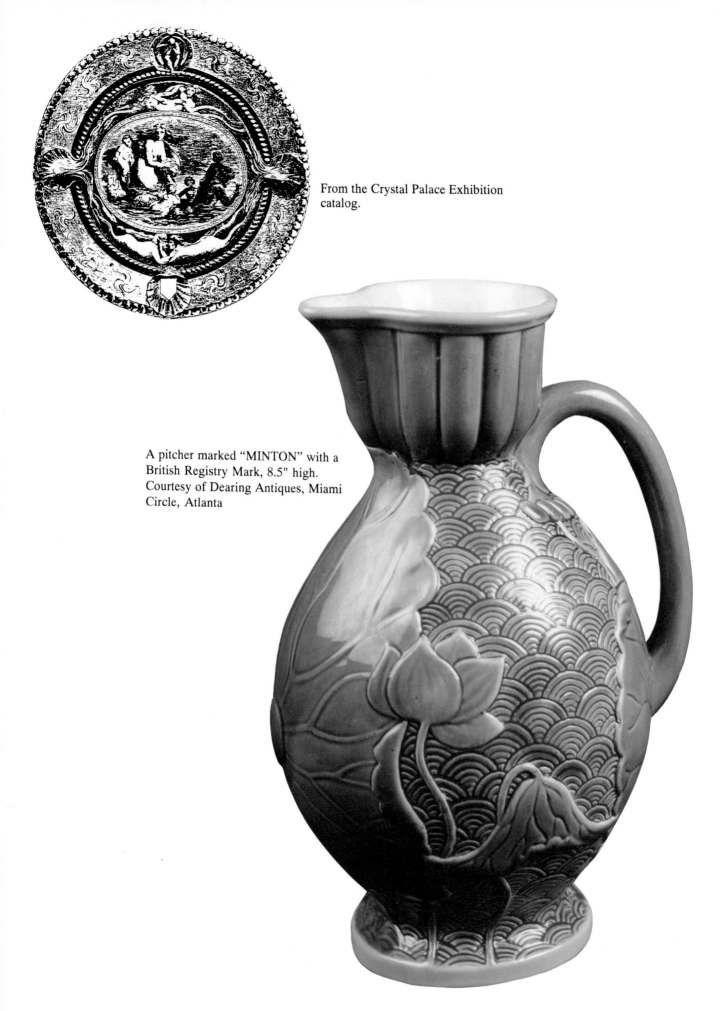

From the Crystal Palace Exhibition catalog.

A pitcher marked "MINTON" with a British Registry Mark, 8.5" high. Courtesy of Dearing Antiques, Miami Circle, Atlanta

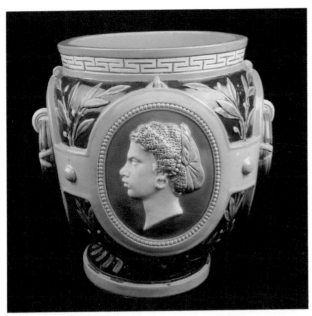
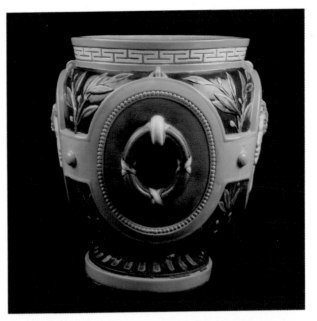
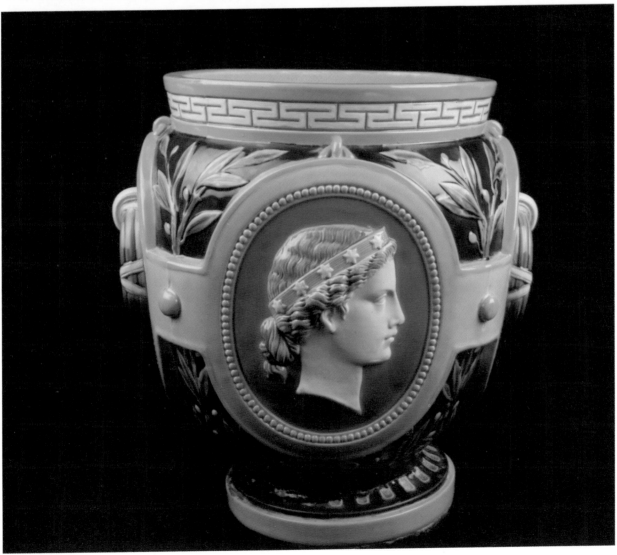

A jardiniere in a Minton design, c.
1860, 13.5" high x 9" dia. (mouth).
Despite major restoration, this piece is
still magnificent. Courtesy of Joseph
Conrad Antiques, Atlanta

By 1860 Minton's majolica was very popular and soon other manufacturers entered the playing field (some of them, like George Jones and Joseph Holdcroft, coming directly from Minton's workshops). Still, Minton remained foremost, consistently producing wares of the highest merit. By the mid-1870s, the company's production required over fifteen hundred employees, making them one of the world's largest manufacturers of decorative ceramics. More than two hundred of ther employees were engaged in painting earthenwares, primarily majolica housewares, display pieces, and architectural tiles. Minton's vast resources and dependable market allowed them to maintain a 'library' of many earthenware molds, representing everything from small dressing-table wares to gigantic sculptural centerpieces and fountains, despite the high cost of making such molds.

As the decades turned, Minton's majolica ventured into each new Victorian style, through the rage for Japan to the limited enthusiasm for the Aesthetic movement, and around the turn of the century explored the growing Art Nouveau style with abstract floral and foliage designs in majolica glazes. This marked the end of Minton's majolica production, however. Most of Minton's majolica molds were destroyed in 1926 to make room for modern development, and the rest were broken up in 1940, when earthenware production was brought to a close there.

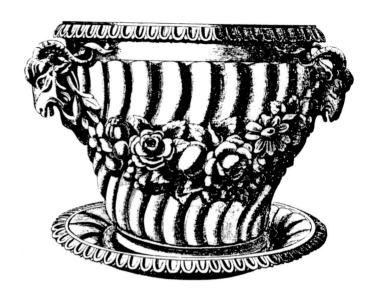

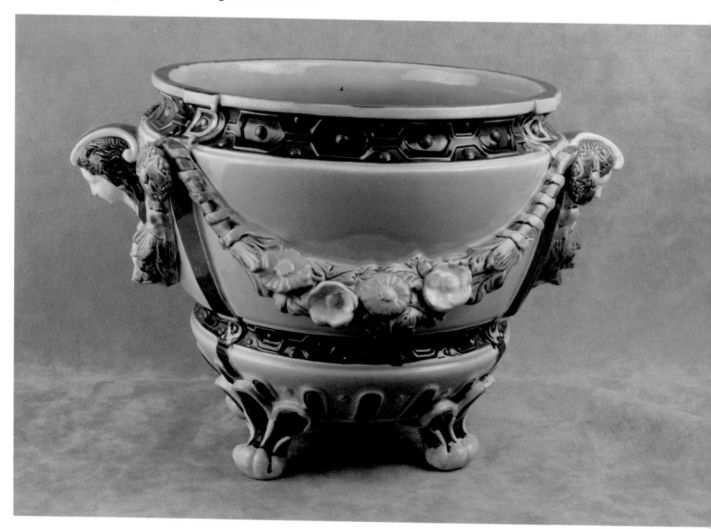

A 9"-tall jardiniere made by Holdcroft, dated 1870. Courtesy of Britannia, Gray's Antique Market, London.

Identifying Minton Majolica

Minton's majolica, unlike the products of lesser firms, is generally well-marked. As of 1862, the impressed stamp "MINTON" was used on all wares, and ten years later the stamp was changed to "MINTONS." Date code symbols and British registry marks were also applied in many cases.

Unmarked pieces by several of the other top majolica manufacturers may be confused with Minton wares (particularly those by George Jones), but there are a few clues to distinguishing them. Minton's undersurfaces are usually pastel shades of pink, blue, or green. The bottoms of their Palissy-style wares are mottled blue, brown and black; Renaissance-style wares are mottled green and yellow. (George Jones' mottled backs are distinctively different.) Naturalistic wares generally have deep emerald green bottoms, although some are white, pale pink, turquoise, or blue. Interiors of Minton pieces are most often the bright rose color known as 'majolica pink', though some are blue or turquoise, green, or very rarely, white.[80]

A 14.5"-high cockatoo, possibly Minton.
Courtesy of John Tribble, Atlanta

A Eulogy For Herbert Minton[81] (1792 - 1858)

delivered by eminent critic Mr. Digby Wyatt

Mr. Herbert Minton's industrial career . . . extend[ed] over some fifty years of the present century, a period hitherto without a rival in the history of civilization—one of social progress and commercial development, of restless energy of thought and untiring labor, crowned by innumerable conquests of mind over matter. Of that apparently inexhaustible activity, intellectual and physical . . . Mr. Minton offered a perfect type . . . Neither a man of profound research nor an educated artist, neither an economist nor an inventor, by courage and ceaseless energy he brought to bear upon the ceration of his ultimately colossal business, such a combination of scinece, art, organization, and invention as can be paralleled only by that rare union of qualities which impressed the stamp of genius upon his great predecessor, Josiah Wedgwood. A clear head, a strong body, rare powers of endurance and observation, a cool judgment, in spite of a singularly sanguine temperment, a kindly nature and genial manner, were the leading characteristics of Mr. Minton; and with such natural gifts, and an amount of perseverance to which I know no parallel in history (excepting, perhaps, that displayed by the celebrated potter, Bernard Palissy), he was enabled to benefit his country, while building up his own fortune, and to do credit to the age in which he was born, thereby winning lasting honour for his memory.

A 14"-tall covered urn in Minton's "Four Seasons" series, this one featuring Autumn and Winter. Courtesy of Britannia, Gray's Antique Market, London.

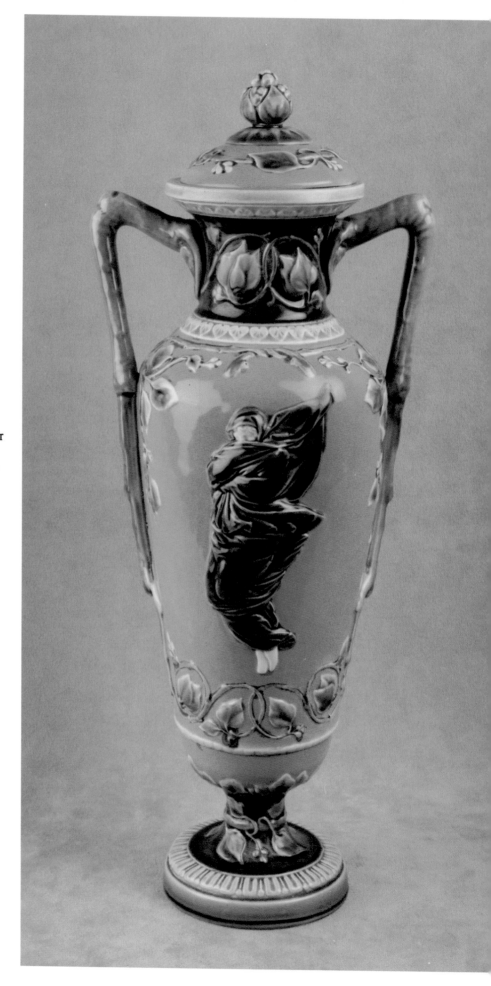

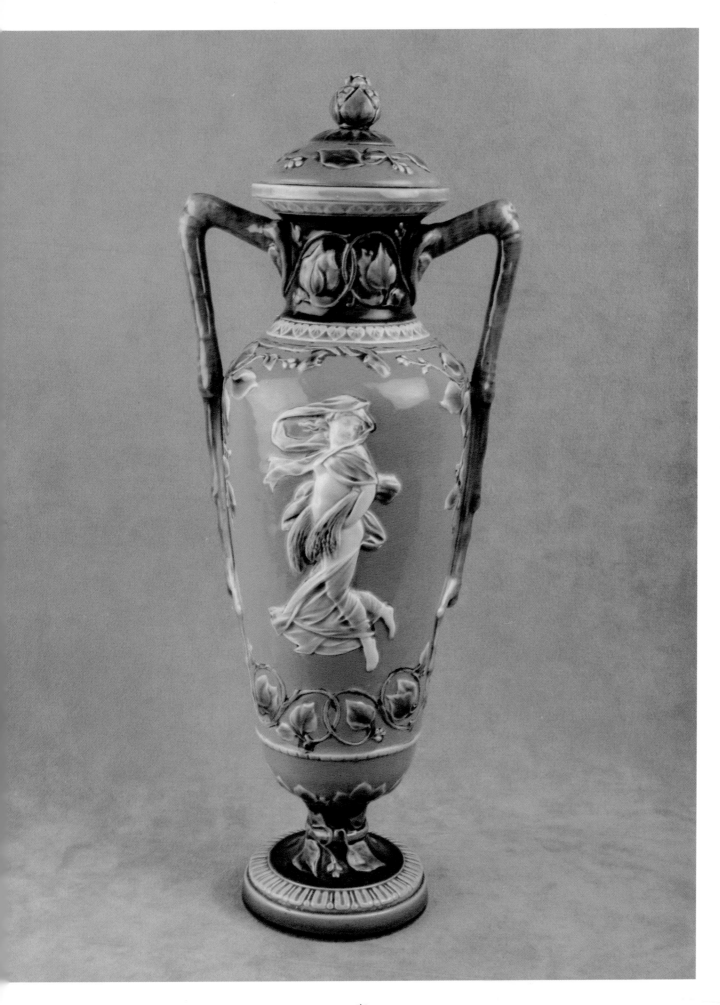

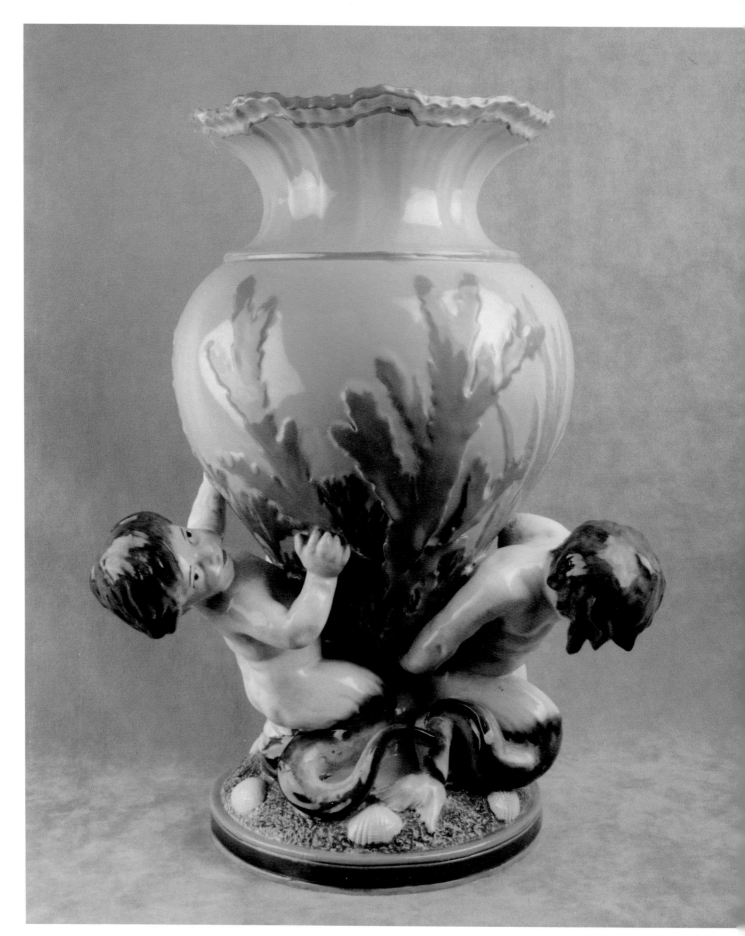

A 17"-tall Minton vase with an undersea
theme. Courtesy of Britannia, Gray's
Antique Market, London.

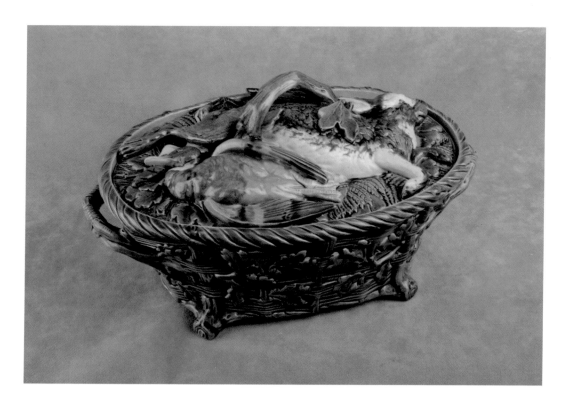

A 13"-long game pie dish by Minton, dating from 1860. Courtesy of Britannia, Gray's Antique Market, London.

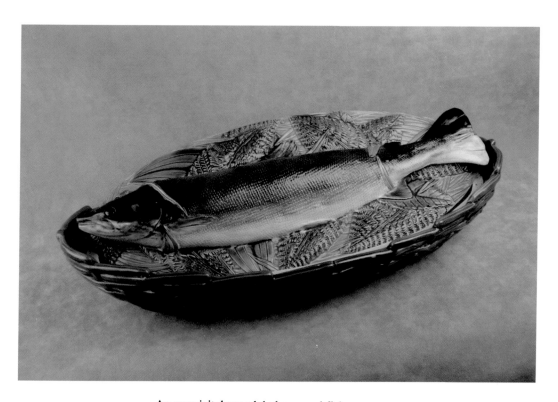

An exquisitely modeled covered fish server by Minton, 19" long, with a British Registry Mark. Sometimes naturalistic ceramic molds were cast over actual plants and animals—not an unlikely explanation for the extreme realism of this piece. Courtesy of Gray's Antique Market, London.

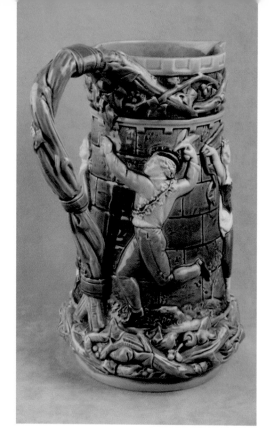

A 10"-tall pitcher with four dancing figures. Made by Minton, 1868. Courtesy of Britannia, Gray's Antique Market, London.

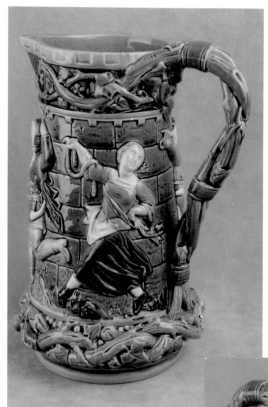

A 9"-tall parrot figure by Minton, marked on the base with a seal reading "MINTONS / ENGLAND." Courtesy of Britannia, Gray's Antique Market, London.

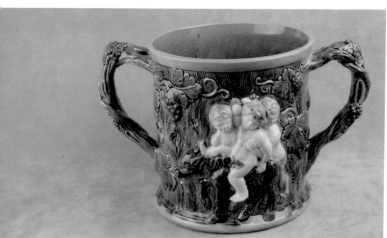

This oversized mug dates from 1869 and was made by Minton. It measures 6" tall x 10" wide (handle to handle). Courtesy of Britannia, Gray's Antique Market, London.

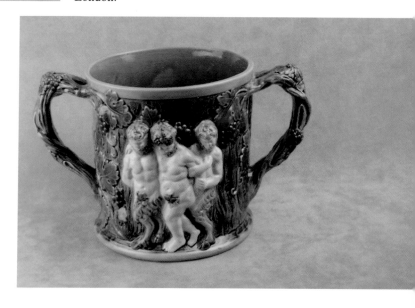

Two putti figurals, each 11" tall, made by
Minton in 1864. Courtesy of Britannia,
Gray's Antique Market, London.

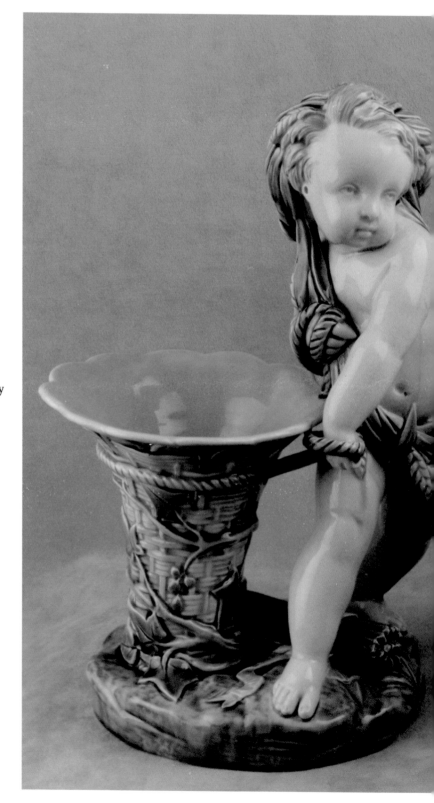

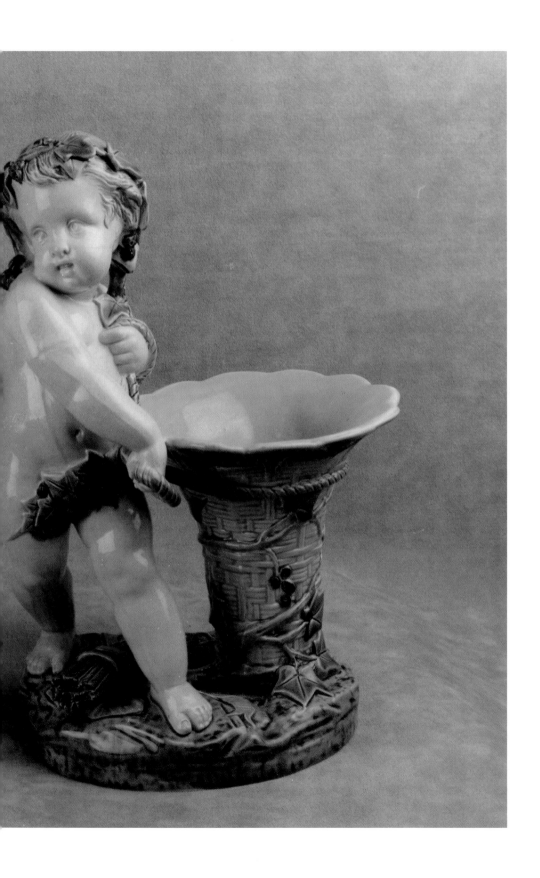

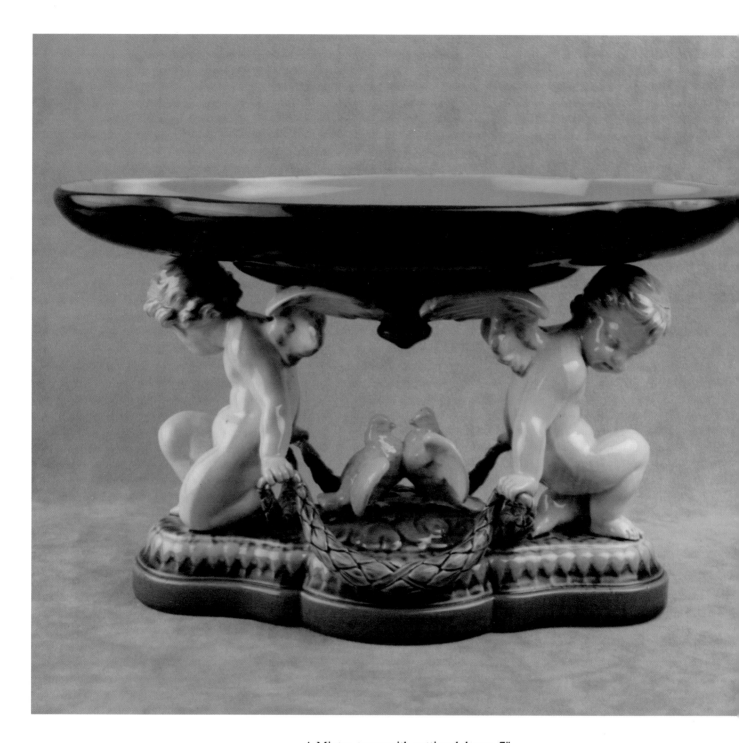

A Minton tazza with putti and doves, 7"
tall. Courtesy of Britannia, Gray's
Antique Market, London.

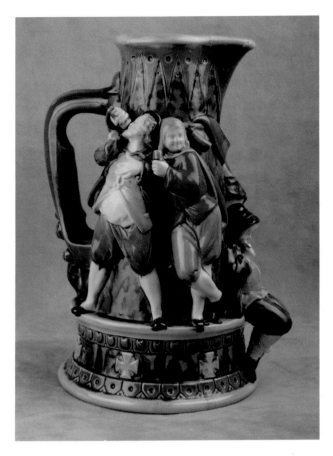

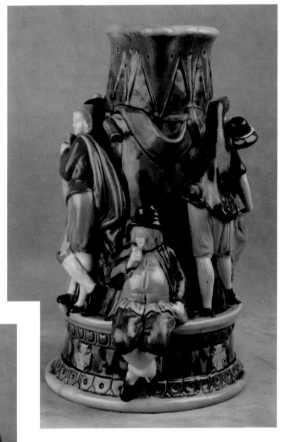

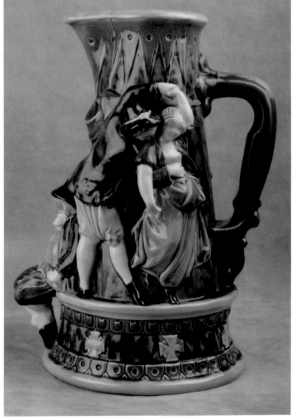

An 11"-tall figural pitcher by Minton, with a frieze of merrymakers. Courtesy of Britannia, Gray's Antique Market, London.

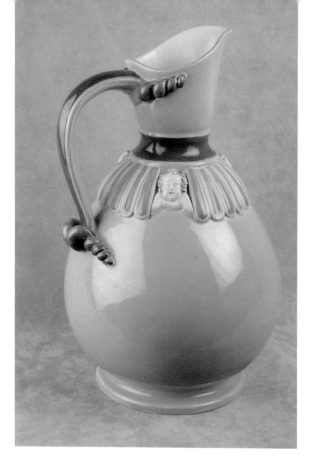

A Minton pitcher, 11.75" tall, dating from 1861. Courtesy of Britannia, Gray's Antique Market, London.

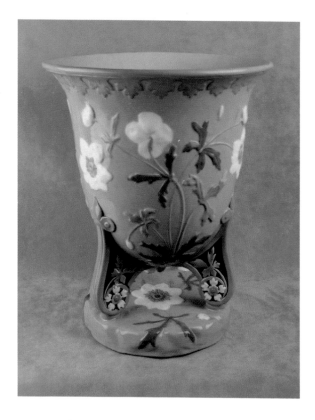

A 14"-tall jardiniere by Minton. Courtesy of Britannia, Gray's Antique Market, London.

WEDGWOOD & SONS

This preeminent pottery was established by Josiah Wedgwood I in the mid-1700s, and has been known consistently for outstanding quality wares. Though Herbert Minton's majolica hit the market in 1851, Wedgwood did not begin producing it until the early 1860s, for several reasons. First, the company's finances during the 1850s had been very tight, and did not allow for much speculative production. Second, the traditional Wedgwood style was monochrome (or at most two- or three-colored) with low-relief modelling, much more restrained and understated than majolica allowed for; a Wedgwood representative at Minton's 1851 exhibition display described the majolica wares there as "vulgar and coarse."[82] Godfrey Wedgwood is credited with first introducing majolica to the Wedgwood production, and the line was to prove very successful.

Wedgwood's designs were often very similar to Minton's—not surprising, since Wedgwood had used a number of Minton's better-known designers on a freelance basis. Minton also helped Wedgwood by sharing chemical and technical knowledge about majolica production, partly, it is speculated, because of Arnoux's respect for Wedgwood's high standards.[83] The two companies insisted on the highest quality, and few other majolica firms can compare to the sharpness of their modelling or the artistic accuracy of their decoration; seldom do pieces by either firm have 'drips'!

Wedgwood's products can be differentiated by their glazes, however; Minton used opaque enamel colors, while Wedgwood pioneered the use of much more brilliant, transparent glazes. In addition, Minton's body was coarse and cane-colored, while Wedgwood's was white.[84] By 1880, Wedgwood had taken an independent tack with majolica, with over three hundred and fifty elaborate wares, often innovative and fantastic tablewares. These pieces made Wedgwood almost unrivaled in the size of their production.

As majolica's popularity declined, Wedgwood adapted their designs to keep up with public taste. Beginning in 1878, the company produced "Argenta Ware," which featured a natural off-white body, with colored glazes applied to raised, molded details. This appealed to the Aesthetic and *japonsime* tastes, and also addressed a new Continental export—white relief-molded dishes with minimal colored decoration with majolica glazes. As one historian explains, the English market was "beginning to tire of excessive flamboyance and to prefer more sober designs, therefore white, cream, and other pastel backgrounds increased in popularity although the deeper coloured grounds were still produced."[85]

Nearly all Wedgwood wares are marked with the impressed "WEDGWOOD" stamp. After 1892, the word "ENGLAND" was added. The letter M appeared on majolica wares between 1873 and 1888, after which the letter K was used (until 1920). Wedgwood also used a complicated alphabet code to indicate the year of manufacture; this code is explained in the "Makers and Marks" section of this book.

For a discussion of Wedgwood's manufacture of majolica precursor greenwares, see the Green Wares section.

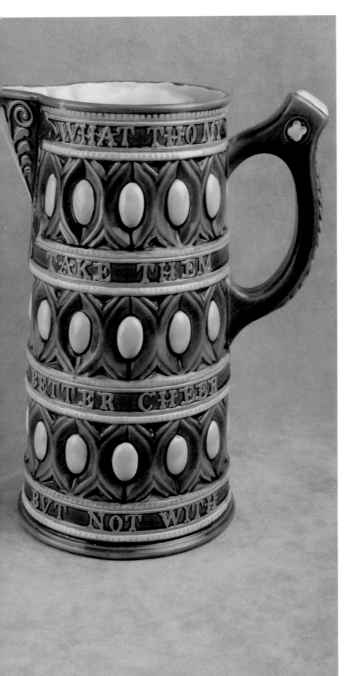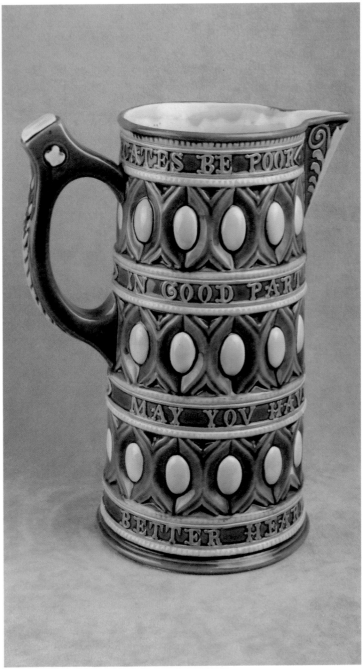

A 10"-tall Tudor pitcher by Wedgwood,
reading "What tho my gates be poor /
take them in good part. Better cheer may
you have / but not with better heart."
Courtesy of Britannia, Gray's Antique
Market, London.

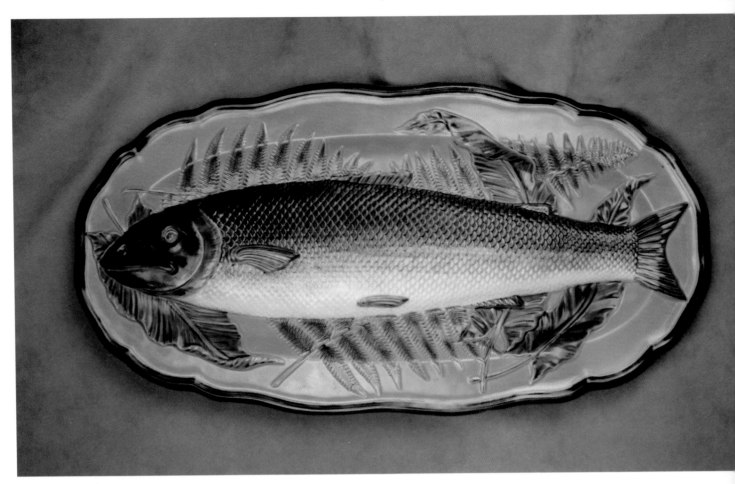

A fish platter marked "WEDGWOOD,"
in a mid-period majolica style far
removed from its roots in Palissy ware,
12.5" x 25." Courtesy of Britannia,
Gray's Antique Market, London.

Two mottled Wedgwood plates, 9", with
reticulated edges, c. 1860. Courtesy of
Joseph Conrad Antiques, Atlanta

A 7.5" yellow ribbon plate; c. 1880.
Courtesy of Dearing Antiques, Miami
Circle, Atlanta

A caulilflower tea set, 5.5" tall (teapot), from Wedgwood's Etruria line. Courtesy of Britannia, Gray's Antique Market, London.

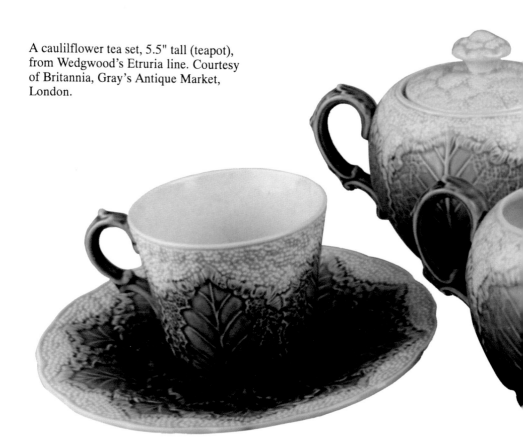

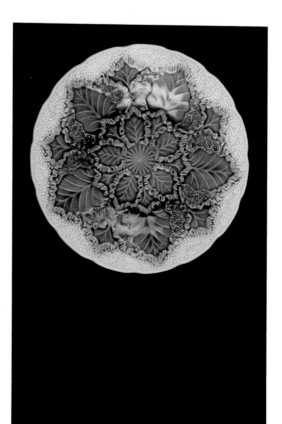

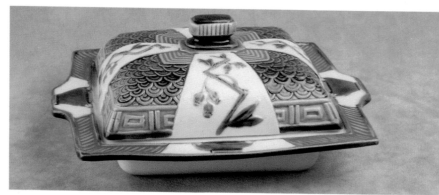

A 9" vegetable serving dish in a geometric 'japonisme' style, with an impressed "WEDGWOOD" mark. Courtesy of Britannia, Gray's Antique Market, London.

An 8" cauliflower dish with the impressed marks "WEDGWOOD" and "MADE IN ENGLAND." Courtesy of Dearing Antiques, Miami Circle, Atlanta

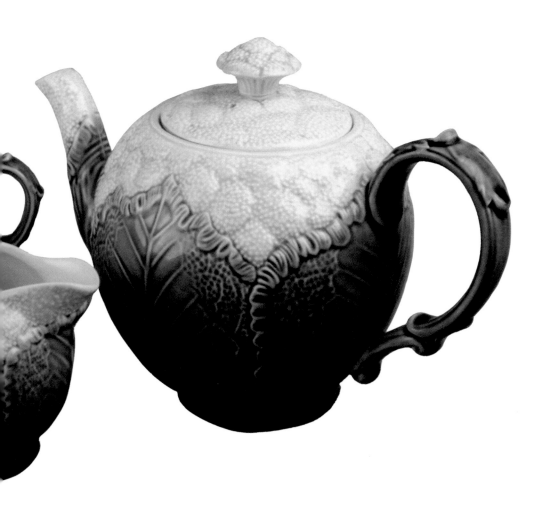

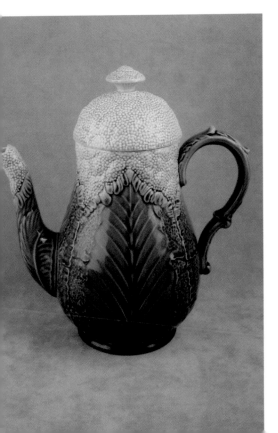

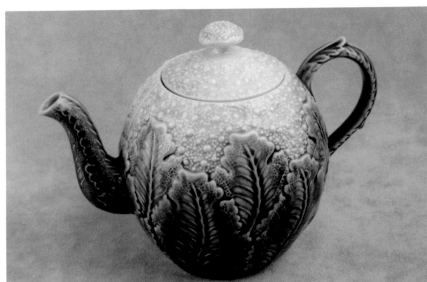

A 9.5" cauliflower coffee pot, with an impressed "WEDGWOOD" mark. Courtesy of Britannia, Gray's Antique Market, London.

A 5" cauliflower teapot, unmarked but probably Wedgwood. Courtesy of Britannia, Gray's Antique Market, London.

GEORGE JONES

A third significant English manufacturer was George Jones, who was employed by Minton for almost a dozen years before establishing his own workshop in Stoke-on-Trent in 1861. His shop is notable not only for the high quality of its wares, but also because it was the only Staffordshire pottery to focus almost exclusively on majolica; over seventy percent of his production was majolica! George Jones pieces are considered to be the greatest rivals of Minton's. Both display the boldness of modeling and coloration that is majolica's greatest strength, and both are technically impeccable.

The difference is largely one of formality; perhaps only in comparison with George Jones could Minton's wares be thought formal, but George Jones creations do have a whimsy lacking in any other manufacturer's wares. Jewitt's comment that Jones' work is "just such a careless, elegant, and surpassingly beautiful object as a naïad or a water nymph, in one of her happier moments, might have improvised, as she rose from the lake, to present to some favoured mortal" — is just what many of us feel upon sighting such a piece on a crowded shopkeeper's shelf.[86]

Identifying George Jones

George Jones' wares are much imitated, on both sides of the Atlantic. Clues to identifying them are the pink or turquoise interiors, which are generally in lighter shades than those used by Minton.[87]

Often a small unglazed spot was left on the mottled base of a George Jones piece, onto which was painted or scratched a design number. These numbers, mostly four-digit, began in the low 1000s in the early 1860s, advancing to the upper 6000s by the 1890s.

Frequently, the impressed, encircled George Jones monogram is present as well, possibly on a raised cartouche (with the look of a wax seal). After 1874, "& Sons" was added to the monogram mark.

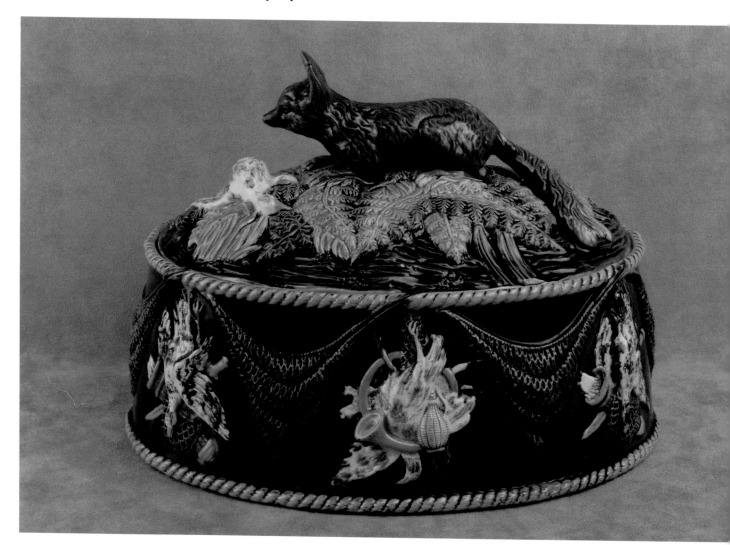

A game pie dish with a fox finial and other hunting-theme decorations, 8" tall x 10.5" long. Courtesy of Britannia, Gray's Antique Market, London.

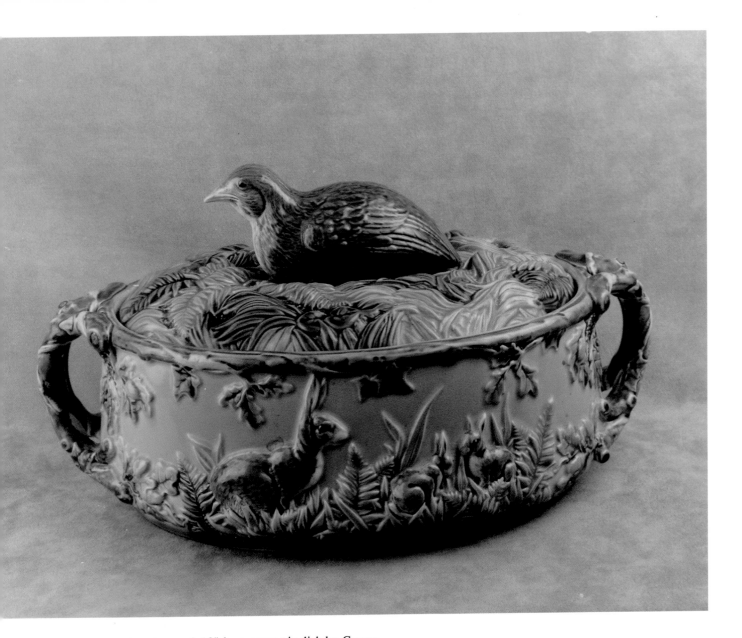

A 12"-long game pie dish by George Jones, dating from 1869. A fragment of a seal, reading "...RENT," remains on the underside of the dish. Courtesy of Britannia, Gray's Antique Market, London.

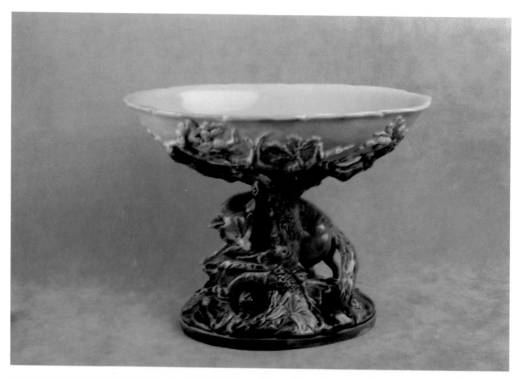

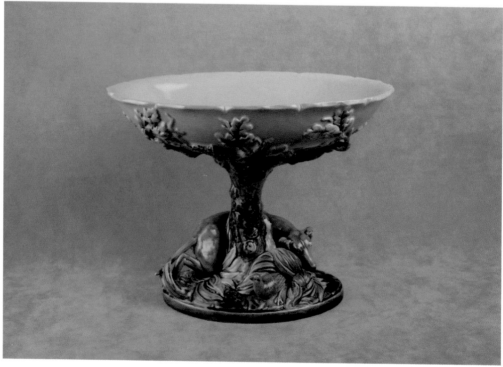

A pair of 8"-tall tazzas, one with a
hunting dog and the other with a hunting
fox. Courtesy of Britannia, Gray's
Antique Market, London.

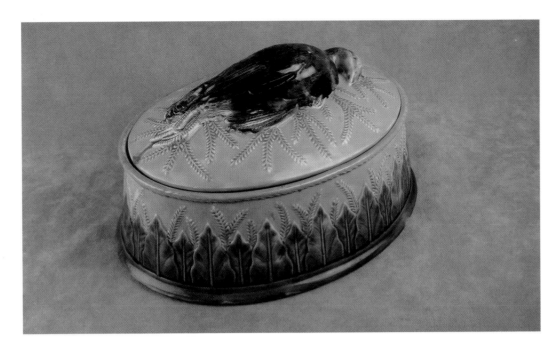

A covered game pie dish, 7" tall x 13" long, with a Registered Design mark. Courtesy of Britannia, Gray's Antique Market, London.

A 12"-tall lidded pitcher with a hunting theme, made by George Jones. A British Registry Mark dates this piece to May 27, 1872. Courtesy of Britannia, Gray's Antique Market, London.

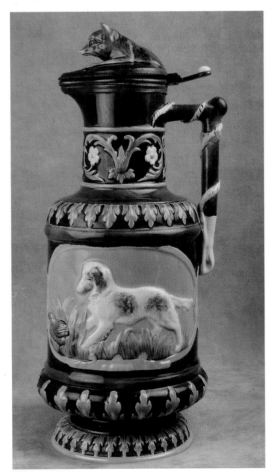

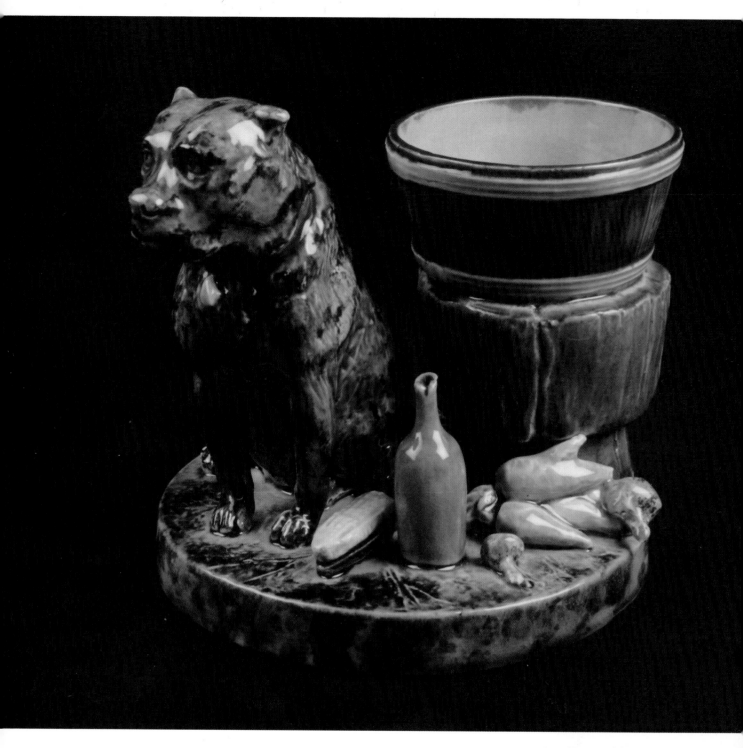

A George Jones piece marked with the "GJ" monogram seal, rare because it is Parian Ware. Courtesy of Dearing Antiques, Miami Circle, Atlanta

A 9.5" George Jones dish, marked with the GJ monogram and a thumbprint potters' mark on the mottled back. Courtesy of Dearing Antiques, Miami Circle, Atlanta GA.

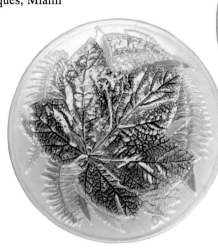

Two 8.5" plates by George Jones, c. 1860, with mottled backs and thumbprint potters' marks typical of Jones. Serious damage and restorations are shown here. Courtesy of Joseph Conrad Antiques, Atlanta

A 13"-tall cheese dome in the form of a
beehive, made by George Jones and
dating from 1872. Courtesy of Britannia,
Gray's Antique Market, London.

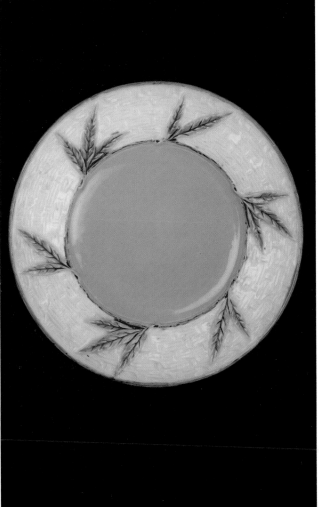

Two George Jones wicker-rim plates in different color schemes, both 9", unmarked. Courtesy of Britannia, Gray's Antique Market, London.

THE DECOR OF VICTORIAN AMERICA

To imagine one's self living in such surroundings
is to imagine rolling up one's sleeves
to begin clearing out the clutter.[88]

Like England in the Victorian era, America was enraptured by quantity; domestic interiors featured "a profusion of household goods, far greater than most people in the eighteenth century ever knew and more than many in the twentieth find comfortable."[89] Knickknacks filled the whatnots, lace and satin were layered over silk and velvet, and stripes, florals, and paisleys covered every surface. As in England, a rapid succession of decorating styles invaded American homes—albeit at a time lag of up to thirty years as the styles crossed the Atlantic.

> In the Victorian room the violent interplay, even clash, of textures, patterns, colors, and forms, and the overpowering number and variety of things—particularly those things whose purpose was decorative rather than functional—create a sort of visual cacophony that tends to outrage the modern eye,

wrote one commentator.[90] The reasons for this proliferation of housewares and textiles are social changes not unlike those that swept England slightly earlier, as industry and business succeeded quieter rural occupations. The growing economy gave birth to an increasingly affluent and populous middle class, whose daily lives grew both more harried and more subject to status evaluations. Victorian homes were intended to provide a buffer of material goods between the dog-eat-dog outside world of commerce and the ideally peaceful, sheltered world of home—providing "a haven from the competitive and immoral business world"[91]—and to impress the neighbors to boot.

But American homeowners' need for a secure haven may have differed slightly from that of their English counterparts. Immediately preceeding the Victorian era were the days of the American frontier experience; indeed, in some parts of the country, life was still very rugged. The answer, one modern sociologist speculates, "is to be found in an understanding of the personal past of the people who made up the Victorian population."

> Behind a Victorian cozy corner or an elaborate Eastlake bedstead or a room bedecked with lambrequins, hair and feather wreaths, whatnots loaded with curios, Brussels carpets and Turkish taborets and flower pots against floral wallpaper, there looms in the figurative middle distance, grey and enormous, the American frontier experience. Far more often than we realize, the people who adorned these rooms, and who lived in the result and loved it, had themselves once lived in a leaky log cabin with nothing but necessities and all too few of those.[92]

This recent history made well-cushioned and well-cluttered Victorian homes not just showpieces for the purposes of social climbing and professional hobnobbing; they were incontrovertible proof to the owner that the difficult days of the past were over—or at least that poverty would have to plow through three layers of wall-paper, tapestries, and curtains to reach them, climbing over huge sideboards and decorative screens and curio-tables to do it. Amidst all the clutter, the Victorian generation saw evidence that they had overcome a lifestyle of mere subsistence, an assurance that they were no longer at risk. "Day by day," writes the sociologist,

> these possessions must have reminded their owners that they had succeeded These things were not status symbols in the modern sense, intended to demonstrate something to the neighbors. Although no doubt the adornments of a Victorian house had something—even much—of that purpose, I submit that they had even more to say to their owners than to the neighbors."

Though not so extreme, the English had suffered through a time of trial in pre-Victorian days; after Napoleon, they faced a terrible agricultural depression, followed by a time of political strife surrounding the 1832 Reform Bill. It is not so difficult to fathom the enthusiasm for luxurious trappings that resulted when prosperity finally arrived, either in England or in America.

A much-improved economy may explain the enthusiasm with which Americans embraced the opulence of Victorian England, but the kaleidoscope of styles and trends that made up the clutter require many other explanations. In the 1840s, homeowners began buying books on how to decorate their houses, and by post-Civil War years there were many popular titles on interior decoration (and even a few professional interior designers). These helped to spread trends throughout the country, as did the advent of trade catalogs, in which majolica would eventually find a significant place. Primarily, these catalogs promoted goods for the middle class, pushing the ideals of gentility, cosmopolitanism, technological progress, and comfort to which they aspired.[93]

Both trade catalogues and interior decoration books began an effort to educate Americans about household fashion, and the country grew increasingly style-conscious. As in England, much of this education focused on the past: on styles with historical precedents. As is evident in the wide range of majolica that was manufactured, this encouraged the continual production of new household items, corresponding to each newly-rediscovered historical style. "In one sense," wrote a modern scholar, "the reason the artifactual universe expanded so markedly was because so many earlier chapters of design history were revived and revised."

> Concurrent with the discovery and emulation of past historical models came a rise in consumer and public understanding of design history. While references [in trade catalogues] to historic design tended to be relatively few or vague early in the nineteenth century, by the end of the century being knowledgeable about historic design became important to the newly found profession of interior designers, and to their customers. Some trade catalogues took on the quality of texts on design history or art history, laying out major periods and styles, discussing traits and characteristics, and suggesting the feelings and meanings each style evoked.[94]

There was some ambivalence among Americans about this education to European standards; one journalist, discussing the presumption that unsophisticated Americans needed a course in art history to pick out a decent set of dishes, was moved to satire: "That we in this country are so little able to comprehend all this," he wrote about pottery's historical and artistic background,

is partly owing to that necessity which has compelled us to pass our lives in hewing down trees, damming rivers, killing bears, cheating Indians; and partly to the fact that we have no examples of pottery or porcelain here.[95]

But the late eighteenth century was to see no shortage of examples, as pottery and porcelain from across the Atlantic was shipped to a new and voracious market. Despite the occasional patriot who took umbrage at the imposition of European standards and invasion of European goods, most consumers preferred goods from Europe and England in any style; they evoked a worldliness that they were sure no domestic product could aspire to.

The worldliness was not limited to historical styles from Europe, but also included styles gathered from contemporary explorations and colonizations; "If the proliferation of goods was enhanced by looking backwards" into the history of design, wrote one scholar, "it was also expanded by looking to the rest of the world." Much of this outward view was channeled through the British Empire, which reached its peak during the reign of Queen Victoria. Since England was often exposed to the influences from other regions of the world first, the versions that reached America were frequently Anglicized—for instance, the American excitement over Asian designs, it has been speculated, may largely have been enthusiasm for *chinoiserie* or *japonisme*, English interpretations of Asian originals.

Before the Victorian era, export products tended to be high-end, and only the very wealthy could afford to furnish their houses with fine English china, French Sevres porcelain, and authentic Japanese artifacts. But the middle class was expanding and growing in purchasing power at the same time that mass-production methods began to allow large-scale manufacture of decorative housewares of a respectable quality. A more affordable range of export products began to be manufactured, and soon American firms began to compete as well:

> Prior to the nineteenth century . . . only affluent Americans could afford to ornament thir homes and tables with [glass and ceramic] imported wares. The advent of mass production facilitated the introduction of distinctive new decorative features and imitations of costly wares which could be made domestically and sold inexpensively. These affordable wares were eagerly purchased by middle-class Americans, who valued . . . the decorative effects.

This certainly did not close the market to foreign goods; genuine exports still had the glamour of worldliness—and presumable costliness. English dishware, in particular, was considered far superior to anything American potteries could produce, despite the arguments of nineteenth-century advocates of the domestic industry:

> It is not in one who is not a potter to say [that American-made dishes] are not better than the old English . . . Certainly they seem as good; and we hope they do and will find their reward in the pecuniary praise of their own people, which we well know is hard to get. Our land is rich in clays . . . and we ought to welcome any new industry and applaud every new art which shall bring up their values and display their beauties.[96]

Still, the bias led many American potters to make direct replicas of English wares. Ironstone wares were often left unmarked or were stamped with an English-type symbol in hope of passing for similar imports, and through the 1880s many potteries used lion and unicorn marks (the English seal), often in conjunction with a coat of arms, heraldic escutcheon, or shield. Some even copied the diamond-shaped British registry mark in hopes of deceiving unwary customers! As late as 1894, the English potter John Maddock & Sons included this *caveat* on the cover of its price list, along with an illustration of the company trademark: "This stamp is being imitated. It is easier to imitate the stamp than the goods."[97]

Any confusion caused by this imitation of marks did not deter the middle class from seeking out anything that could boast European sophistication or English quality. An American trade catalogue from the French firm Le Grande Depot, which proudly offered English majolica and transfer-printed dishware,[98] must have offered a double thrill to even the most pretentious sophisticate!

Despite the educational efforts of trade catalogues and books about interior decoration, the American presumption that European goods were automatically elegant left customers open to many poor-quality products. "Cartloads of bric-a-brac," wrote one nineteenth century Englishman, "have recently gone to America, for the most part of no great beauty or value, the sum paid for which would set up a bank."[99] Eventually—towards the end of the 1800s—this decline in export quality would allow domestic American manufacturers to gain greater shares of their home market.

It was during the last twenty-five years of the 1800s that majolica became as rampant a fad among American consumers as it had earlier been among the English. A few English potters had emigrated to the States during the 1850s and 1860s (notably James Carr, formerly of Ridgways, and the Bennett brothers), but their very limited production of the ware had not really caught on. Even Minton's majolica, shown at the New York Crystal Palace Exhibition just two years after its smashing London debut, drew little attention.

It took the right combination of social factors and marketing to launch majolica's American run. Again, manufacturers found that huge exhibitions of artifacts and industrial works were the key to popularizing the ware. However, at the 1876 Philadelphia Centennial Exposition, majolica became a sensation. Almost ten million people visited the 236 acres of fairgrounds, and were exposed to a world's worth of new products and antiques alike, including English majolica. Minton's wares won recognition from the judges, with a display that "came as a revelation" to Americans according to historian W. P. Jervis (p. 21). These and other majolica wares shown by distributor Daniels & Son provided fresh inspiration for fashion-conscious consumers and ambitious manufacturers alike. There were just three American manufacturers at the time who exhibited majolica wares at the exhibition—J. E. Jeffords of the Philadelphia City Pottery, John Moses of the Trenton area's Glasgow Pottery, and the aforementioned gold-medal-winner James Carr of the New York City Pottery.

Majolica began its second life because, as Jervis explained, "after the exhibition at Philadelphia, there immediately grew up a demand for the decorated earthenware" (p. 21). But some American critics expressed their doubts, just as English highbrows had theirs in 1851. One visitor to the Centennial, who seems to have thought that majolica's introduction in England happened only in mid-1860s (the same time it began to trickle into the U.S.), wrote this:

> Within a decade a bold decorative pottery has appeared in England and elsewhere, and is called 'majolica', for what reason one cannot divine. Some very large vases and pots of this work are to be seen in the Main Building . . . The work seems a cross between the Italian maiolicas and the Palissy ware. It does not attempt fineness or delicacy of form, or subtlety of color or meaning in its decoration; and indeed it is not possible to understand why it should be. But it has for the last ten years been largely produced and widely sold, and it must gratify a certain want. Who buys it and where it goes, who can tell? for in these ten years, the writer has seen but one piece of it in any house except a hotel. Is it true that the people who go to hotels and who travel in steamboats demand this sort of thing? Is it indeed true that whatever is bad and big finds its pedestal in those palaces because their patrons cry for them; or is it that the designers of these cravansaries suppose they so, and are frightfully mistaken? Or is it possible that what no one else will buy a hotel-manager always does?[100]

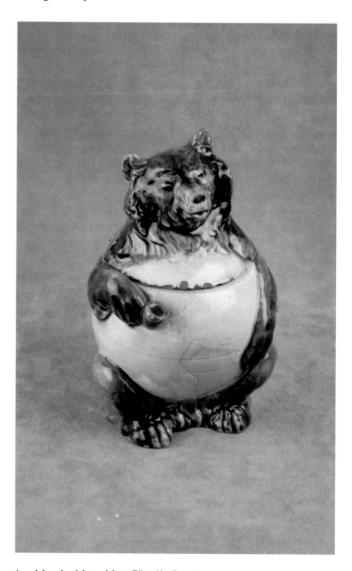

A whimsical humidor, 7" tall. Courtesy of Britannia, Gray's Antique Market, London.

An unmarked 8" pitcher in pale pastels seldom seen on majolica wares. Courtesy of Britannia, Gray's Antique Market, London.

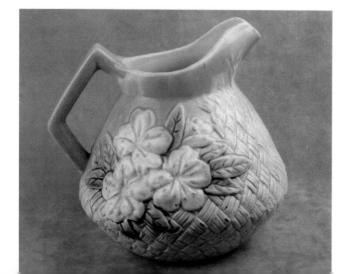

Inflammatory as it seems, this spectator's polemic foresees the differences that would develop between English-made and America-made majolica. The ornate centerpieces, candelabras, and ewers that were most spectacular among the English wares found a reduced audience in America; baroque Anglo-French styles and elaborate Renaissance grotesques and gargoyles were poorly received as well. While the most fashion-conscious in the U.S. appreciated the elegance and spectacle of these impressive pieces, most consumers were not particularly well-versed in historical styles, nor did they host many of the lavish dinner parties for which the fanciest majolica was designed. American consumers quickly developed a predilection for more useful majolica forms—pitchers, vases, dishes, and platters—in designs that were most often organically based on plants, animals, and sea life. American manufacturers were quick to comply, and majolica quickly became assimilated into American culture, adapting to American needs and expanding to include American tastes.

AMERICAN MAJOLICA

The American pottery industry had been established on a small scale since colonial days; most potters were farmers, tradesmen, or craftsmen called "Blue-bird potters," who made crockery-ware when time, weather, and materials allowed.[101] But by the time of the Civil War, when majolica made its first appearances on American shores, a more organized industry had developed in regions with the proper natural resources—clay, water, and enough wood to fuel the kilns. Two of the most significant pottery centers, especially for majolica production, were Trenton, New Jersey (known as the 'Staffordshire of America'), and East Liverpool, Ohio. Active potteries did produce quality wares in other areas of the country, but a great deal of the attributable wares produced originated in these three regions. For majolica, however, one American manufacturer stands out above all the rest: Griffen, Smith & Company.

A Victorian etching of the Centennial Exhibition's opening ceremonies.

GRIFFEN, SMITH & COMPANY

Though this firm was not the first to produce majolica in America, it is considered to have produced the greatest quantity, of the highest quality. Located strategically near kaolin clay deposits in Phoenixville, Pennsylvania, the pottery facility was operated by a number of different pottery enterprises over the years. None of them were successful until 1879, when Henry and David Griffen, David Smith, and William Hill leased the property. Initially calling their firm Griffen, Smith & Hill (to which name the firm's majolica often mistakenly answers), they marked a variety of wares with a "GSH" monogram. William Hill left the company before majolica was introduced into the company line, however, and the company was renamed Griffen, Smith & Company. The GSH monogram was retained, however, now said to stand for the motto "Good, Strong, and Handsome." In 1882, the pottery first offered majolica among its products, giving it the trade name "Etruscan." David Hill, a native of the Staffordshire town of Fenton, was responsible for the brilliant glaze colors that give Etruscan majolica their vibrant look.

Though the firm was six years too late to participate in the Centennial Exhibition, they were just in time for the 1884 World's Industrial and Cotton Centennial Exposition, held in New Orleans. Their contributions to this exhibition won critical acclaim, and captured the public's attention with a full-color catalog of their wares. This tremendous exposure led George Hartford, founder of the huge A & P grocery store chain, to approach Griffen, Smith & Company about providing him with small pieces of their ware which he would give away as premiums. Soon, Mr. Hartford had become the company's biggest customer, doubling the size of the pottery, and distributing their wares from, as the "A & P" name implied, the Atlantic to the Pacific.

Griffen, Smith & Company's majolica wares are often thickly potted, and have a lightweight feel, due to the local gray clays used in their manufacture. The glazes tend to flow together, typical of almost all American wares (and all but the best English wares, for that matter). This gives a soft, lovely look to certain of the Etruscan patterns, especially the much-loved Shell and Seaweed design.

Like English majolica, American wares were influenced by the taste for Asian design. Griffen, Smith & Company wares can be found in Asian inspired designs including bamboo motifs. Naturalistic influences, so important in American majolica, are found throughout the Etruscan line, particularly in the famous Begonia Leaf pickle dishes and butter pats.

There are a number of Etruscan wares that can be traced directly to English antecedents, notably a strawberry server copied directly from a Wedgwood example. Such reliance on English precursors can be forgiven if it is remembered that American consumers were looking primarily for English wares, or for American wares that would pass for them. It must have given the "Good, Strong, & Handsome" team great pride to read this notice in a local paper:

We have been shown a number of articles of majolica ware just manufactured . . . which were equal to any made at Wedgwood, Minton or other celebrated potteries in Europe. The articles . . . consisted of two strawberry dishes with sugar bowl and cream mug attached . . . The ones made at the Phoenixville works were similar in form but the details were more carefully worked up while the glazing and coloring was, we think, superior to the English.[102]

In another imitation of Wedgwood, Griffen, Smith & Company produced a line called Albino, white with a bit of colored detailing much like Wedgwood's Argenta ware. Like Argenta-ware, Albino ware came into production towards the end of majolica's popularity, when public taste had turned away from bright colors.

In 1889, the company closed its doors, and produced no more majolica wares.

Identifying Griffen, Smith & Company Wares

Most of this firm's wares are attributable, since they were either impressed or stamped with one of four company marks: a GSH intertwined monogram, the monogram plus the word ETRUSCAN, a double circle with the word ETRUSCAN above and MAJOLICA below, and, most rare, the single impressed word ETRUSCAN.

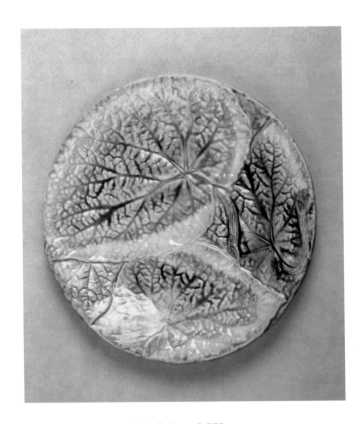

An unmarked begonia leaf plate, 8.75", c. 1860. Though they are hard to see, there are three firing marks on the back and three on the front, evidence that the potter used three 'stilts' to separate each plate in a tall stack while they were being fired. Courtesy of Joseph Conrad Antiques, Atlanta

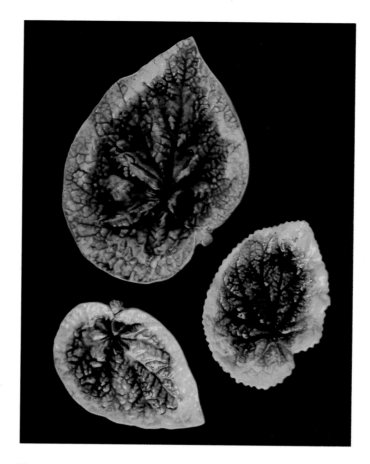

Three begonia leaf dishes. The largest,
measuring 12" long, is English; the two
smaller dishes are 8" long apiece, both c.
1860, and the narrower of the two is
English. Griffen, Smith & Company's
well-loved begonia-leaf wares were made
in imitation of pieces like this.

A 7"-tall tazza with a shell and dolphin
theme, unmarked, possibly Griffen,
Smith & Company. Courtesy of Britan-
nia, Gray's Antique Market, London.

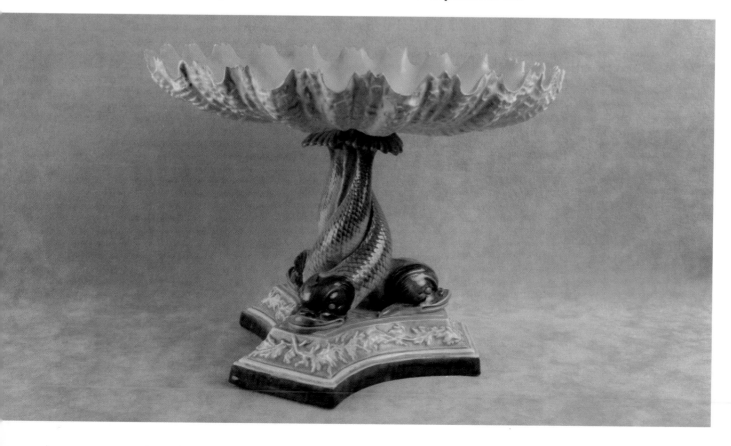

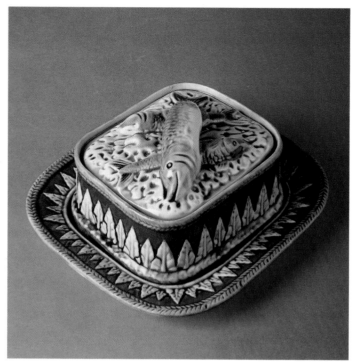

A rare sardine box with attached underplate, 9" x 7.5". This piece was made by Griffen, Smith & Company and is marked "ETRUSCAN." Courtesy of Michael G. Strawser, Majolica Auctions.

Cover of the catalogue printed by Griffen, Smith & Company in time for the 1884 Cotton Centennial Exposition in New Orleans. Its full-color presentation of majolica wares launched the company onto the national market.

A 6" teapot, 7" coffee pot, and 5.5" sugar bowl by Griffen, Smith & Company, in their well-known Shell and Seaweed pattern. Courtesy of Michael G. Strawser, Majolica Auctions.

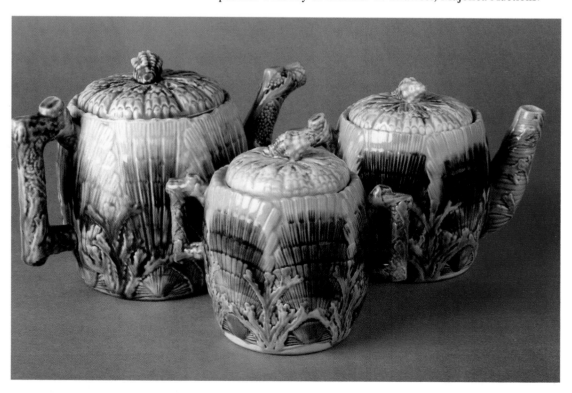

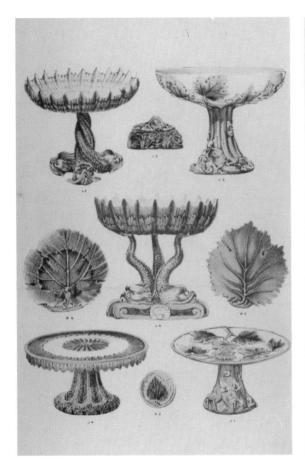 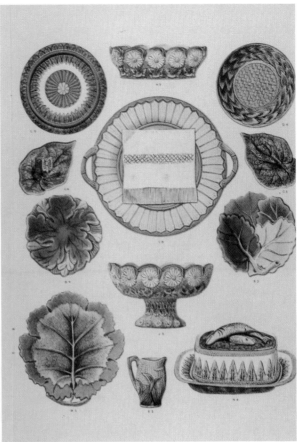

Two pages from the Griffen, Smith & Company catalogue,
showing a broad range of their styles and forms.

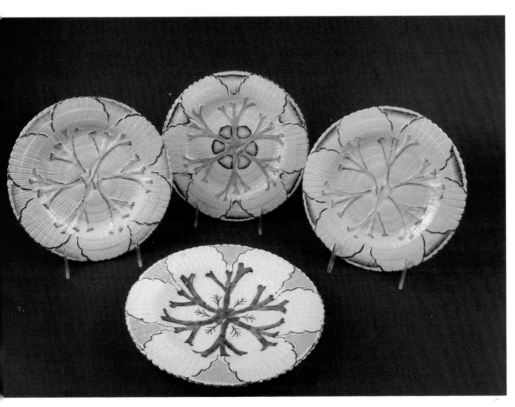

Four dishes by Griffen, Smith
& Company, in an Albino
version of the Shell and
Seaweed pattern. Dishes range
from 8.25" to 9" in diameter.

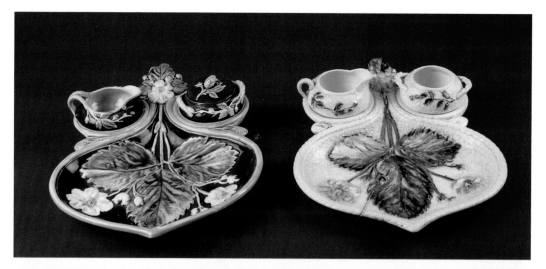

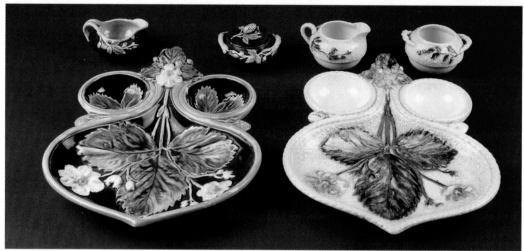

Comparing strawberry servers by Wedgwood (cobalt) and
Griffen, Smith & company (white).

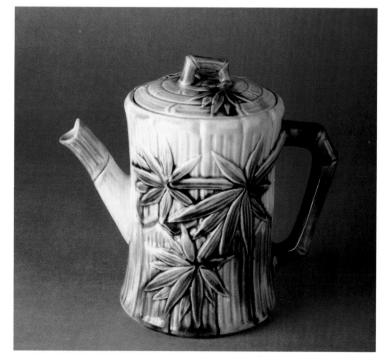

A bamboo-motif teapot, 5.5" high, by Griffen, Smith &
Company. Courtesy of Michael G. Strawser, Majolica
Auctions.

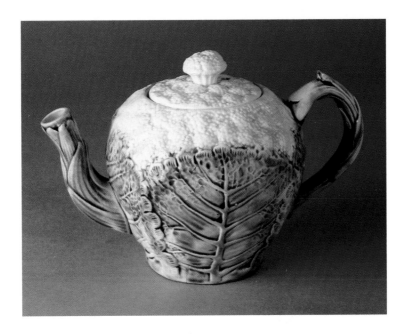

A cauliflower-motif teapot by Griffen, Smith & Company, 5"
x 9". Courtesy of Michael G. Strawser, Majolica Auctions.

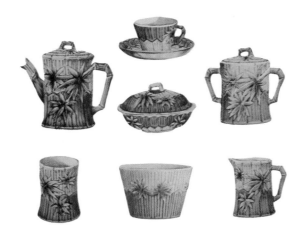

Japanese-style wares with a bamboo motif, shown in Griffen,
Smith & Company's 1884 catalogue for the exhibition in New
Orleans.

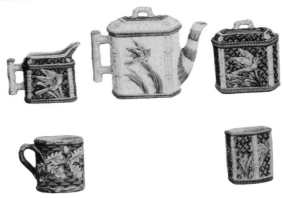

More Japanese-inspired wares from the Griffen, Smith &
Company catalogue. This pattern is Bird and Bamboo.

CONTINENTAL MAJOLICA

While many European countries had long being producing *faience* or *delft* pottery that was similar in glazing to Victorian majolica, their production lines were nonetheless strongly affected by the new market for such wares and by the new influences upon design exerted by English and American potters. Exposed to Victorian majolica at exhibitions in Paris, London, and Vienna, Continental potters began contributing to the genre, pulling inspiration both from English majolica and their own historical styles. Work began arriving on the market from France and Italy, not surprisingly, but also from Austria, Germany, Scandinavia, and Portugal.

The designs of Wedgwood and other established English makers were particularly popular sources for manufacturers in France, Germany, and Austria. The older, more established European firms, however, often deliberately avoided Anglicized forms, preferring to refer to their own Renaissance heritages for inspiration. Among these was French potter Charles Jean Avisseau, who turned to the source—Palissy—on which to base his nineteenth-century majolica. Portuguese potters also based much of their manufacture on the organic designs of Palissy's Rustic wares. Some of the results of this Continental delving into the past are quite magnificent. Of note is the Czechoslovakian firm Wilhelm Schiller & Sons, which produced monumental pieces with excellent modeling.

Among the best Continental majolica is that made by the French firm Sarreguemines. Previously a *faience* manufacturer, their majolica glazework is particularly fine. Their work, and that of the German firm Villeroy & Boch, was particularly suited for the more streamlined, stylized looks that became fashionable towards the end of the century.

In the 1870s, as English production slowed, European potters began to produce cheaper majolica wares in novelty forms, intended as souvenier ware to be sent to England and America. This continued well into the twentieth century.

As the nineteenth century drew to a close, Continental majolica manufacturers followed the design style that most English and American majolica designers had ignored: the style called Art Nouveau in France, *Jugendstil* in Germany and northern Europe. In England and the U.S., this style was adapted by the Art Pottery movement while majolica faded, but some of the most prominent Continental firms continued to make lovely majolica wares decorated with these designs on wares that were either heavily modeled and sculptural, or else lightly 'trailed' with thin ridges of clay to define the outlines of the pattern.

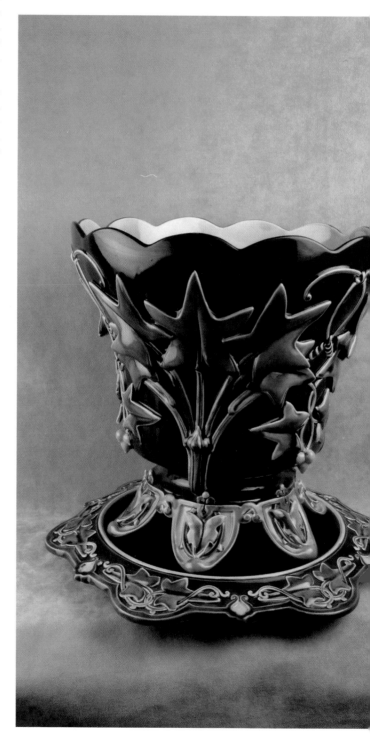

A magnificent three-piece jardiniere, marked "MAJOLICA / SARREGUEMINES." Courtesy of Britannia, Gray's Antique Market, London.

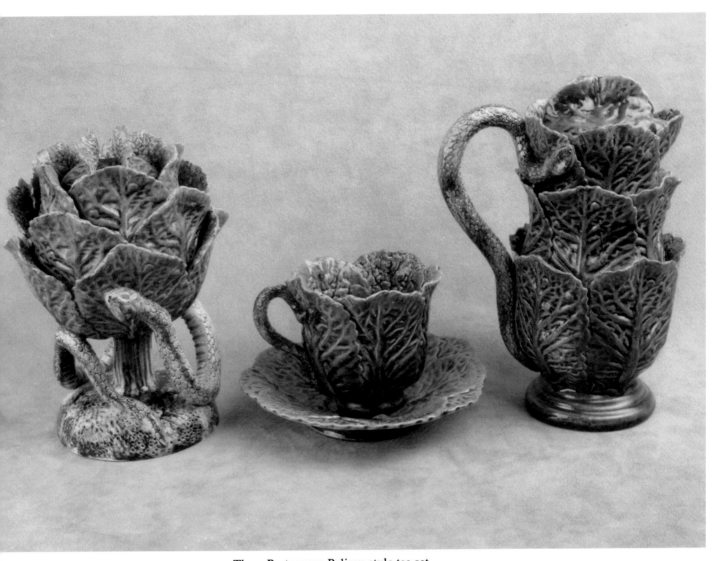

Three Portuguese Palissy-style tea set
pieces possibly made by Mafra & Son,
marked "CALDAS RAINHA." The
largest piece stands 6" tall. Courtesy of
Britannia, Gray's Antique Market,
London.

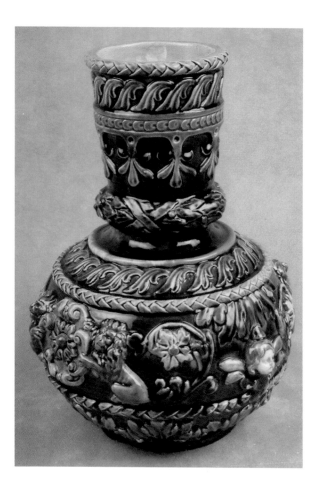

An unmarked vase, 9" high. Courtesy of Joseph Conrad Antiques, Atlanta

A 9.5"-tall figural cat pitcher, made by Onaing.

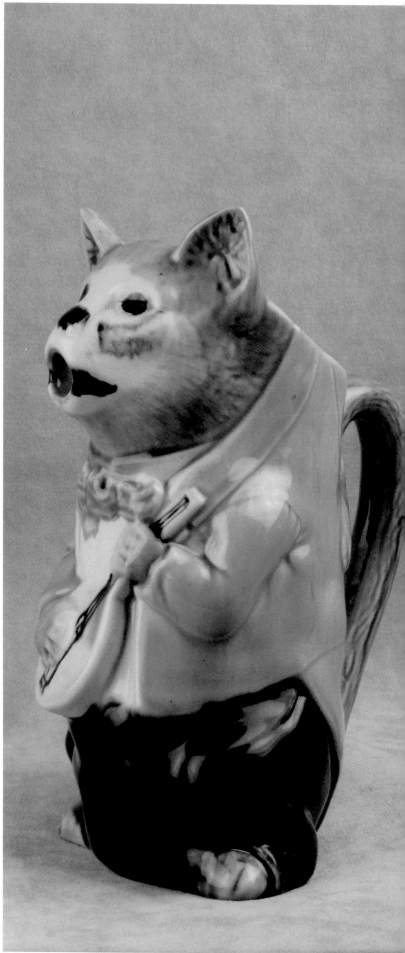

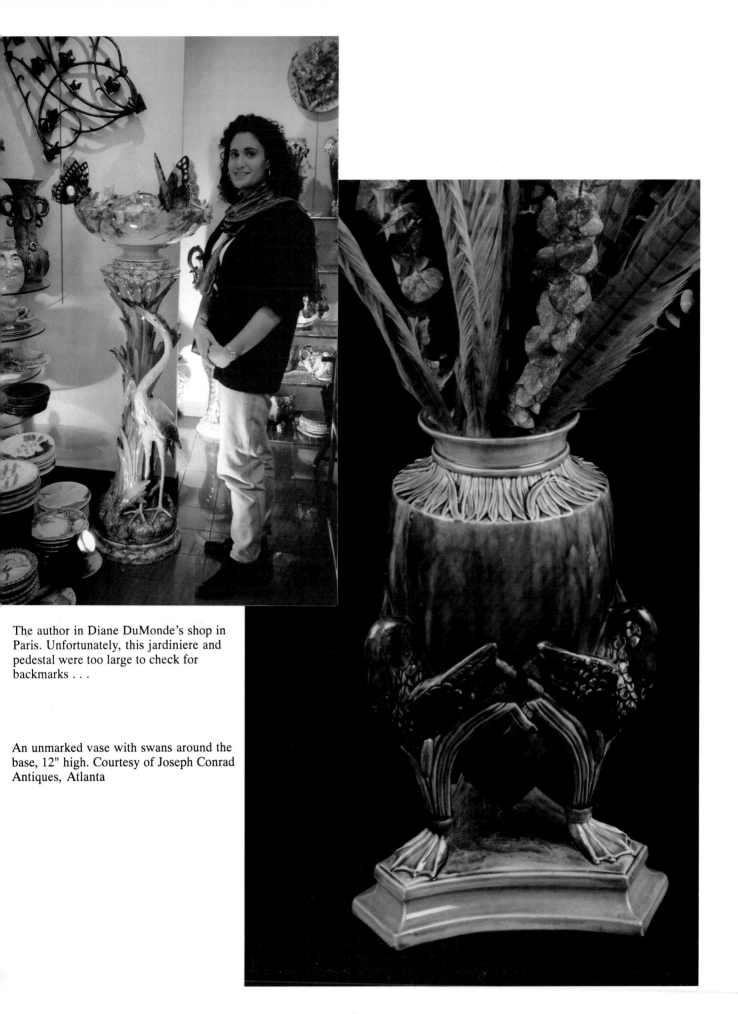

The author in Diane DuMonde's shop in Paris. Unfortunately, this jardiniere and pedestal were too large to check for backmarks . . .

An unmarked vase with swans around the base, 12" high. Courtesy of Joseph Conrad Antiques, Atlanta

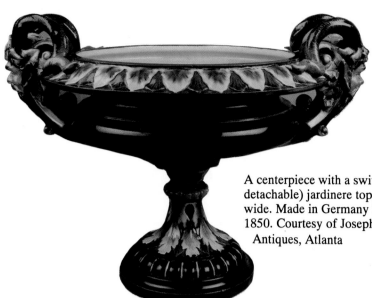

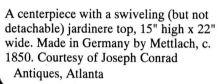

A centerpiece with a swiveling (but not detachable) jardinere top, 15" high x 22" wide. Made in Germany by Mettlach, c. 1850. Courtesy of Joseph Conrad Antiques, Atlanta

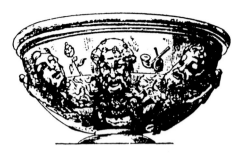

A Victorian etching of a Nuremberg-ware vessel, a design predecessor for some Continental majolica.

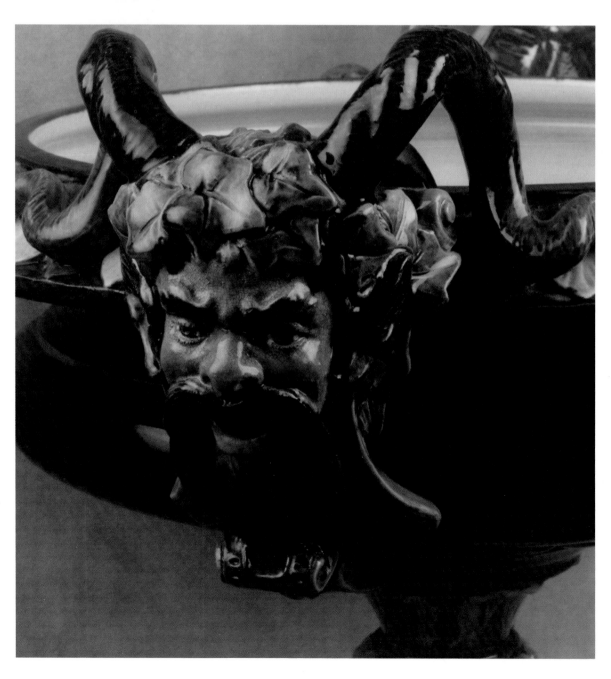

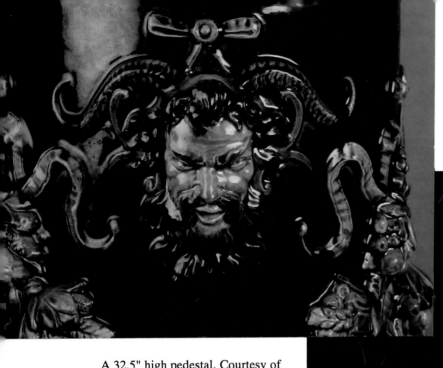

A 32.5" high pedestal. Courtesy of
Joseph Conrad Antiques, Atlanta GA.

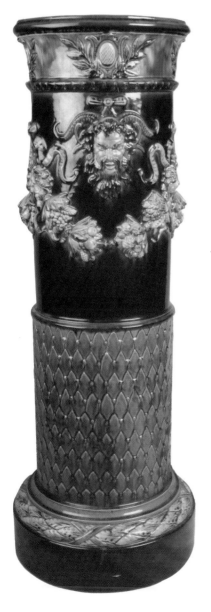

Another etching of
a Nuremberg-ware
vessel.

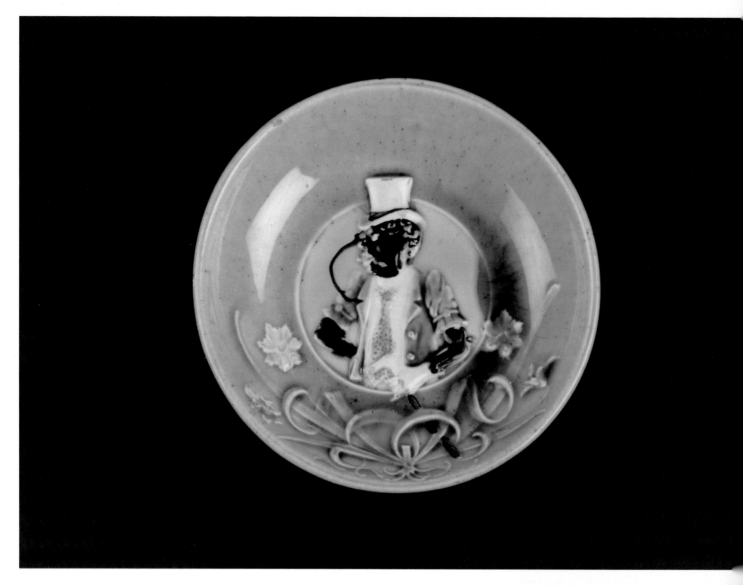

A 6" piece by Villeroy & Boch, marked "V & B S" and "MADE IN GER-MANY." Courtesy of Dearing Antiques, Miami Circle, Atlanta

An ornamental piece of Palissy-style ware, 4.5", featuring a sea urchin, a crab, and several shells on a 'seaweed' bed. Marked with an impressed crown, and illegible maker's name, and the location "CALDAS / PORTUGAL."

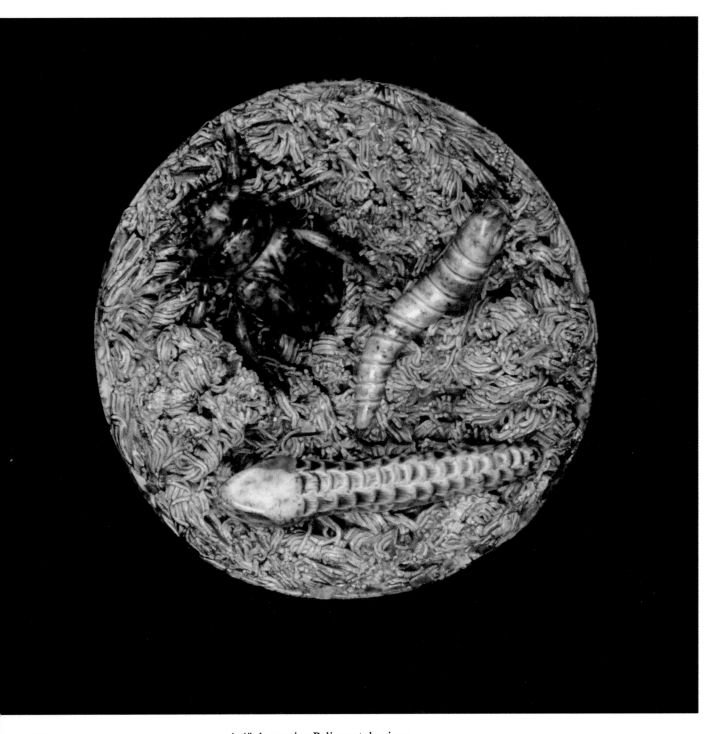

A 4" decorative Palissy-style piece, featuring three insects. Marked with an impressed crown, an illegible maker's name, and the location "CALDAS / PORTUGAL."

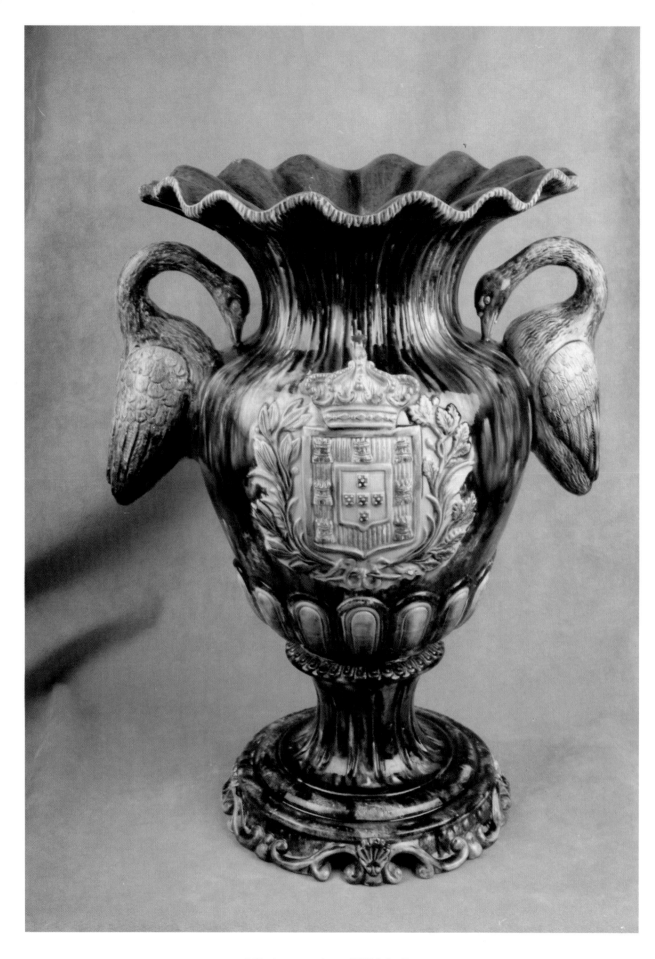

A Portuguese piece, 19" high. Courtesy
of Joseph Conrad Antiques, Atlanta

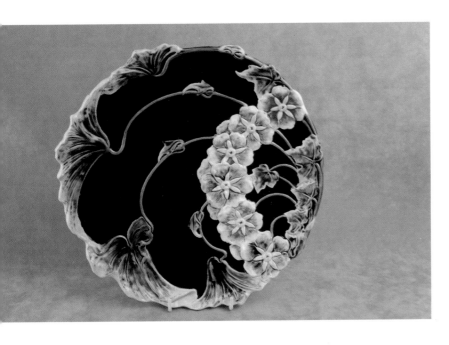

A stylized floral plate, 11" diam., with an illegibly small crest impressed on the back. Courtesy of Britannia, Gray's Antique Market, London.

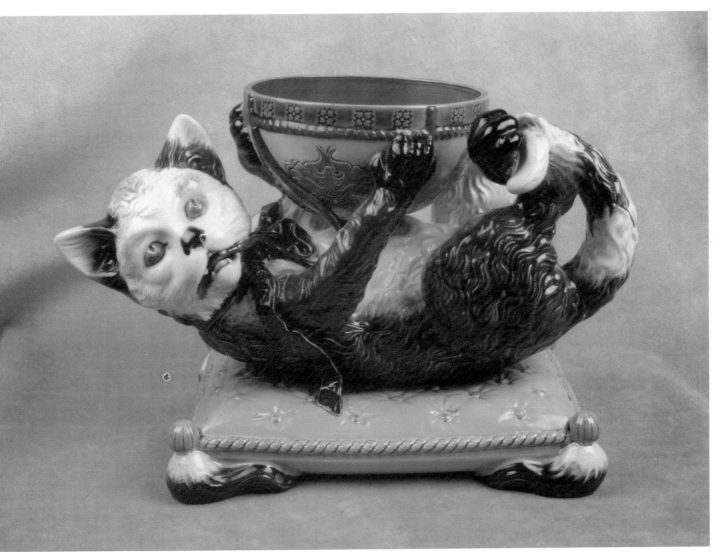

A figural cat planter, made in Austria, c. 1875. 14" wide x 8.5" high, marked "S + St" in gothic letters. Courtesy of Joseph Conrad Antiques, Atlanta

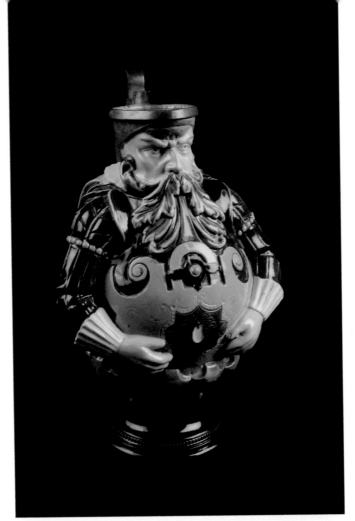

A 12" pitcher, unmarked. Courtesy of
Dearing Antiques, Miami Circle, Atlanta

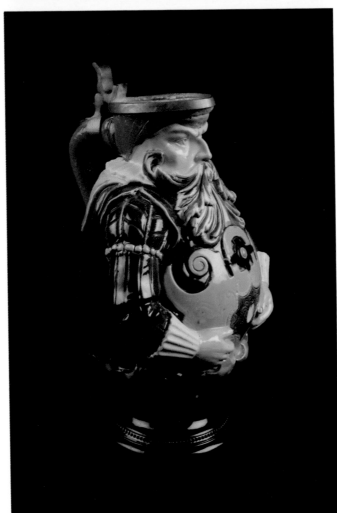

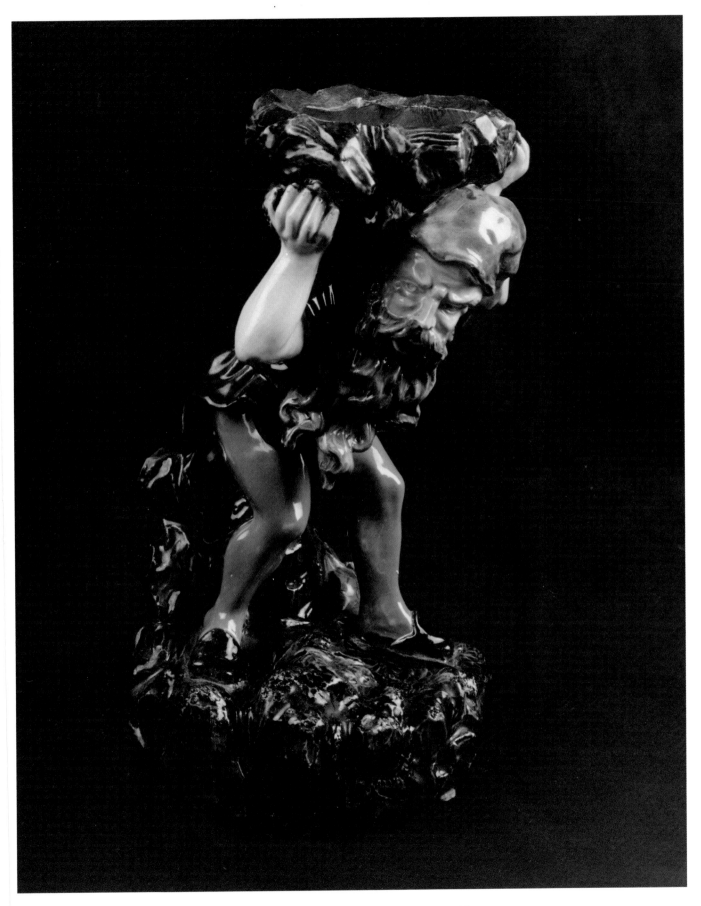

A 9" figurine by Mettlach Co., marked with
a crest and the initials MK. Courtesy of
Dearing Antiques, Miami Circle, Atlanta

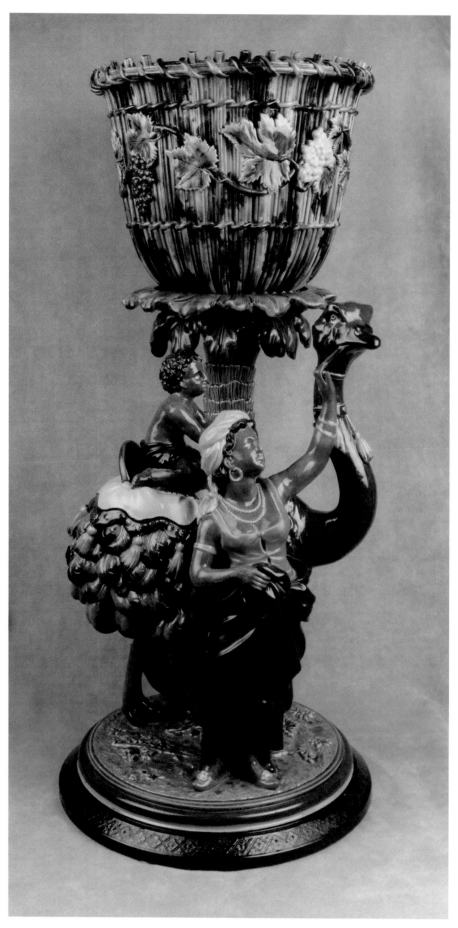

A two-piece planter by Wilhelm Schiller
& Sons. Courtesy of Joseph Conrad
Antiques, Atlanta

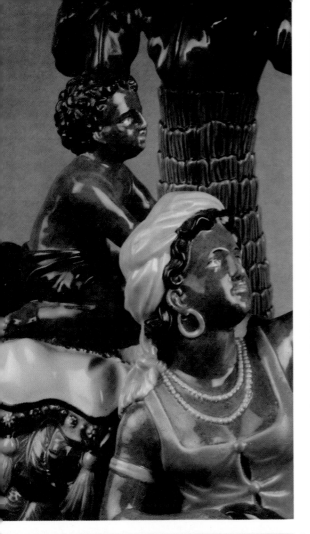

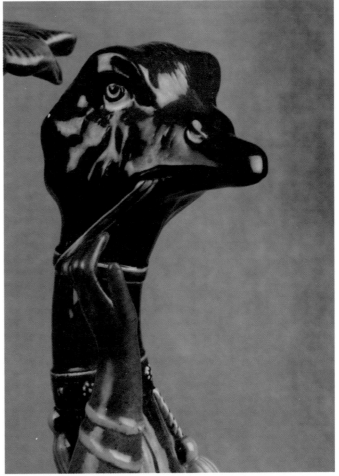

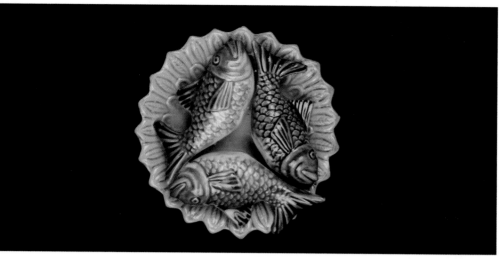

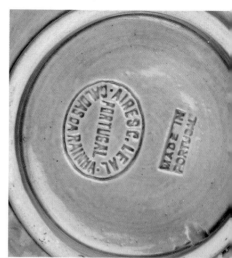

This piece of Portuguese majolica is a far cry from the organic realism of 14th century Palissy wares and the Victorian majolica modeled after it. Marked with an impressed backstamp reading "Aires C. Leal / Caldas da Rainha."

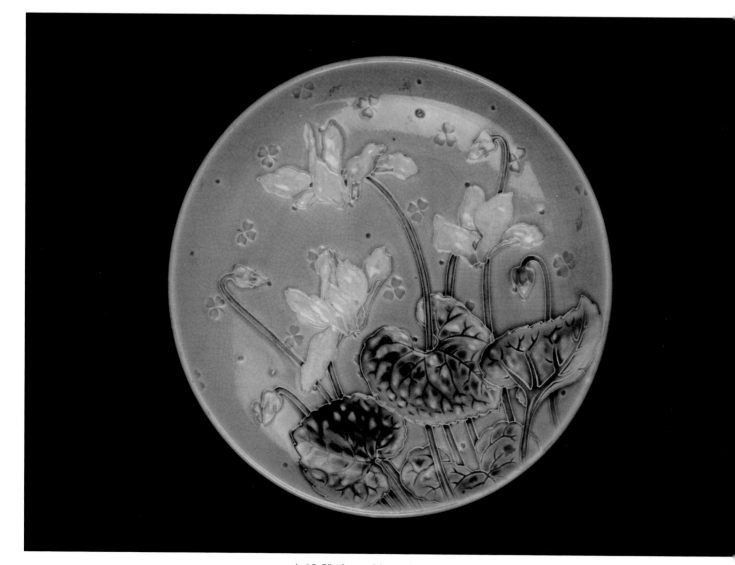

A 10.5" plate with a subtly tinted floral design, unmarked. Courtesy of Britannia, Gray's Antique Market, London.

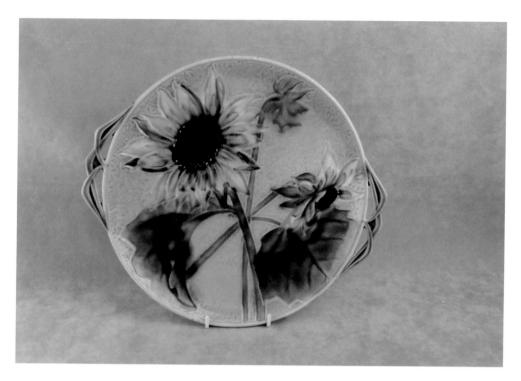

A 12" sunflower platter by Villeroy &
Boch. Note how te intaglio technique
was used to create a subtle but detailed
background texture. Courtesy of Britan-
nia, Gray's Antique Market, London.

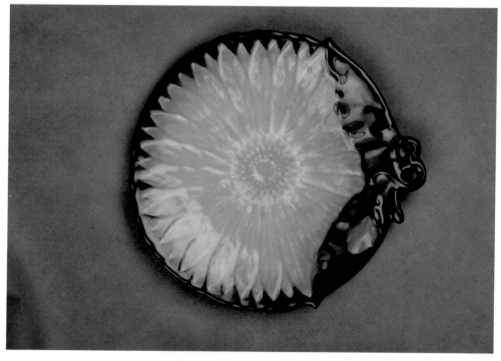

An 8" plate in the shape of a Gerber
daisy, unmarked, with a slightly dulled
gloss. Courtesy of Britannia, Gray's
Antique Market, London.

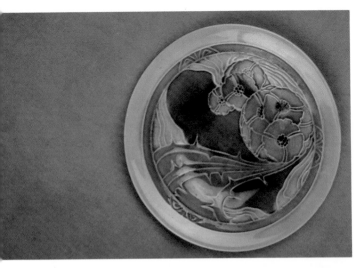

This saucer by Minton features a stylized floral pattern, clearly influenced by the work of the Vienna Secessionists. 5.25" diam. Courtesy of Britannia, Gray's Antique Market, London.

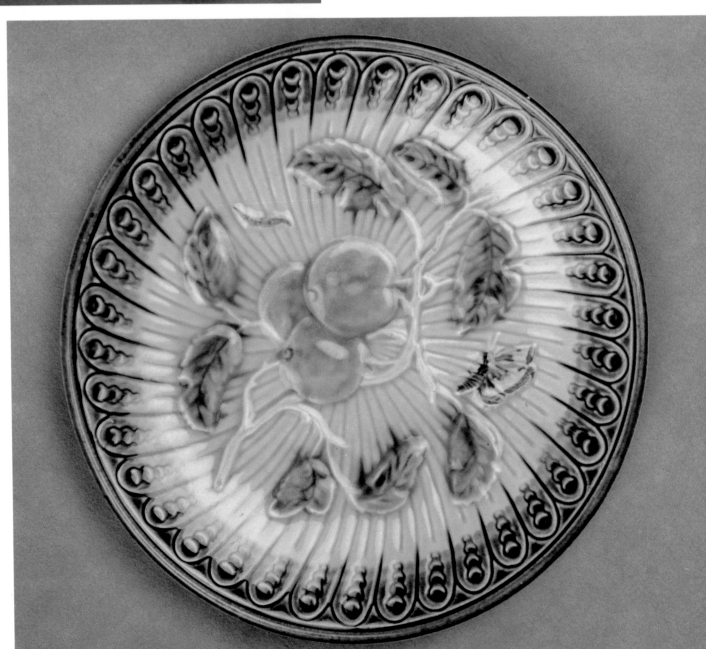

An 8" plate with a fruit decoration, unmarked. Courtesy of Britannia, Gray's Antique Market, London.

THE CANADIAN MARKET

Very little attention has been given to the Canadian reception of majolica, perhaps because no major manufacturers are known to have sprung up there. However, Canada imported just as much majolica from England as the United States did, and it became equally fashionable among the Canadian middle and upper-middle classes. The English majolica available was "massive, bold and positive....the ware of innumerable fern jardinieres, of umbrella stands, and of the more refined of spitoons which once adorned the lobbies of Canadian hotels." Other wares sent to Canada included figurines, wall plaques, "fanciful candlesticks and commanding vases." But these traditional parlor pieces and dining-room highlights did not mark the end of majolica in Canada; Canadians "were offered every facility for laying their floors, panelling their walls and outlining their fireplaces with decorative earthenware slabs and tiles," primarily of English origin.

Majolica was widely advertised in Canada. Gigantic ornamental cheese stands were advertised in 1879 by a merchant named Glover Harrison, who operated at Toronto's China Hall. Harrison also advertised "fashionable majolica boxes (usually with crossed fishes on the covers) known as 'sardine boxes'"— though English merchandise crossed the Atlantic, the fashions and dining traditions that prompted it did not always pave the way! A.T. Wiley of Wiley's China Hall was a Montreal merchant who advertised majolica wares. He classified them with his "New Novelties" and "Bric-a-Brac," which, according to a modern Canadian ceramics historian, is how much of it was sold.[104] In the *Daily Witness*, Wiley's ad appeared under the "Fine Arts in the Household" heading, and he categorized majolica as "BRIC-A-BRAC in endless variety"![105] A Winnipeg advertiser in the 1880s praised majolica for both "utility and vertu [ornament]," but most Canadian customers bought it exclusively for the 'vertu'—for show. As one historian explained,

> "The line between ornamental and useful was loosely drawn with majolica wares. Much majolica was actually produced in useful forms and yet kept by the Victorian housewife solely for display. 'Unique' cheese stands and porridge sets (a bowl and a small pitcher) were advertised in majolica by Montreal china merchants, but how often these came to the table with cheese or oatmeal may be questioned."[106]

Most majolica in Canada was purchased by those of elevated taste, the art-conscious of liberal means. The less daring could simply decorate the interiors of their homes with English majolica tiles (see the section on tiles for further discussion), especially after they were introduced at a Montreal exhibition in 1857.

For customers who were more conservative with their money or their style, "the perennial Staffordshire figures and commemorative pieces" remained available in the Canadian market.[107] Still, some of the more elaborate English majolica did make its way out of the large cities and into rural homes of modest means;

> In the country, many a Methodist minister on his circuit rounds baptized the baby from a majolica berry bowl—the best bowl in the house, and never used for berries.[108]

In England, specialized majolica pieces had been manufactured to suit specific social trends and traditions in dining; but as the wares dispersed from the fashionable centers of their origin, their uses became more varied.

Canadian Manufacturers

Canadian potters faced the same challenges that their American cohorts did in competition with the English. Almost all high-quality china and earthenware was imported during the Victorian era, since English potteries had long years of experience and greater resources, as well as the authority of English style to recommend them. As a Canadian historian wrote about domestic potters,

> Whenever his ambition soared he was met at once by the relentless competition from overseas potters with larger resources and long experience. Even protective tariffs, which came into force early to defend the types of ware that could be made in Canada, were not enough to give him an equal chance with his rivals. He worked in their shadow, his best advertisement the cry that his products were "warranted equal to English make."[109]

While American potters came into their own in time to fire a resurgence of majolica popularity on their own shores, Canadian potters seem to have missed out on the trend. William Wickliffe Johnson, the Canadian author of 1882's *Sketches of the Late Depression*, defended them, writing that "it is hardly to be expected that infant industries, comparatively speaking, such as our potteries are, can jump at once to perfection."[110] Most American manufacturers of majolica found that perfection was hardly necessary to produce saleable merchandise, but it is true that much of the majolica potters troubled to mark was of quite respectable quality. A great quantity of unmarked (and unattributable) lower-quality majolica exists that seems to be North American in origin, and some of that may certainly be Canadian. However, no pottery from that country has distinguished itself with marked examples of high-quality majolica ware.

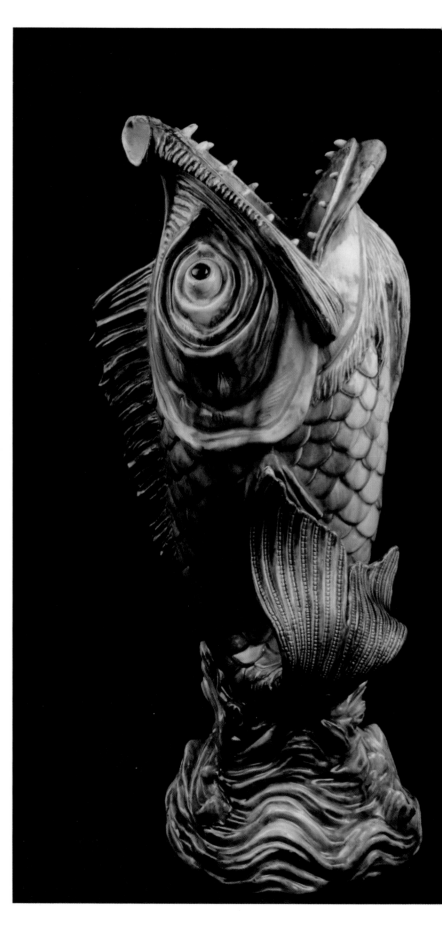

One of a pair, this unmarked fish vase
has exquisite modeling and coloration.
24" high. Courtesy of Marilyn Karmason.

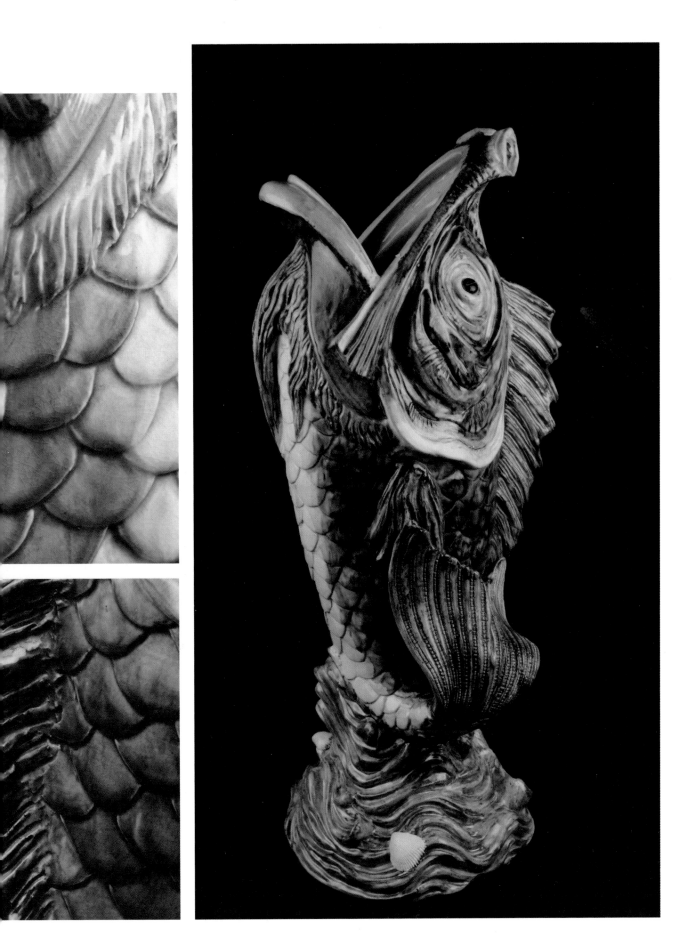

The second fish in the pair, with slightly
different coloration. Courtesy of John
Tribble, Atlanta

WOMEN IN THE POTTERIES

*Since it is conceded that our Mother Eve was
the first object made of clay of a decorative character,
it seems quite fitting that her daughters should
engage in painting pottery.* [111]—*1896*

Working women in Victorian days faced challenges and dilemas not unlike those faced by women today, including a barrage of opinions about their suitability for work outside the home. When pottery became industrialized, it quickly became one of the many employments open to British and American women on a large scale. While pottery had its share of strenous labor, it also called for light work of which women were considered capable. Pottery had the delicate tasks of modelling and decoration, making it seem a more genteel and feminine occupation than heavier industry. "It has been one particularly gratifying incident of the passion for decoration in this country that it has been the means of opening to women beautiful and congenial employments," wrote one commentator on the situation.[112]

Painting the wares was women's most frequent occupation, and a great deal of the majolica available today was dressed in its bright colors by an adult woman or young girl contributing to her family's income. But painting under what conditions? As discussed earlier, it was generally thought that Staffordshire was a good location for those who had to work in industry. The area was still green and rural, the factories were clean and sociable, and the living standards were high. One visitor to the area noted that "besides the 9,000 *men* potters, there is a much larger number of women and children, all employed in the lighter branches of this beautiful manufacture. You will go into a room and see a dozen women or girls, pallete in hand, all engaged in painting"[113]—without the noise, heat, or exertion that were unavoidable in the textiles industry, another primary employer of female workers.

Girls who intended to enter the profession in Staffordshire were apprenticed for five years (as opposed to seven years for boys), and received substantial wages early in their training.[114] The schools of design were open to women as well, first in the various towns of the Potteries and later in America, when schools arose in Trenton, East Liverpool, Baltimore, and Syracuse.[115]

At the Griffen, Smith & Company pottery in Phoenixville, PA, a skilled decorator would provide an impeccably painted example of each piece in the workshop, to which the entire team of paintresses could refer throughout the day. Set before each worker was a camel's hair brush, and little pots of majolica glaze. In America no less than in most English firms, there was "a great demand for fineness of touch, sense of form, and manual dexterity."[116] Quality certainly varied, as anyone who has compared a Minton or George Jones piece with a later knock-off can tell, sometimes even between pieces decorated by different painters in the same workroom. Mary Murphy, a Griffen, Smith & Company paintress, pointed out that "part of the people just worked for the money, but others really cared for their work."[117] Realizing that employee morale and quality workmanship were inextricably entwined, some firms encouraged each worker to mark the bottom of their pieces with a personal code number, a

hallmark, or initials, so that each paintress could feel pride in making the highest-quality product she was capable of—a wise strategy. Keep an eye out for these marks on pieces in your majolica collection, and someday you may find two that match. Today, a few firms maintain archives, with records of marks used by particular painters. With some aggressive research you may be able to find out the name of the painter who made your favorite piece the work of art it remains today.

While not every pottery employee worked "just for the money," it was a major consideration for all of them. Women working in the potteries often did so out of economic necessity, and children working there came from even greater need. Like today, women earned less for their time and effort than their male counterparts. In Staffordshire, the best male painters of earthenware and china took home 35s. each week, a good wage; but paintresses took home only 18s. Teenaged girls in American potteries often worked ten to twelve hours a day for six or seven days a week, at a wage of under ten cents an hour.[118] Other firms paid some of their workers by piecework rates. A young majolica paintress who earned a flat $5.00 a week at Griffen, Smith & Company negotiated a significant raise one year, by simply persuading Mr. Smith to pay her at a piecework rate. The change was a great incentive to her, and she reported "I'll never forget the Christmas I came home with a $19.75 paycheck."[119]

While such a whopping paycheck must have thrilled the American paintress's family, there is no doubt that pottery households were greatly affected by the employment of women—an issue still confronting modern society. Many households could not have survived without the income generated by wives and children employed in light industry, but some observers believed that their quality of life would have been higher with the girls and women at home, even without the extra money. Even as early as 1871, a critic of Staffordshire wrote that

> Girls and women are employed in large numbers, and, but for this circumstance, the tone of the domestic life of the operative classes would doubtless be higher than that already attained to. Viewed in this light, the high wages obtained by women are a temptation which, yeilded to, deadens the maternal sensibilities, and hinders the full and healthy development of home associations.[120]

Majolica was decorated by women to fill the decorating needs of other women. Yet the women on either side of majolica production led very different lives, and had very different outlooks. The working class women who painted majolica were participating in their families as wage-earners like their husbands, leaving domestic tasks for whatever time and energy remained to all family members; the upper middle class women who purchased majolica were responsible solely for the workings of the home, making a rich, secure, and tasteful haven to greet their wage-earning husbands when they returned in the evenings. The difference was a division of labor and a result of varying resources, much as it is today, and the upper classes then saw fit to criticize the working classes for their way of life.

While then, as now, a primary subject for debate is the welfare of the children of working mothers, in the Victorian era the

issue had its deepest foundations in class distinctions. In both rural and urban communities in earlier decades and centuries, families were either the wealthy elite and nobility, or they were part of the struggling poor. Women in working families were (of necessity) full-fledged partners in their families' income-generating activity, whether this was farming, some cottage industry, or commerce. With the Industrial Revolution, a more prosperous middle class began to evolve from the working lower classes, and naturally they wished to distance themselves from their "lowly" origins. A first step in clarifying this distinction was removing women from public work, and limiting them to the domestic domain. As the middle class grew in wealth through the Victorian era, women's role in homemaking was glorified into a "cult of domesticity," in which women were charged with the duty of making a home that would be suitably glorious for their husbands' professional aspirations. Along with this change in attitude came a disparagement of those who could not afford such expensive gender distinctions; women who were comfortably ensconced in their velvet-swathed Victorian rooms looked down their noses at their sisters who worked in the ever-growing factories and trades.

A similar transition occured in the young United States. While upper class spokesman Timothy Dwight asserted that "women in New England [were] employed only in and about the house and in the proper business of their sex," farmer's almanacs discussed how farmer's wives often contributed to the heavy labor of bringing in the crops, raking and bundling the hay.[121] As more farmers became prosperous and left the struggle of the working class poor behind them, they could afford to remove their wives from the fields and constrain them to the house. From there, both husbands and wives learned to regard as low-class those women whose families required women to continue working—whether in the fields or, later, in industries like pottery and textiles. In subsequent criticisms, the negative effects of working mothers on their children was emphasized, with the critics often neglecting to note that the restriction of women to domestic work was a fairly recent phenomenon.

Over a hundred years later, the same criticisms are being leveled at families with working mothers, along lines of contention none too different. Still no easy solution is in sight. It is amazing to realize that the arguments facing us today in daily news reports and scientific studies can trace their roots back to the bright majolica pottery in our collections and beyond. While the fact the majolica was made both *by* and *for* women has been seen as a bond between women, on a deeper level it points out the fundamental differences between women (and men) of the moneyed classes, and those of the working class.

CLASSES OF WARES

GREENWARES

Many collectors are initially drawn into the world of majolica by gleaming, dark green plates pressed with foliage designs of countless sorts, relatively inexpensive and infinitely handsome. Some of these lead-glazed earthenware pieces really are majolica—made in the Victorian era after Minton's coining of the term in 1851—but other examples are not, coming from as far back as 1759! Often it is impossible to tell, since early potters frequently neglected to mark their work. Adding greenware to your majolica collection can be tricky, but still worthwhile.

Greenwares had their origin almost one hundred years before Minton introduced majolica at the Crystal Palace Exhibition. Between 1754 and 1759, Josiah Wedgwood was working in collaboration with Thomas Wheildon in a pottery at Fenton Low. On March 23, 1759 Josiah Wedgwood noted in his Experimental Book that "Experiment No. 7" had been successful, resulting in a soft lead glaze with a perfect green color, due to the addition of copper oxide to the lead. This glaze was the first step in the English development of majolica glazes.[122]

The 1865 newsletter "Once-A-Week" mentions that Messrs. Wheildon and Wedgwood used the green glaze to make

> a new green earthenware, which had the smoothness and brilliancy of glass, and was soon extensively used for dessert services. These were generally admired, both for their intrinsic beauty and cheapness, and the name of the new firm soon stood high, not only in the little world of Staffordshire, but in the chief towns of the kingdom.[123]

Whieldon and Wedgwood worked together for five years, during which time they produced green glazed wares described by Once-A-Week as "remarkably good in quality and form." By 1865, the newsletter reported, the company's greenwares were very scarce, and thus already highly prized by collectors.

After parting company with Wheildon in 1759, Josiah Wedgwood continued to make a great deal of green glazed earthenware. In particular, Once-A-Week noted that he made tea services in the shape of fruits and vegetables—apples, melons, and pears, in addition to the lovely cauliflower and pineapple forms that are most commonly known today. Creamware and porcelain versions of pineapple and cauliflower forms can generally be distinguished from their majolica counterparts without too much difficulty; the other types of ware are much more delicate than soft-bodied majolica.

In the early nineteenth century, before the advent of majolica, Wedgwood popularized leaf-patterned dishes in his translucent green glaze. Many other potteries followed suit with similar wares. Between 1850 and 1860 Wedgwood's greenware dessert services (mid-sized plates with serving pieces like compotes, berry servers, one- or two-handled platters, etc.) became exceedingly popular.[123] Spode, Minton, Rockingham, Davenport, Ridgway, Baker Bevins & Irwin, Copeland, William Adams, and Brameld also made greenwares in similar foliate designs, along with forty or fifty other firms.[124]

Since wares in the style of Wedgwood's pre-1851 greenwares continued to be manufactured during the years of official majolica production, there is a great deal of ambiguity about how to categorize them: are they predecessors? are they real majolica? The early greenwares were often made from creamware or pearlware ceramic bodies, which were very light. Later greenwares made in the Victorian era were made of the same common earthenware that majolica was,[125] making them identical both in body and in glaze to majolica. Indeed, some pieces were made in several versions—in standard multi-color majolica, and in a solid green. The modeling of greenware is often lower in relief than pieces of sculptural majolica are,[126] but no different in depth than that of many later pieces of decorative, non-sculptural majolica. The archivists at the Wedgwood Museum have chosen to call them "transition pieces," since they can pre-date both Minton's and Wedgwood's initial use of the term majolica, in 1851 and 1860 respectively.[127] However, it is thought that the popularity of Minton's foliate majolica prompted Wedgwood to rejuvenate their greenware line with large-scale, all-over relief foliage designs, undoubtedly majolica.[128] The ware has been made ever since it was first introduced,[129] and thus a good deal of it was indeed made under the aegis of the majolica trade name.

Greenwares were also produced on the Continent, primarily in France. Collector Victoria Bergesen has noted that the French greenwares most often found in England were manufactured by Gien and by Clairfontaine. Some French potteries, beginning with that of the Baron Alexis du Tremblay at Rubelles, made greenwares in a modeling style known as émail obrant, or intaglio. The designs on these wares were not raised, but embossed. The glaze pooled in the impressions of the design, thus making darker green outlines and shadings wherever the designer wished. The best of these, Bergeson says, have an almost

photographic effect. Some intaglio pieces can be found with blue or brown majolica glazes, but most were made in green. Wedgwood and several French firms bought the molds of the Rubelles firm in the early 1870s.

Like all other majolica, greenware quality is effected by the freshness of the mold used to make it. A piece that is crisply modeled was made when the mold was new, and the detailing should be clear. As the mold is used, it loses its sharpness, and the pieces made in it suffer—the entire pattern become soft, in-distinct. The companies responsible for the best wares generally destroyed their molds before they degenerated, but these molds could also be sold to smaller firms.[130]

Just as few collectors would deny the place of an Italian maiolica urn or a genuine Palissy platter on their display shelves, so should collectors not scorn these greenwares; they represent a significant step in advancing English pottery techniques and styles towards majolica, and are lovely examples of an enduring aspect of majolica style.

A Wedgwood greenware tazza, 4" tall x 12" x 8". The intaglio technique has been used to define the design; deeper impressions in the modeling appear darker, since they are pooled with glaze color. Courtesy of Britannia, Gray's Antique Market, London.

A 9" greenware plate with the impressed mark "WEDGWOOD." The intaglio technique was used to give this design a near-photographic quality. Courtesy of Dearing Antiques, Miami Circle, Atlanta

An 8.5" green fern leaf and frond plate, with a printed mark reading "COPELAND" on the back. Low cake stands in this pattern were also made. Courtesy of Britannia, Gray's Antique Market, London.

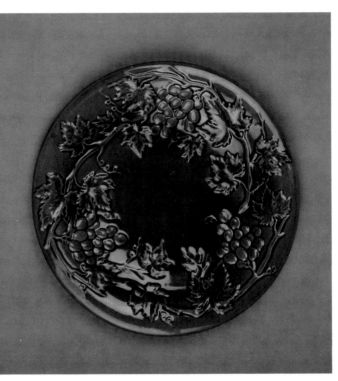

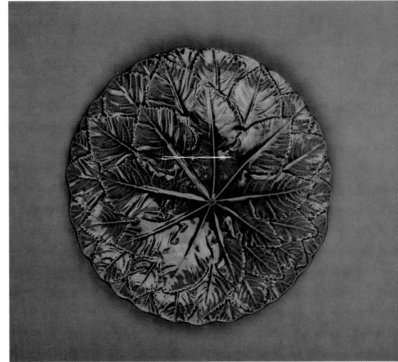

A 9.25" green plate with a grapevine
pattern, unmarked. Courtesy of Britannia, Gray's Antique Market, London.

A 9" green plate with a palmate leaf
design, unmarked. Courtesy of Britannia,
Gray's Antiques Market, London.

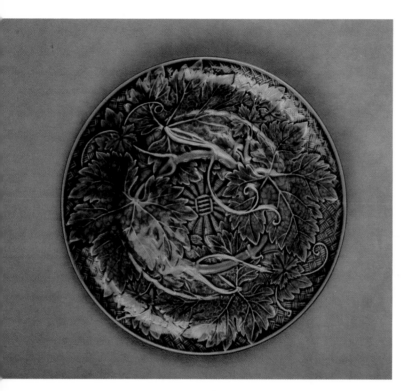

An 8.25" green plate with a grapeleaf and wicker design, marked with an impressed "WEDGWOOD" on the back.

An 8.5" green plate with a sunflower design, marked with an impressed "WEDGWOOD" on the back.

All items courtesy of Britannia, Gray's Antiques Market, London.

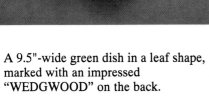

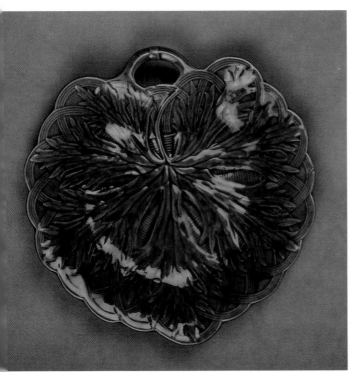

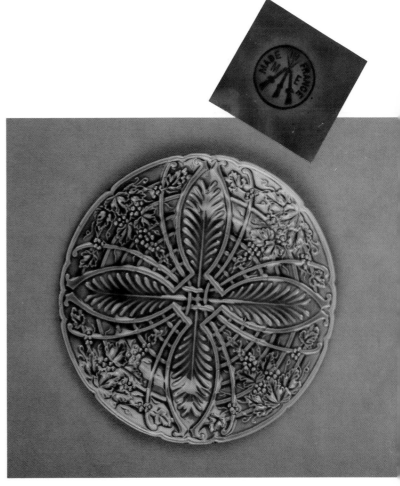

A 9.5"-wide green dish in a leaf shape, marked with an impressed "WEDGWOOD" on the back.

An 8" green plate with a geometric and grapevine design, made in France by Max Emanuel Mosanic Pottery, a company operating in Bavaria and France.

These three pre-majolica pieces of
greenware were made by the Dom
Pottery c. 1820. It is easy to see how very
different they are from majolica in glaze
and in modeling. Courtesy of Dearing
Antiques, Miami Circle, Atlanta

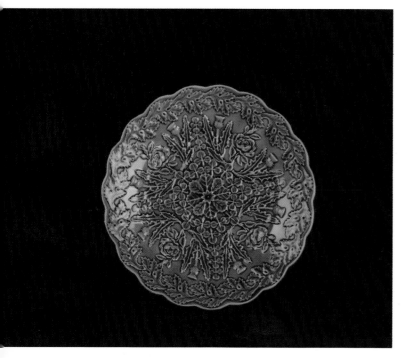 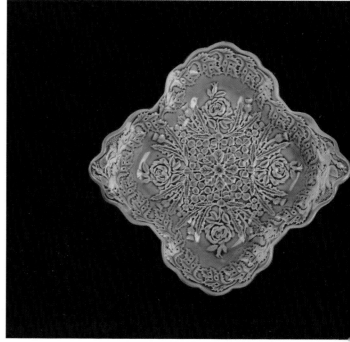

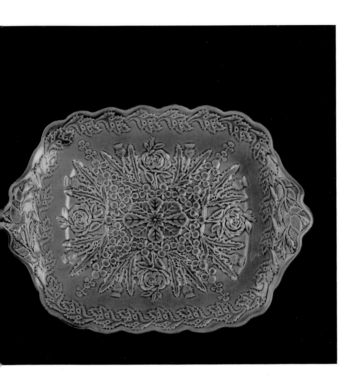

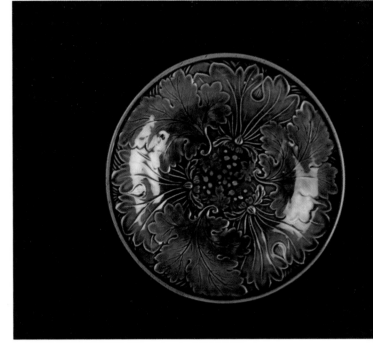

An unmarked 9" greenware plate.
Courtesy of Dearing Antiques, Miami
Circle, Atlanta

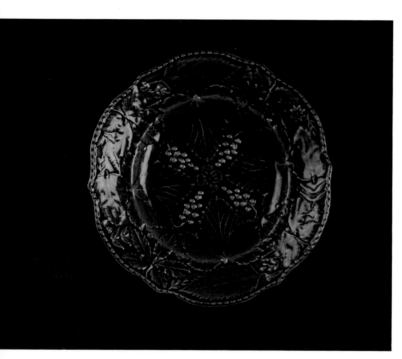

An unmarked 9" greenware plate.
Courtesy of Dearing Antiques, Miami
Circle, Atlanta

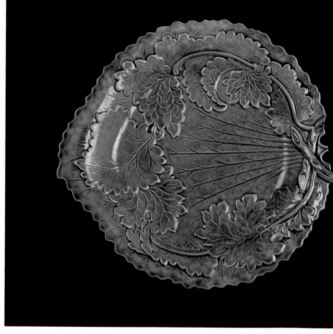

A 9.5" greenware plate, unmarked.
Courtesy of Dearing Antiques, Miami
Circle, Atlanta

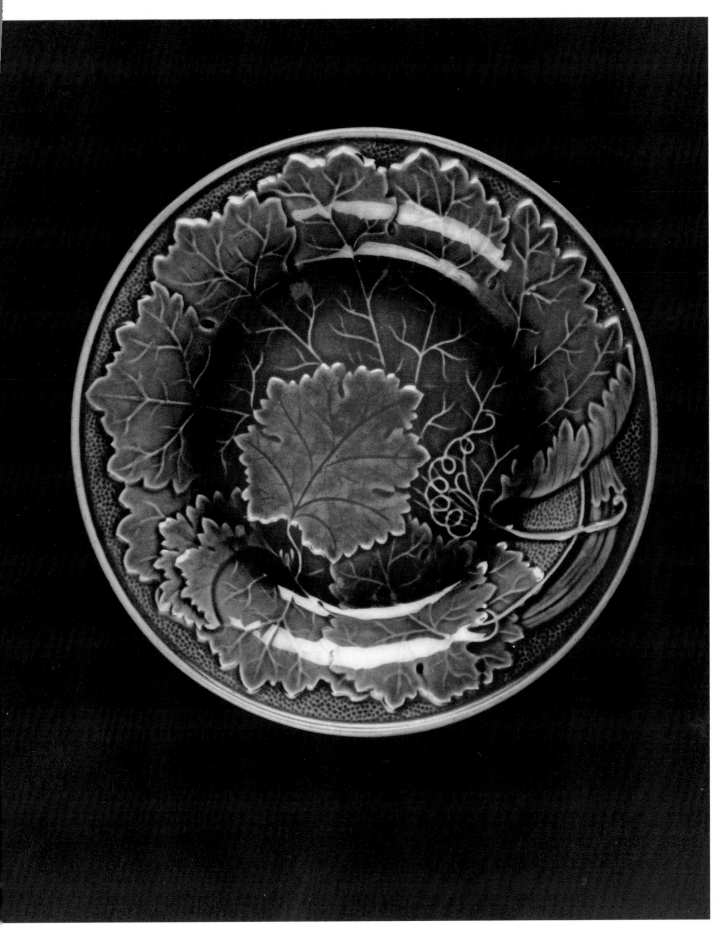

A foliate plate in green, 10" diam.
Courtesy of Dearing Antiques, Miami
Circle, Atlanta

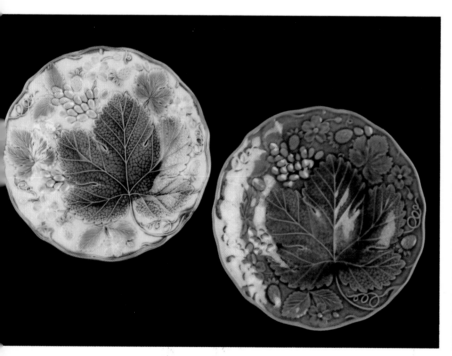
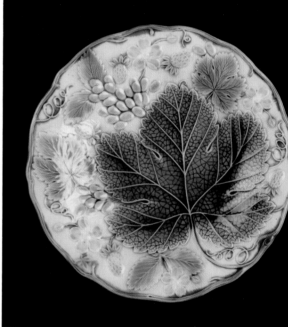

Two 9" plates, marked "WEDGWOOD" and "MADE IN ENGLAND." Finding a multi-colored majolica version of a greenware plate in your collection is a good way to confirm that the greenware was made during the majolica years. Courtesy of Dearing Antiques, Miami Circle, Atlanta

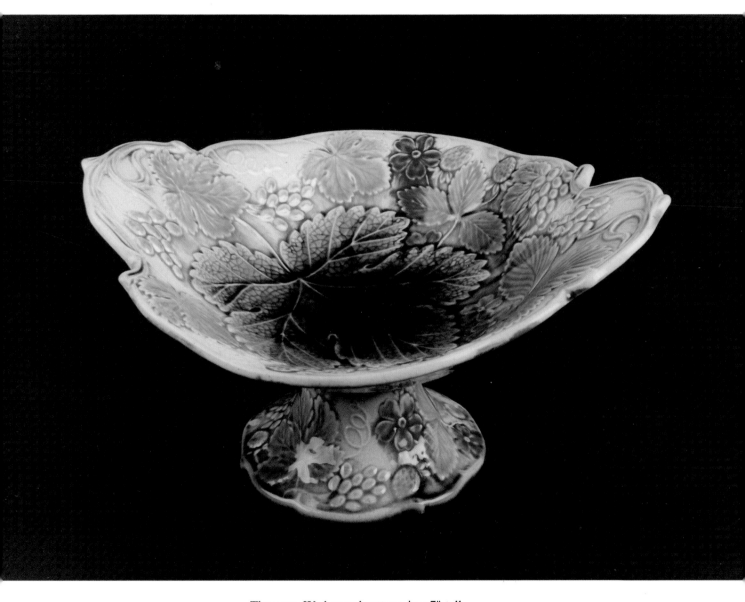

The same Wedgwood pattern, in a 7"-tall
tazza. Courtesy of Dearing Antiques,
Miami Circle, Atlanta

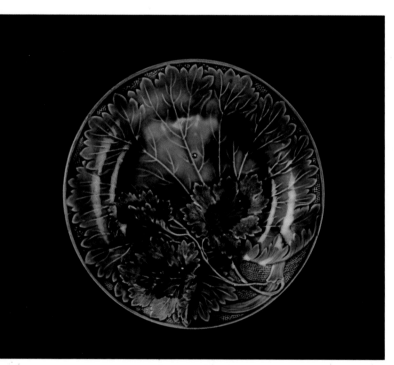

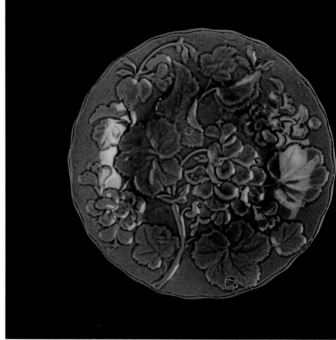

A 10" unmarked dish in a similar foliate
design, green with some multicolor
detailing. Courtesy of Dearing Antiques,
Miami Circle, Atlanta

A 9" geranium plate, English, c. 1860.
Marks from the firing stilts can be seen
on both the front and the back of the
plate, indicating that this plate was not
considered part of its manufacturer's
finer grades of ware. Courtesy of Joseph
Conrad Antiques, Atlanta

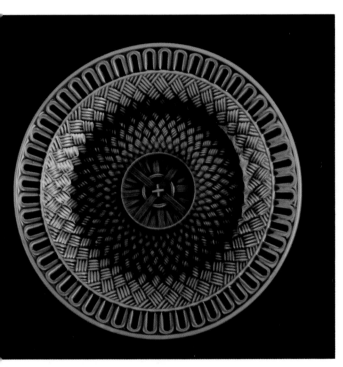

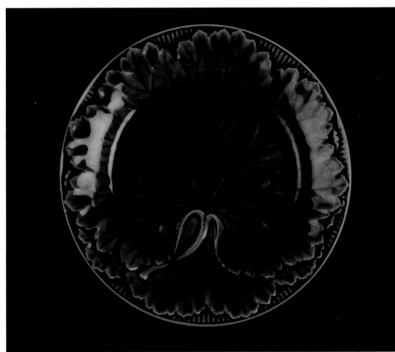

An 8" greenware plate in a reticulated basketweave design, French, c. 1870. The impressed mark on the back appears to read "SCHRAMBERG." Courtesy of Joseph Conrad Antiques, Atlanta

An 8" green leaf dish, impressed "WEDGWOOD," c. 1860. Courtesy of Joseph Conrad Antiques, Atlanta

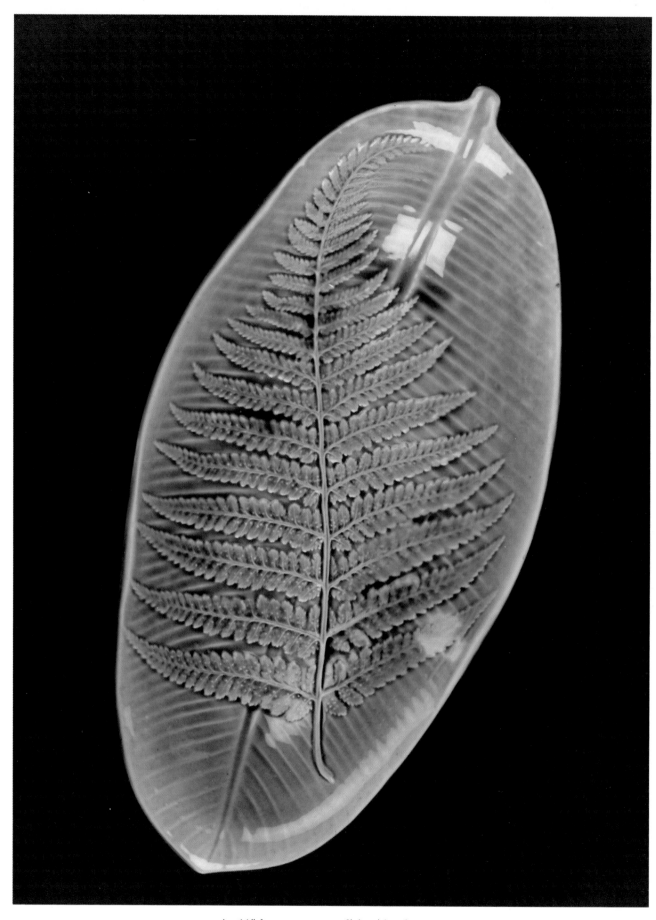

An 11"-long greenware dish with a fern
and a banana leaf, impressed "MADE IN
ENGLAND." Courtesy of Joseph Conrad
Antiques, Atlanta

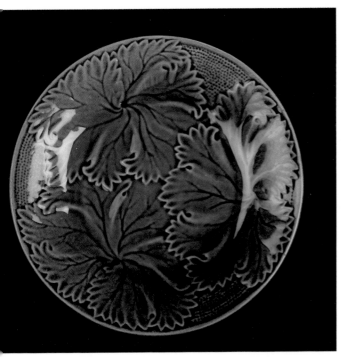

An 8" plate, olive green, modeled with
leaves and stippling. Marked with the
initials R and S, and an anchor. Courtesy
of Joseph Conrad Antiques, Atlanta

FOOD SPECIALTY WARES

A great deal of Victorian majolica was made for dining purposes, much of it spectacular ware meant to impress guests at lavish dinner parties thrown by members of high society (or those who hoped to join it). Among other changes in Victorian life was a change in eating habits, menus, and entertaining styles, all of which are reflected in the pieces of majolica shown here.

Recently developed technology—refrigerated cars, and efficient rail systems—allowed fresh seafood to be brought inland, and fish courses became more important in fashionable dining rooms. Among popular dishes were sardines, which were served in wide array of sardine dishes, many of them majolica. Oysters, too, were extremely popular, and hostesses often chose to serve them in magnificent plates designed expressly for the purpose; again, many of these were majolica. Oyster plates and sardine boxes made certain that every guest noticed the presence of these fashionable foods.

Strawberry servers were a lovely way to present the harvest of many a conservatory garden. They were often decorated with strawberry plant designs and three-dimensional, fully modeled strawberries. Generally they offer wells in which creamer pitchers and sugar bowls could be placed, though now these accessories are often missing or broken.

Asparagus plates, though most often manufactured on the Continent, also found their way onto English and American tables. Serving pieces for asparagus—colloquially called "sparrow-grass" in England—appear in many forms, from covered tureens to curving open servers, often with undertrays to match.

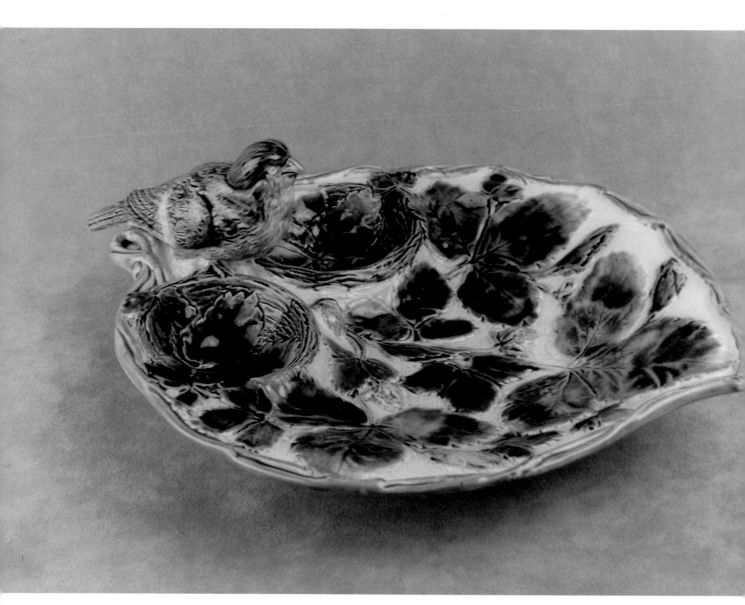

A 12" strawberry server, unmarked.
Courtesy of Britannia, Gray's Antique
Market, London.

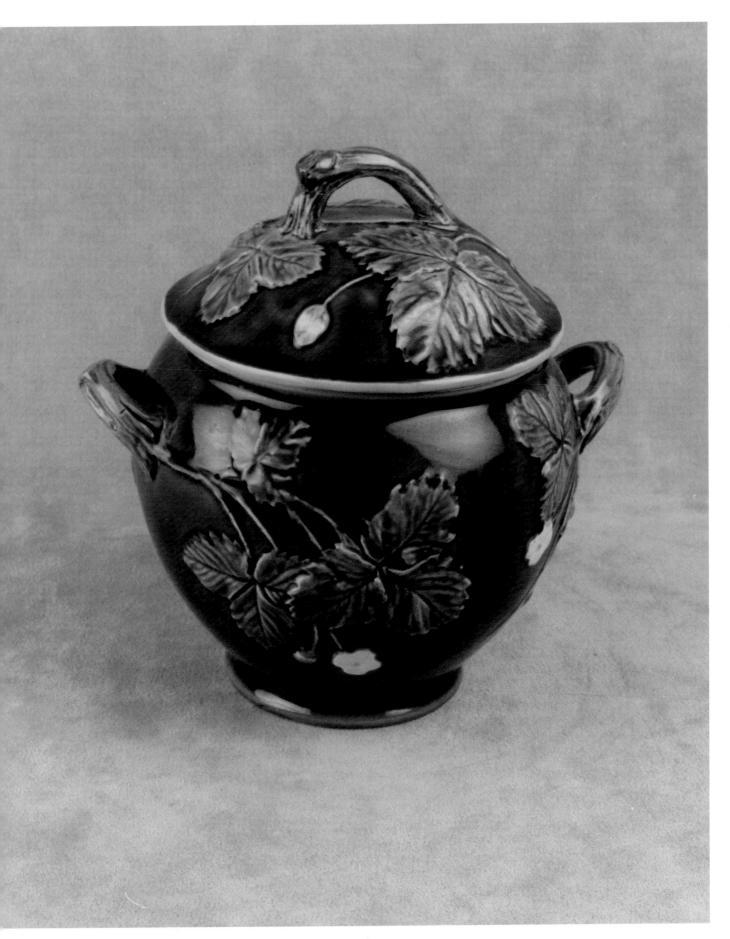

A 6"-tall covered sugar bowl. Courtesy of
Britannia, Gray's Antique Market,
London.

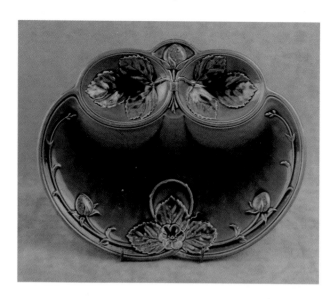

A simple, green-glazed strawberry dish,
9.25" wide, marked "MINTONS."
Courtesy of Britannia, Gray's Antique
Market, London.

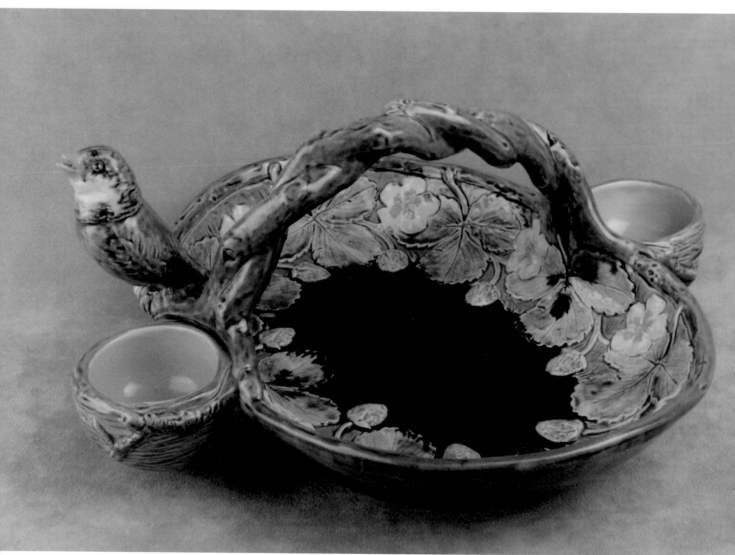

A 6"-tall strawberry server by Holdcroft,
1877. Courtesy of Britannia, Gray's
Antique Market, London.

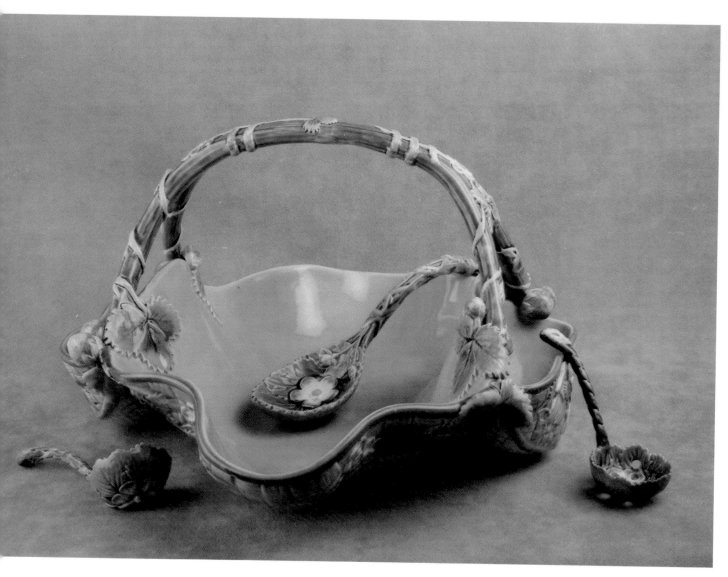

A strawberry server, 6.5" tall x 12" wide, with three spoons. The small spoons are pierced so that sugar can be sprinkled from them. Courtesy of Britannia, Gray's Antique Market, London.

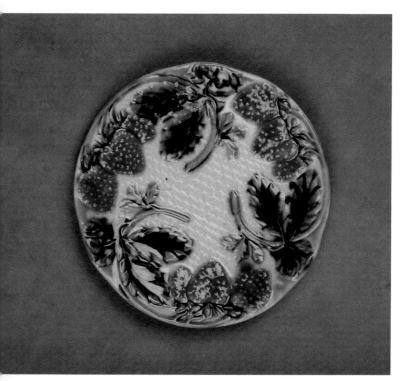

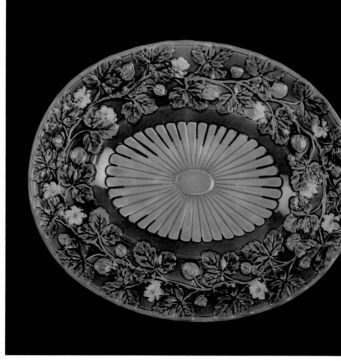

An 8" strawberry plate, unmarked. This cheerful piece has three stilt-marks on the front surface, indicating that it was fired in a stack of similar plates. The higher the quality (and the price) of a piece, the more care the potters took to hide stilt-marks. This plate, apparently, was not meant to be 'high-end' merchandise. Courtesy of Britannia, Gray's Antique Market, London.

A 13.5" x 11" strawberry platter by Wedgwood. Courtesy of Dearing Antiques, Miami Circle, Atlanta

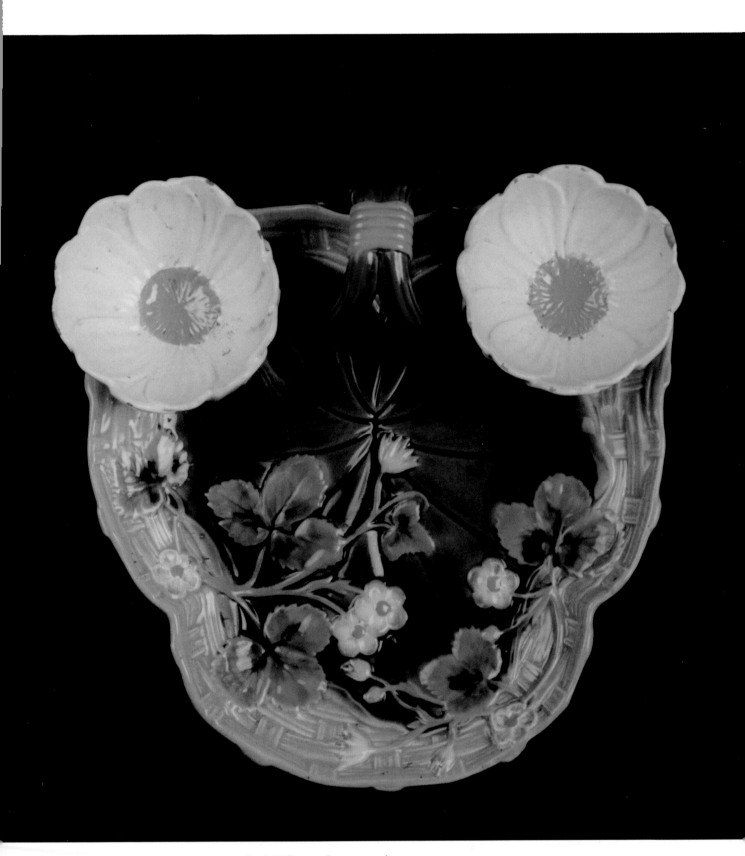

An 11" George Jones strawberry server
with a mottled, thumbprint-marked back.
Courtesy of Dearing Antiques, Miami
Circle, Atlanta

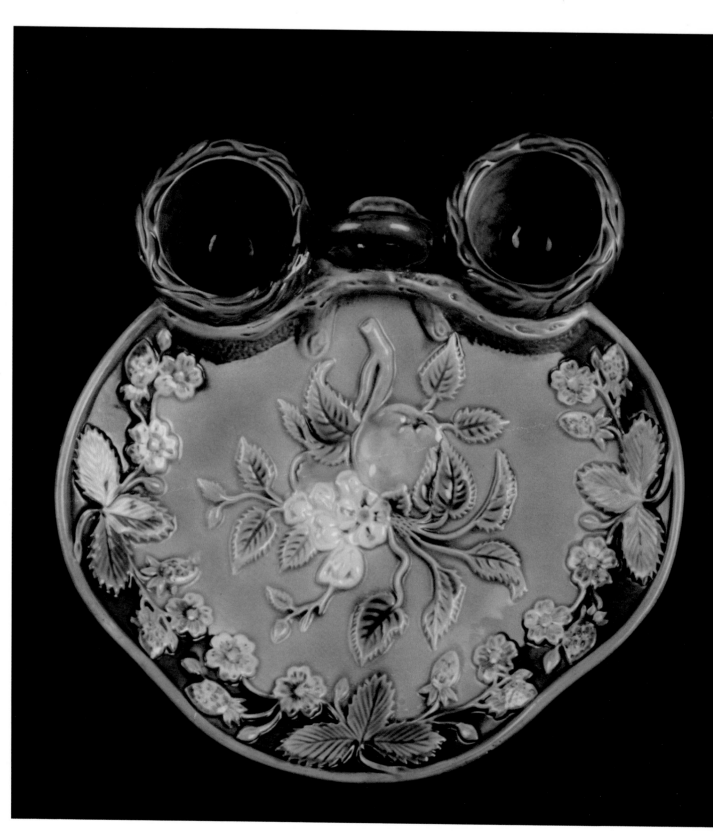

A 12" strawberry dish, unmarked.
Courtesy of Dearing Antiques, Miami
Circle, Atlanta

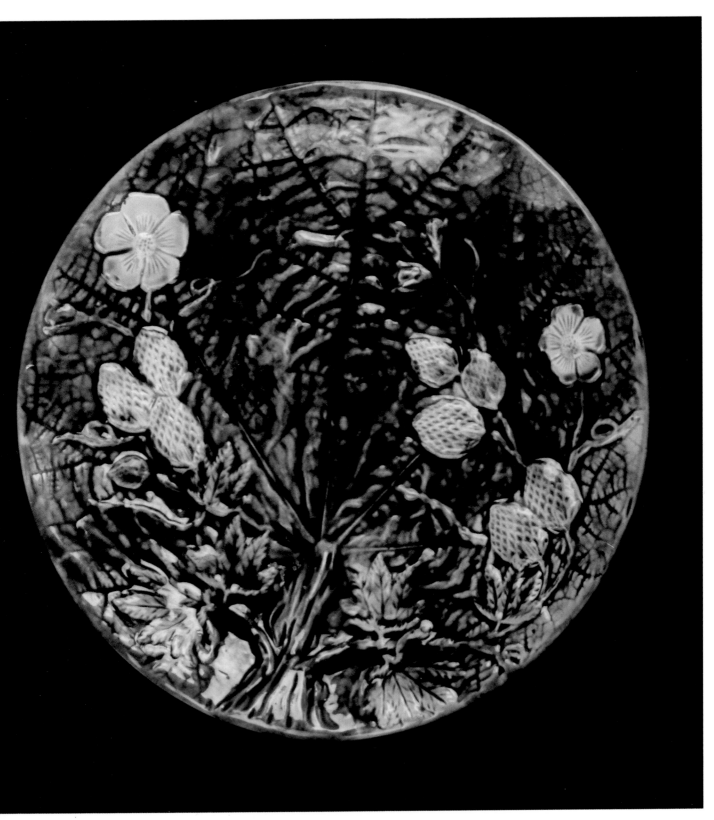

An 8.5" strawberry dish, unmarked.
Courtesy of Dearing Antiques, Miami
Circle, Atlanta

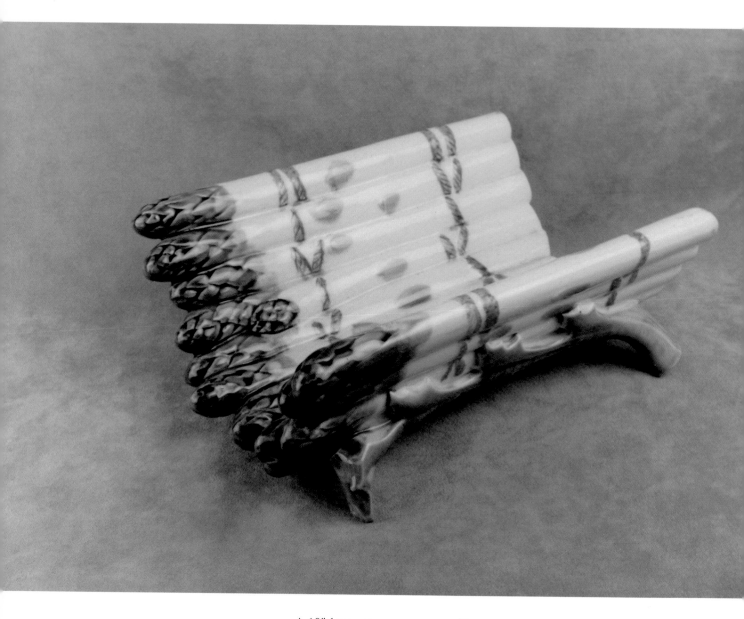

A 10"-long asparagus server, with an
impressed mark reading "LUNEVILLE."
Courtesy of Britannia, Gray's Antique
Market, London.

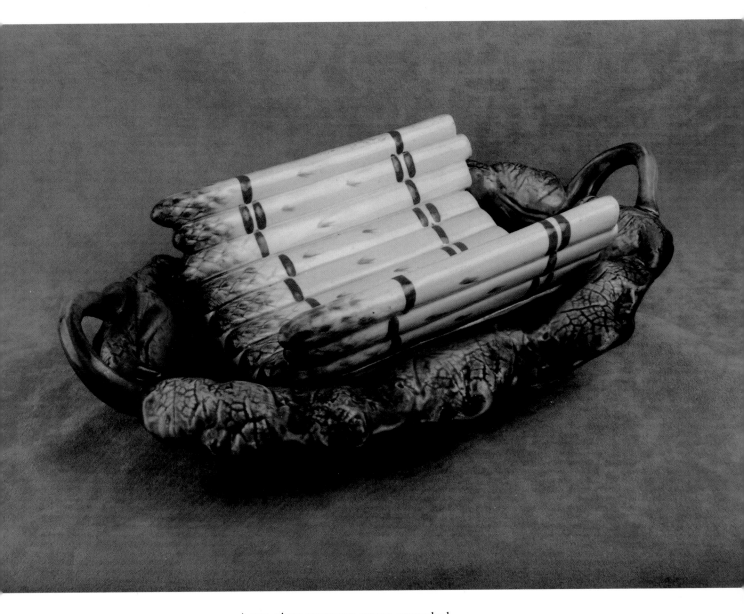

A one-piece asparagus server, unmarked,
14" long. Courtesy of Britannia, Gray's
Antique Market, London.

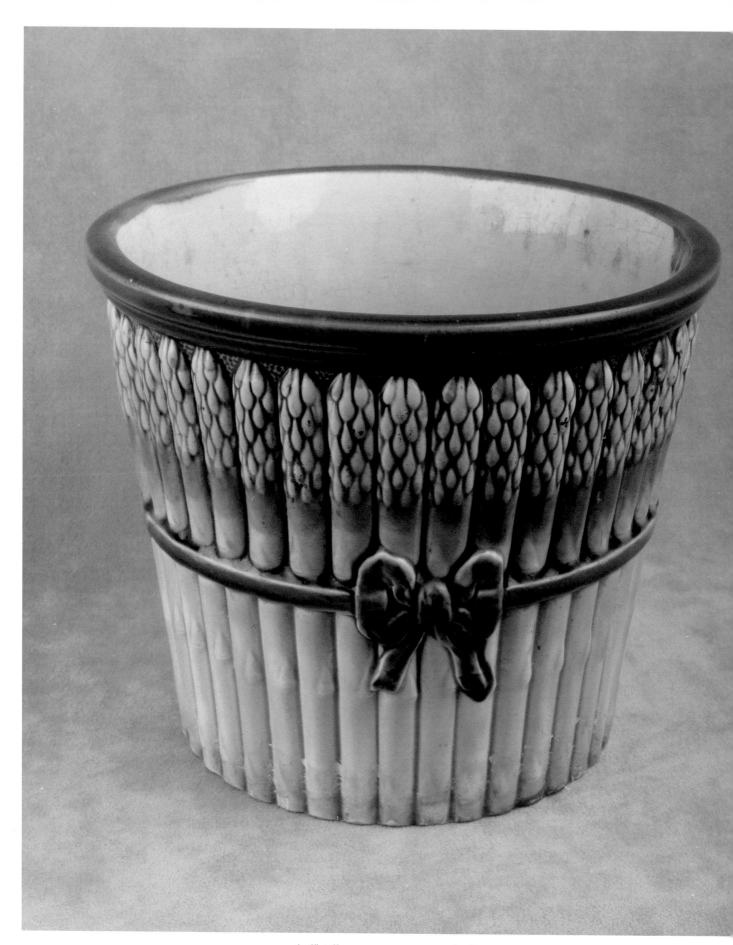

A 6"-tall asparagus pot, unmarked.
Courtesy of Britannia, Gray's Antique
Market, London.

142

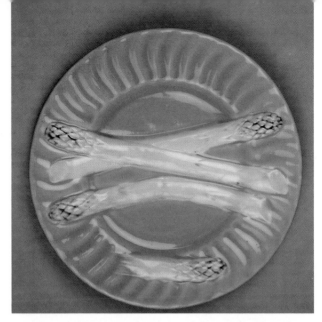

A simple 9" asparagus plate with a fluted rim, unmarked. Courtesy of Britannia, Gray's Antique Market, London.

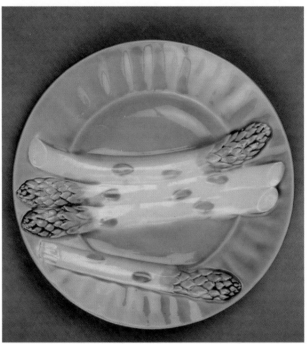

A simply designed 8.75" asparagus plate marked "Depose / K et G / LUNEVILLE." Courtesy of Britannia, Gray's Antique Market, London.

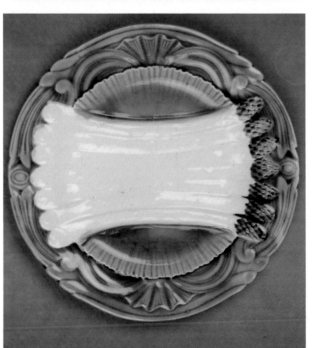

A 9.75" asparagus plate, marked with an impressed windmill and the initials RCH.

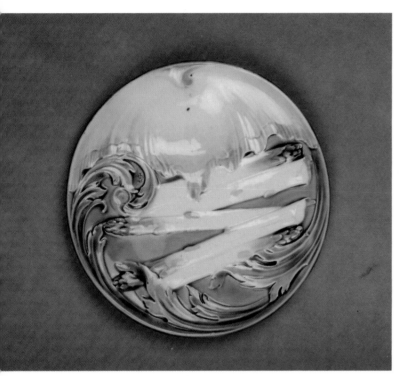

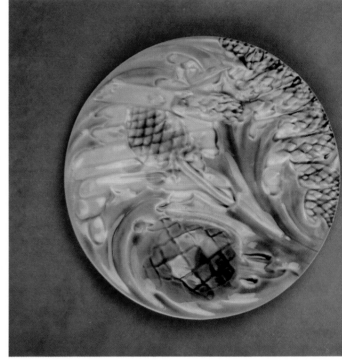

A 9" asparagus plate with a well (in pink) for sauce. Marked "Depose / K et G / LUNEVILLE." Courtesy of Britannia, Gray's Antique Market, London.

A 9" asparagus plate with a single well, marked "DEPOSE / K et G / LUNEVILLE."

All items courtesy of Britannia, Gray's Antique Market, London.

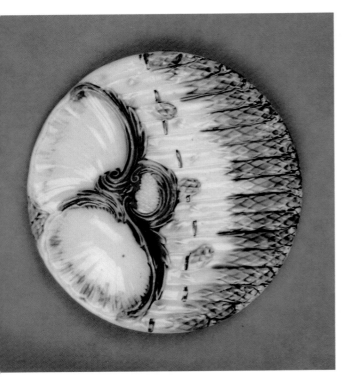

A 10" asparagus plate with two wells, unmarked.

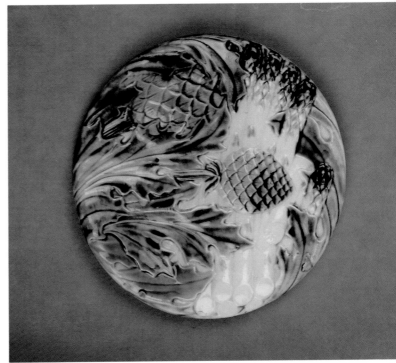

An asparagus plate with two wells, unmarked.

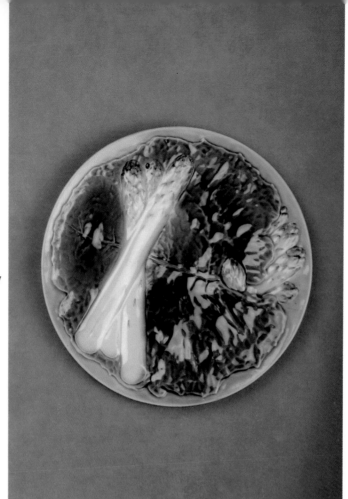

A 9.25" French asparagus plate with an unusual leaf design, unmarked. Courtesy of Britannia, Gray's Antique Market, London.

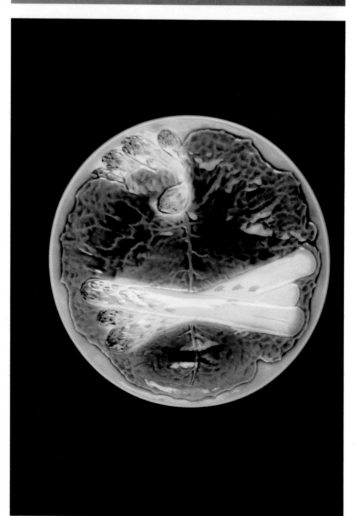

Another example of the same asparagus dish, with slight differences in the glazing. Courtesy of Dearing Antiques, Miami Circle, Atlanta

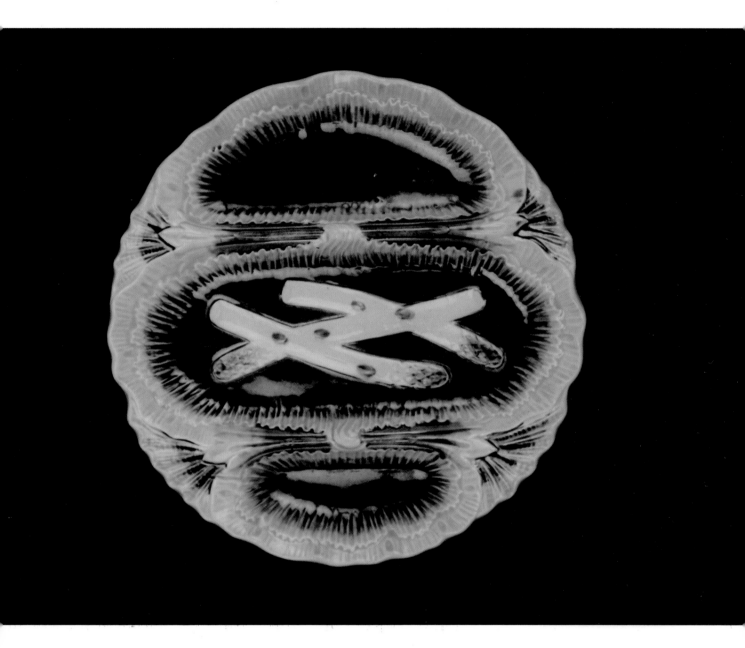

A 9.75" asparagus plate in an unusual
pink and brown design, with two side
wells, unmarked. Courtesy of Britannia,
Gray's Antique Market, London.

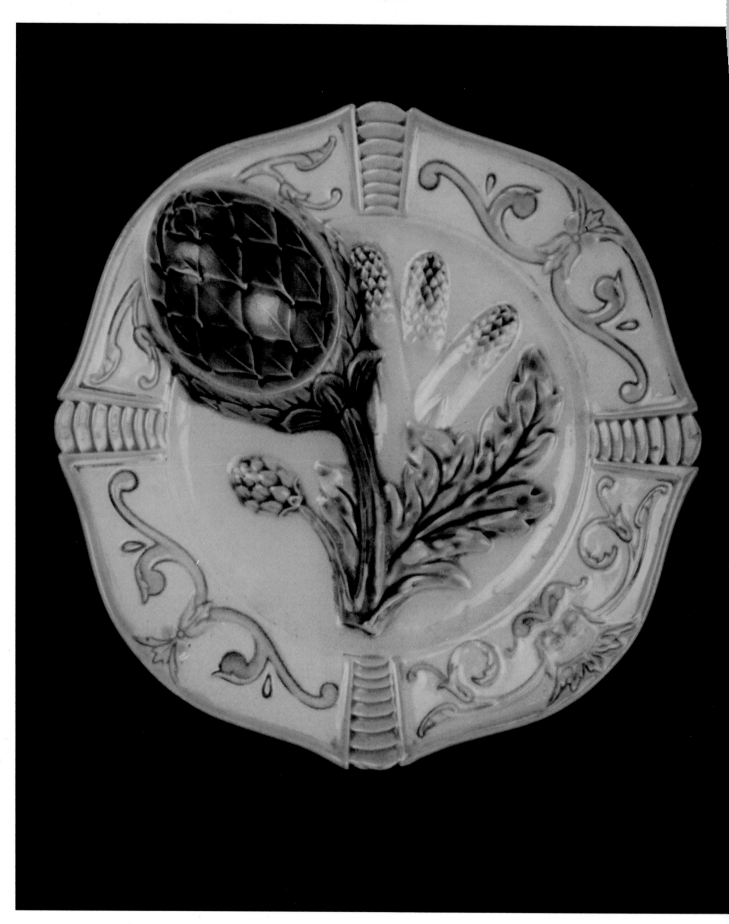

A 9.75" asparagus plate in a delicately
painted design, with a single well,
unmarked. Courtesy of Britannia, Gray's
Antique Market, London.

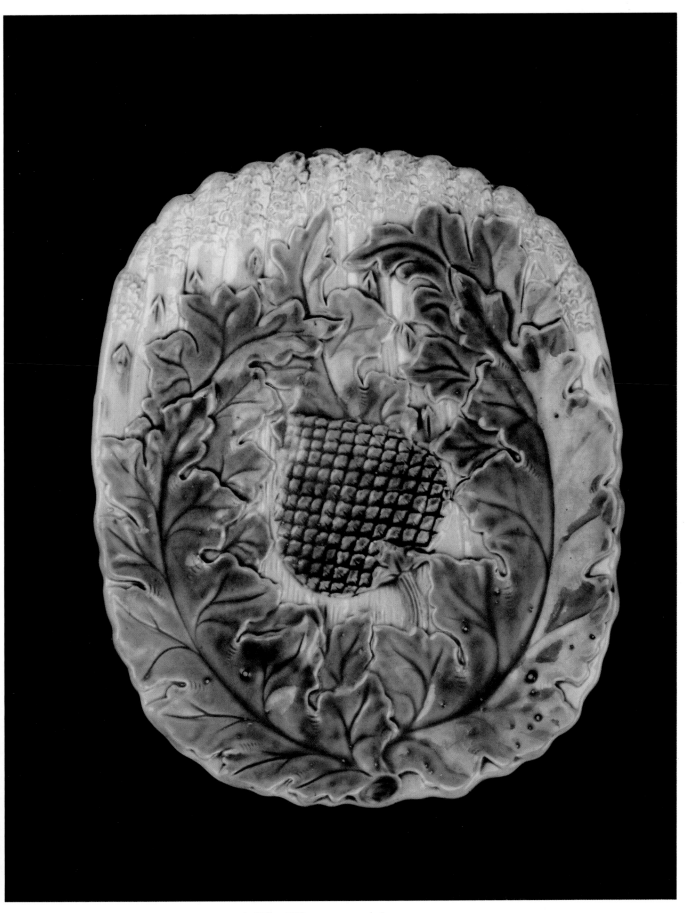

A 12" x 10" asparagus platter, un-
marked. Courtesy of Britannia, Gray's
Antique Market, London.

A 12" x 9.5" asparagus platter, with an
impressed mark reading "[star] S."
Courtesy of Britannia, Gray's Antique
Market, London.

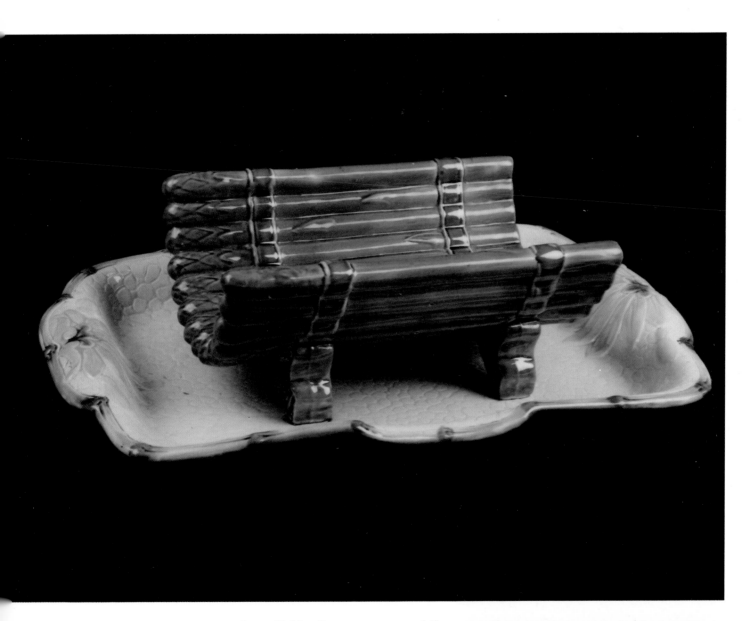

A rare Holdcroft asparagus server, 14"
long. Marked "J HOLDCROFT."
Courtesy of Dearing Antiques, Miami
Circle, Atlanta

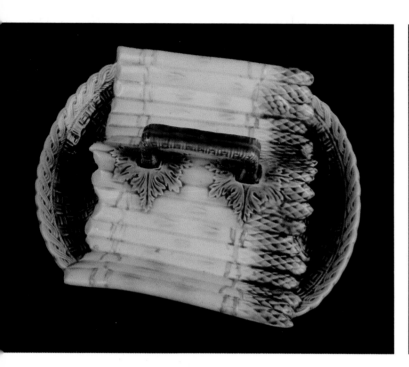

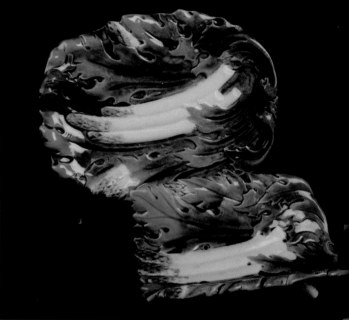

A French asparagus server, c. 1870, 13.5"
wide. Courtesy of Dearing Antiques,
Miami Circle, Atlanta

A two-piece French asparagus server,
unmarked, c. 1880. The top measures 4"
high x 10.5" long and has three drain
holes; the bottom measures 10.5" x 13".
Courtesy of Joseph Conrad Antiques,
Atlanta

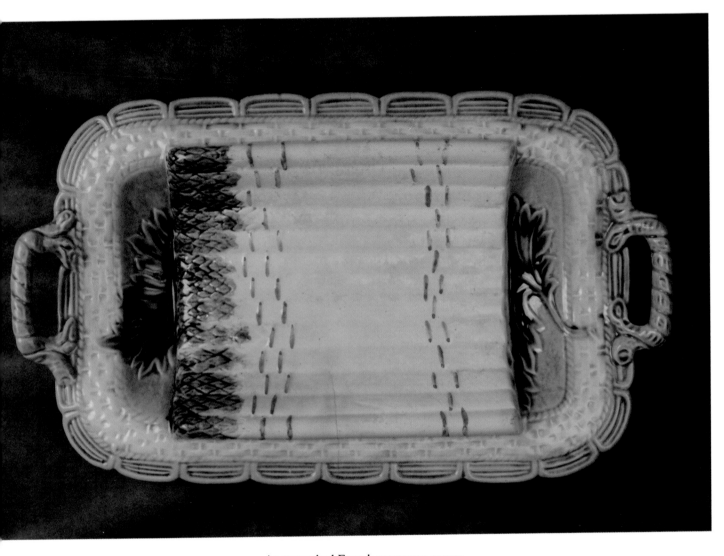

An unmarked French asparagus server,
17" long, c. 1880. Courtesy of Joseph
Conrad Antiques, Atlanta

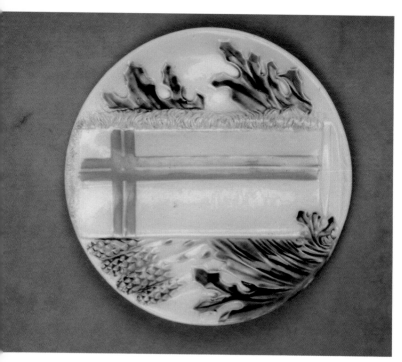

A 9.25" asparagus plate in a napkin
design with two wells, marked on the
back with an impressed "SALINS."
Courtesy of Britannia, Gray's Antique
Market, London.

An intricately molded 9.5" oyster plate
by the French pottery Longchamp, with
an impressed back mark reading
"LONGCHAMP / TERRE / FER."
Courtesy of Britannia, Gray's Antique
Market, London.

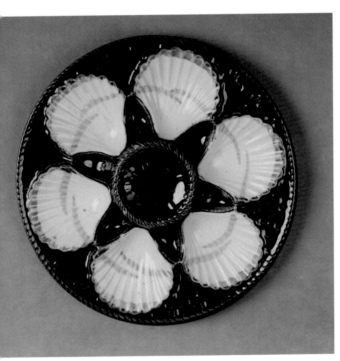

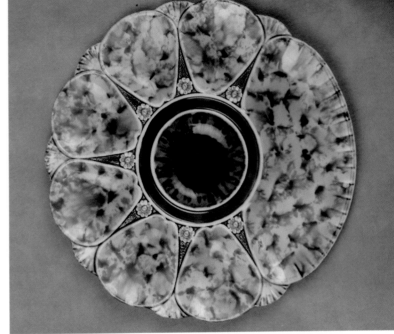

A 9.75" French oyster plate by
Longchamp, c. 1860, marked
"LONGCHAMP / TERRE / DE FER."
Courtesy of Joseph Conrad Antiques,
Atlanta

A gorgeously mottled 10" oyster plate
made by Minton. With in impressed back
mark reading "MINTONS," and an
impressed British Registry Mark.
Courtesy of Britannia, Gray's Antique
Market, London.

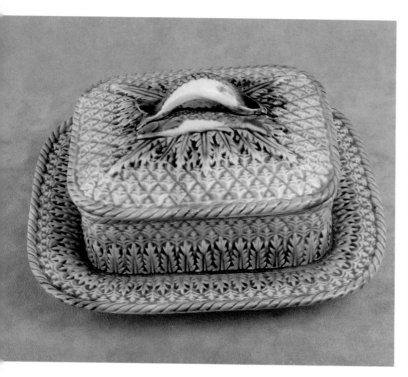

A two-piece sardine box with a pine-apple-style background pattern, 8.25" long.

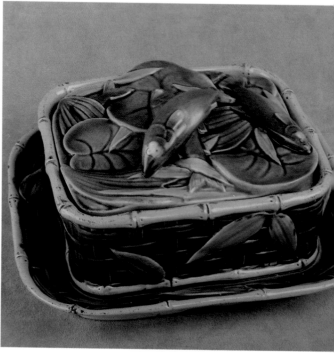

An 8" sardine box with a bamboo and basketweave design.

All items courtesy of Britannia, Gray's Antique Market, London.

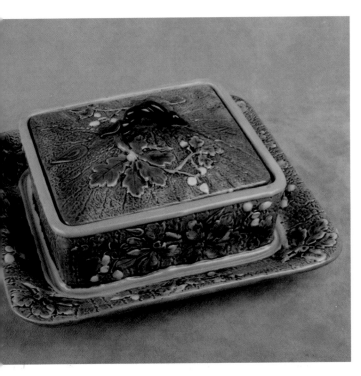

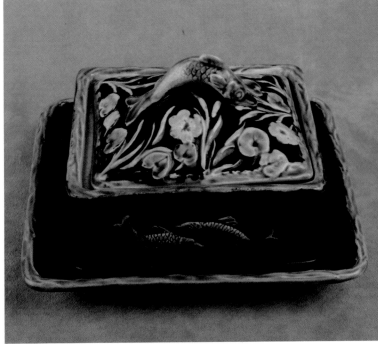

An acorn-motif sardine box, 9" wide.

A cobalt sardine box by Holdroft.

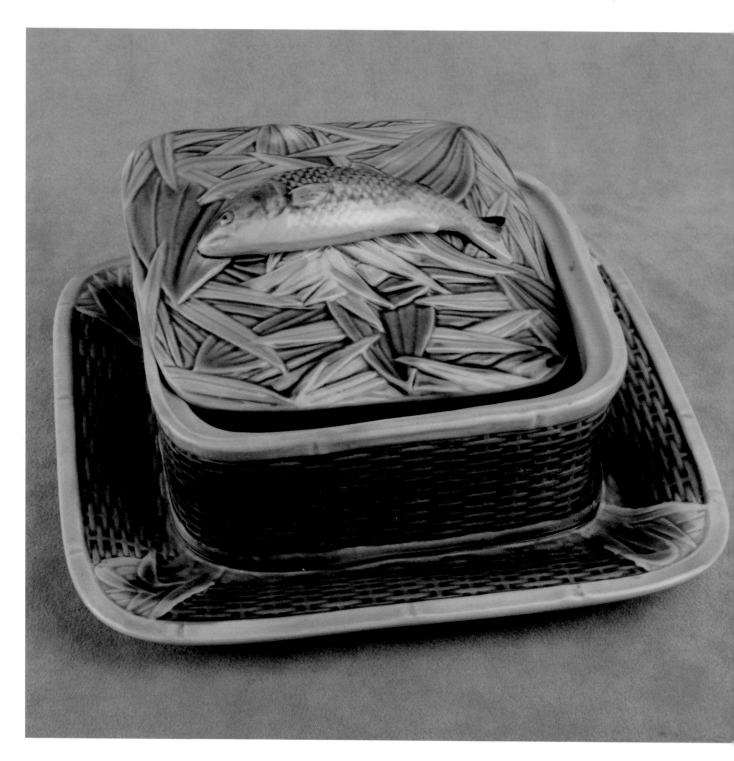

A basketweave sardine box with the
George Jones crescent mark. Courtesy of
Britannia, Gray's Antique Market,
London.

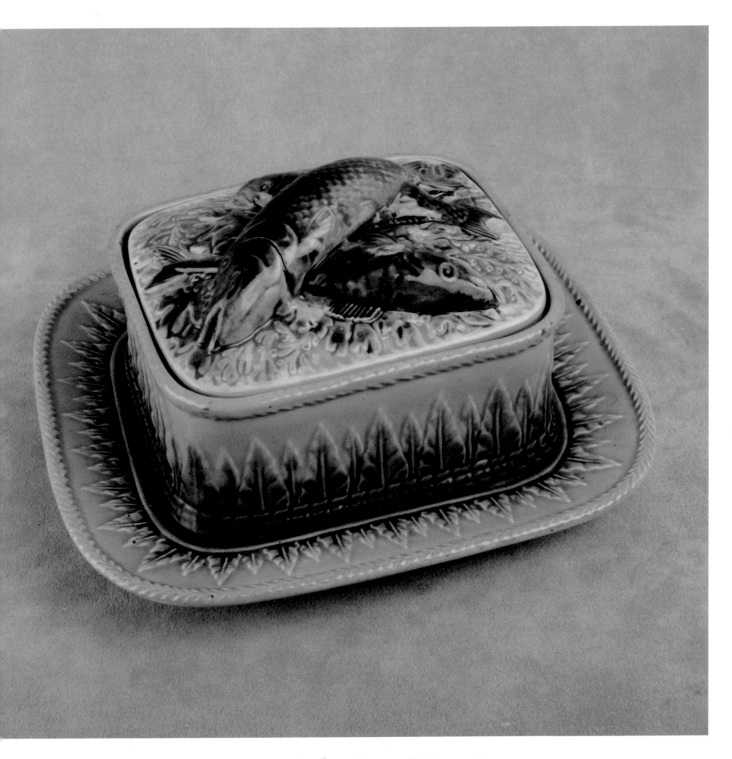

A three-piece George Jones sardine box
with a dark pink interior, dating frm
1867. The underplate measures 8.5" x
7.625". Courtesy of Britannia, Gray's
Antique Market, London.

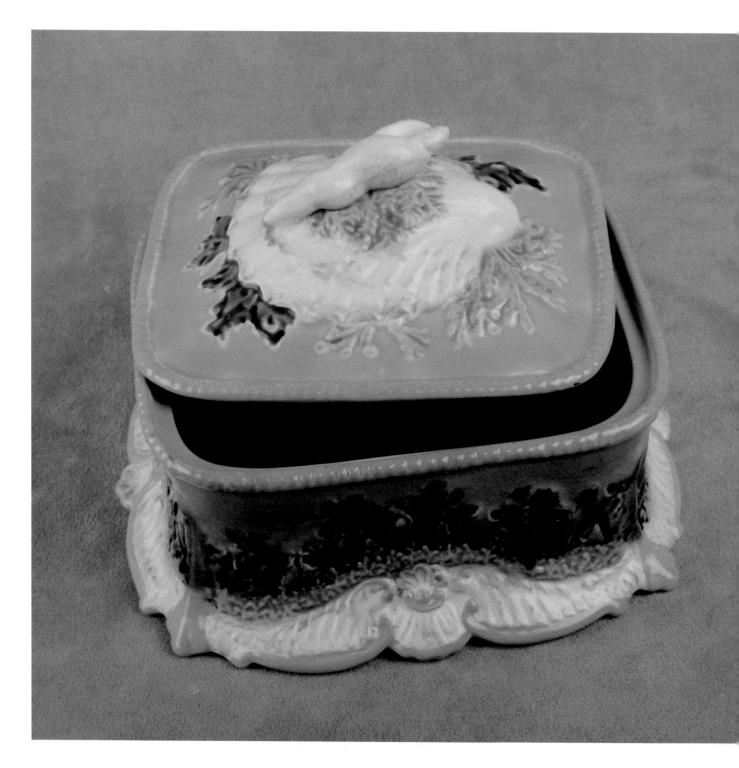

A sardine box with a seashell finial and
a typical pale pink interior, made by
George Jones and dating from 1865.
Courtesy of Britannia, Gray's Antique
Market, London.

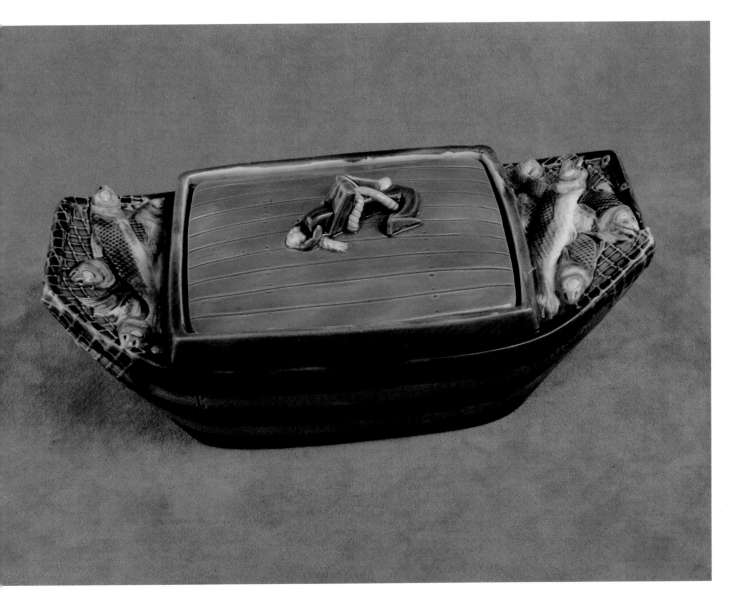

A 10"-long sardine box by Wedgwood,
with an impressed British Registry
Mark. Courtesy of Britannia, Gray's
Antique Market, London.

MAJOLICA TILES

I will make these tiles, Man,
if they cost me a guinea each.
—Herbert Minton

During the Victorian and pre-Victorian era, growing industrial cities on both sides of the Atlantic were plagued with filth and grime. These unsanitary conditions encouraged the spread of disease, especially in the crowded quarters of the lower classes. The upper classes were not immune from these concerns, but they did enjoy relatively better health. In exchange, they were troubled with the challenge of defending the elegance of their persons and their homes against the encroaching mud and sludge of the street and the all-pervasive smoke and smog of industry. Majolica tiles, first used widely in London in the interests of public sanitation and disease prevention, later came into play in the homes of the wealthy for the sake of tidiness, and then for decoration.

During the 1840s, the English government's Poor Law Commissions investigated the spread of disease—particularly cholera—and came to the conclusion that using new building materials could solve the problem, at least in part. What they had in mind for these new sanitary surfaces was ceramics, with both rough-surfaced salt-glazing and with impermeable, glassy-surfaced lead-glazing. While salt-glazed ceramics were largely constrained to sewer piping, smooth lead-glazed tiles were perfect for architectural surfaces, since they lent themselves so readily to decorative applications and were so resistant to the filth of Victorian industrial towns:

> red brick and terra cotta discolor, colored stones and marbles grow dim and perish in shocking haste; and it would seem as if no building material but what had got practically a glass face to it would be able to contend against the corrosion of the air of a manufacturing town,[131]

wrote an architect who collaborated with Wedgwood on majolica fireplace tiles. In the second half of the nineteenth century, as majolica glazes grew easier and less expensive to produce, lead-glazed tiles came into greater use, ornamenting and protecting the exteriors of buildings, the interiors of train stations, and providing decorative detail on the walls, ceilings, and floors of many Victorian homes. They became especially useful in public buildings like museums, banks, town halls, churches, and immense gin palaces.[132]

Herbert Minton, the father of Victorian majolica, was instrumental in the first large-scale production of lead-glazed tiles. He had begun experimenting with tile manufacture in the late 1820s,[133] and by the time of Queen Victoria's ascension to the throne, he had been deeply engrossed in his experiments with tile for some years. His suffering was nothing compared to that of Bernard Palissy, but still he accumulated quite a disheartening scrap heap of failures. When the waster pile had reached enormous proportions, with bills to match, Herbert's partner at the time admonished him. But Herbert was determined; legend has it that he replied, "I will make these tiles, Man, if they cost me a guinea each"![134] The date of this telling conversation is unknown; Herbert and his father Thomas temporarily dissolved their business partnership in 1828, possibly over this issue,[135] maybe even because of this conversation; however, the partner in this anecdote might be Herbert's later partner Samuel Wright instead.

As the years passed, Herbert was proved right in his determination. He is now credited with recovering the ancient art of encaustic tiles, a medieval form which used a variety of clays interwoven into an intricate flat design, and industrializing the manufacturing process. He soon progressed to lead-glazed tiles of molded earthenware, identical to majolica in composition, which skyrocketed in popularity because of their beauty and practical utility. These found broad application in the second half of the nineteenth century, in England, America, and Canada alike. Many of the early designs were made to replace or extend pre-existing pavements of antique origins.[136]

In 1845, Herbert established a tile-making concern independent of the main Minton company, teaming up with his nephew Michael Daintry Hollins and naming their firm Minton Hollins & Company. Together they focused on tiles for architectural uses, fireplace ornament, and flower boxes.[137] One American writer from that day described to his readers the fruitful collaboration of uncle and nephew, calling Mr. Hollins

> a gentleman whose genius and skill as a chemist have not reached the recognition they deserve, and but for whom Minton's triumphs would probably never have reached the perfection they attained, though to his credit be it said that Herbert Minton himself was always ready to acknowledge his great obligations.[138]

When Herbert died in 1858, the business was turned over to Mr. Hollins and another nephew, Colin Minton Campbell. During the previous year, Herbert's tiles had gone to North America, to be shown in an exhibition in Montreal. A Canadian newspaper called *The New Era* reported that they were available in several patterns to create "a very handsome effect," an opinion shared by the owners of opulent homes from east to west, and Minton's tile market became international.

In 1860, when Ottawa was made the capital of the Province of Canada, the Prince of Wales made the trip to lay the cornerstone of the new parliament building. When it was completed, many people considered it "perfect in every detail"—despite its lack of majolica tiles. But the poet Lidstone, writing about the Parliament building, makes clear how strongly some citizens felt about the decor of their national headquarters, about tile ornament, and about Minton tiles in particular:[139]

> O, thy contractors, Ottawa, should full well be shent,
> Those edifices the glory of the Western Continent,
> Disgraced, alas! with floors paved with Yankee cement.
> Had I been there when that same contract was being given out,
> I would have put the Vandal horde into an utter rout,
> And with Mintonian products have paved the halls thro'out.

On both sides of the Atlantic, Victorians with money to spend and expensively furnished drawing-rooms to protect discovered that the glossy, glass-surfaced Minton tiles were perfect for the entrance halls of their homes. These foyers were the part of the house most exposed to grime from the outside world,

and needed protection—preferably something sturdy and easy to clean. The tiles were a fashionable concession to necessity, and were made to match any style within the Victorian repertoire—"sometimes painted, sometimes printed, and sometimes manufactured in the majolica style, with embossed designs covered with thick glazes." Soon there was a strong market for lead-glazed tiles being made by a wide range of well-regarded potteries, among them Doulton, Copeland, Booths, and others.[140] Perhaps the most important tile manufacturer through the second half of the nineteenth century was Maw & Company, located in Jackfield, near Brosely. Maw began working with majolica glazes over their terra cotta tiles in the 1860s. By 1880 their agents had developed markets in Europe, Canada, the U.S., South Africa, Australia, New Zealand, India, China and Japan.[141] By the mid-1880s they had grown to immense proportions, producing twenty million items a year in over nine thousand designs.[142]

Even Sir Charles Eastlake, arbiter of Victorian taste and advocate of simplicity, recommended that majolica tiles like those made by Minton and Maw be set into foyer walls, not just for appearances' sake. It was in these entrance halls that Victorian ladies shook the dirt out of their long, massive skirts, which had been sweeping the filthy streets, before entering the main portions of the house. Eastlake suggested that the walls be tiled for three or four feet above floor-level (creating a 'dado'), to protect them from "the shower of street dirt that was inevitable when the Victorian lady came in the front door."[143] Tile dados were especially appreciated in Canadian cities, "where streets were muddier and roads dirtier than anywhere else in the world, if contemporary accounts can be believed."[144]

Majolica tiles were not limited to foyer dados, and quickly came to be found trimming fireplace openings, defining doorframes, and composing ornamental murals. They were soon being made in quantity by many of the best firms, for a public "bent on tearing up floors and ripping out fireplace surrounds in order to walk on new earthenware and gaze at tilework patterns on the wall." A popular Victorian pastime was handpainting china and ceramic tiles to be framed as teapot rests, inset into furniture surfaces, or tile small tabletops,[145] but as the years passed, painting became passé. Then majolica tiles replaced the home-made versions; "the present fashion tends more toward adopting majolica embossed tiles," advised one ladies' home decorating textbook, "with their superb green blues, blacks, grays and crimsons."[146]

By the time American artist James Abbot MacNeil Whistler had set up house in London in the mid-1870s, the practical use of tiles to protect foyer walls had gone out of fashion. A description of Whistler's very stylish house in an article about English decorative arts made the comment that "of course tiles are sometimes used to make the dado, but either because of their common use in hotels and public buildings, or for some other reason, they appear with increasing rarity in private houses in any other capacity than that of adorning the fire-place." Perhaps the functionality of tiled dados shone too obviously through the ornamental pretense for Victorian tastes! Tiles were still fashionably acceptable if used in unadulteratedly decorative, purely useless plaques, "to be hung as fine works of art . . . which is now frequent, and is the means of producing a great deal of beautiful work."[147]

This 6" green tile is by Minton-Hollins, and bears a graceful floral pattern. Tiles were still part of the majolica repertoire even into the Art Nouveau era at the end of the nineteenth century. Courtesy of Britannia, Gray's Antique Market, London.

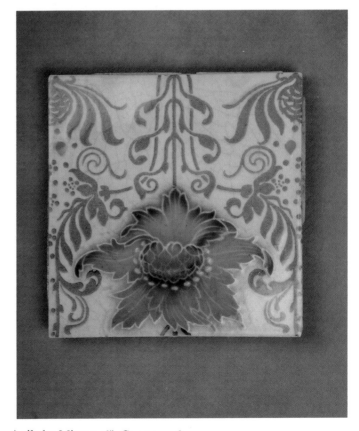

A tile by Minton, 6". Courtesy of Britannia, Gray's Antique Market, London.

Today, majolica tiles can be found scattered throughout antique shops and shows, though seldom in sets of more than two. Dealers who specialize in antique tiles may be better sources of matching sets by Minton Hollins or Maw & Company than dealers who focus on majolica in general.

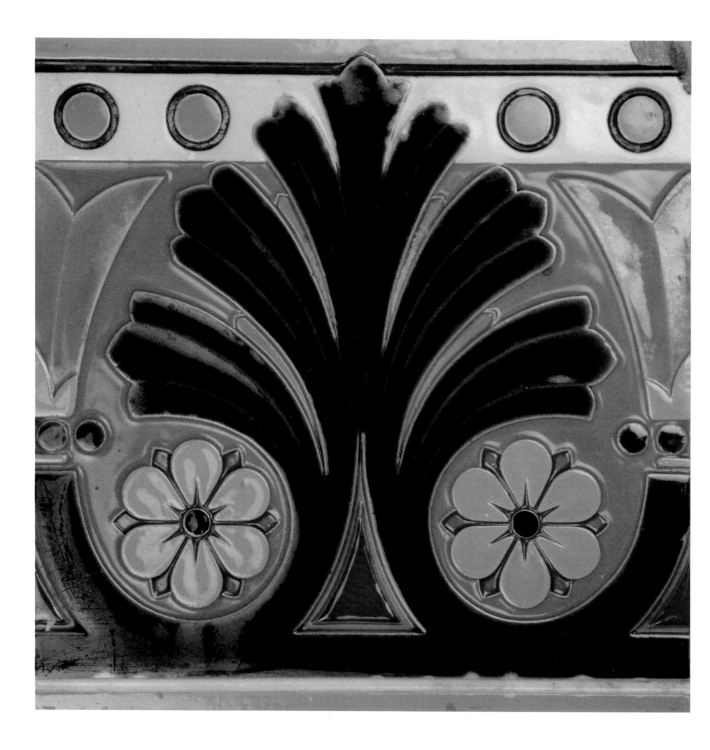

A bright, patterned tile by Minton Hollins, 7.75". Courtesy of Britannia, Gray's Antique Market, London.

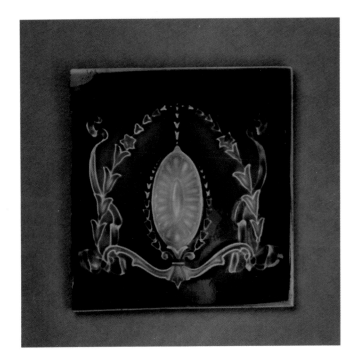

An unmarked tile in a delicate, formal pattern. 6". Courtesy of Britannia, Gray's Antique Market, London.

DECORATIVE WARES

In the Victorian era, consumers had a marked preference for wares that were ornamental first, and useful second. Majolica suited their purposes perfectly, for no matter *how* useful an individual piece might be, its functionality could not help but be overshadowed by its delightful modeling and whimsical coloration. From huge centerpieces, imposing jardinieres, and lovely vases, to serving bowls, dessert services, and tea sets, every piece of majolica was—and remains to be—decorative.

1879: "Why any limit should be prescribed for it [literature about ceramics] more than to the literature of painting or sculpture involves a question not easily answered. Painters and sculptors all over the world are busy making additions to galleries public and private, and their achievements are chronicled and criticised without cessations. Potters and their associate artists are not less busy"[150]

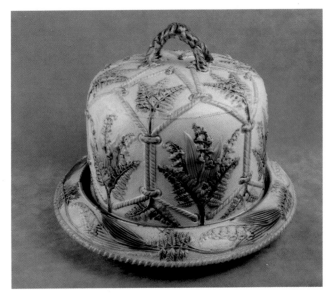

A finely detailed cake plate, 11" diam., in delicate pastels. This unmarked plate is an example of Samuel Lear's Lily of the Valley pattern. An 8.5" high cheese bell and a 12.5" pitcher are also known to have been made. Courtesy of Britannia, Gray's Antique Market, London.

Late 1800s: "What thought and brain power, what an expenditure of wealth and muscle has it taken to produce this little cup, worth no more than a few cents; what number of hands has it passed through since it lay in embryo in the mountains of King-teh-Chin, or in the heart of the mine amid the rugged Cornish hills?

"And with the same such thought has come the desire for knowledge; but the textbooks have been too technical, have been written from a standpoint too high for any but the pronounced enthusiast, and the desire has gradually faded—disappeared."[148]

1876: "Auction-rooms and pawnbrokers' shops contain a large element of knickknackery. Art-sales include much that is not strictly artistic, and such famous places as Christie & Manson's are good mines whence to dig the chatelains, bonbonières and battered snuff-boxes of the eighteenth century, the age that inaugurated knick-knacks. But a shop where unredeemed pledges are sold, either at auction or in the common retail way, is more interesting and more characteristic yet. Such places exist by the score in London, especially toward the antique parts of the city...china of the willow-patern degrades to kitchen use, and china that has served at royal tête-à-têtes— Dresden, Sèvres, Limoges, Chinese, Japanese, Indian, Wedgwood, Minton, majolica, etc...innumerable pretty nothings, even very modern things, but all tarnished, damaged, cracked, from long standing in that terrible pawn-shop, where the owners could see them every day as they walked past for years, but over which one might as well write the ban of Dante's Inferno—'All ye who enter here, leave hope behind.' Such are the wares we see in this dismal charnel-house of human hopes and happiness...It is a relief to come out of this den of forlorn knickknackery, even if we have nothing better to expect outside than the smell of the wharves and warehouses of Thames Street."[149]

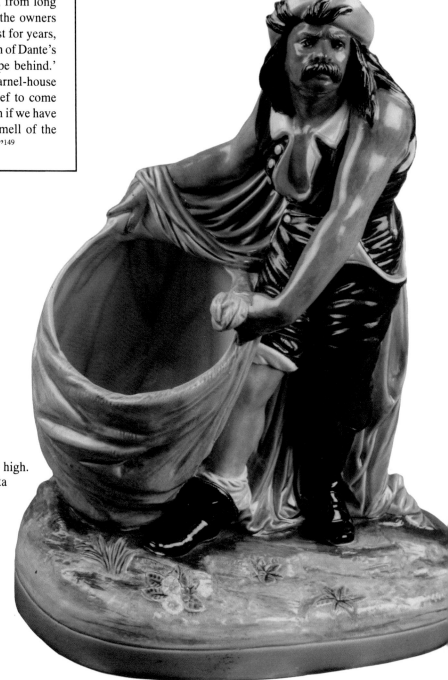

An unmarked pirate planter, 16" high.
Courtesy of John Tribble, Atlanta

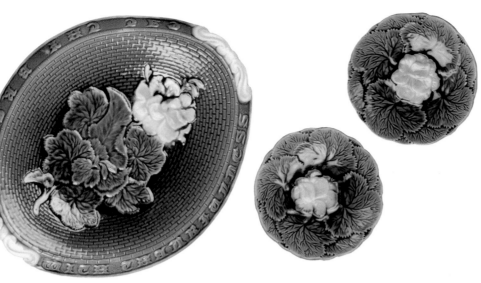

Two individual bread plates and a 13" serving plate, unmarked, with a geranium motif and the motto "Eat Thy Bread With Thankfulness." Courtesy of Dearing Antiques, Miami Circle, Atlanta

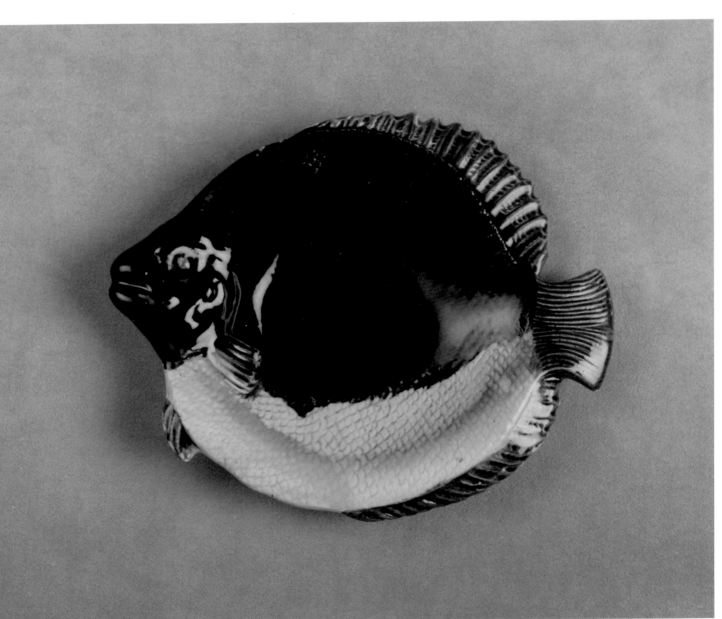

An unmarked fish dish measuring 8" from head to tail, English, c. 1860. Courtesy of Joseph Conrad Antiques, Atlanta

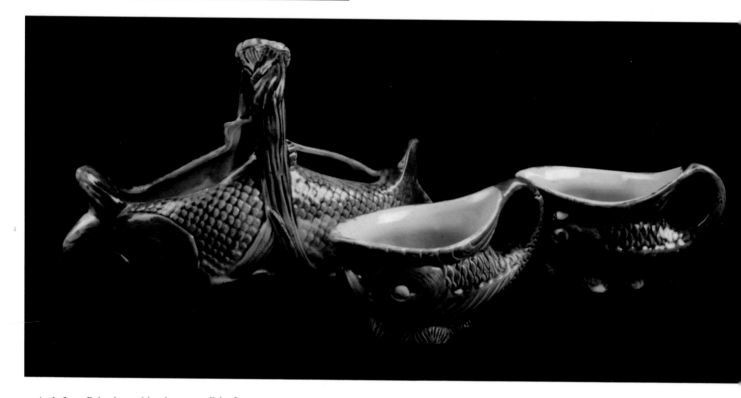

At left, a fish-shaped basket, possibly for sweetmeats, with an illegible British Registry Mark, c. 1870, 9.5" wide. The small fish at center and at right are 5" wide. Courtesy of Dearing Antiques, Miami Circle, Atlanta

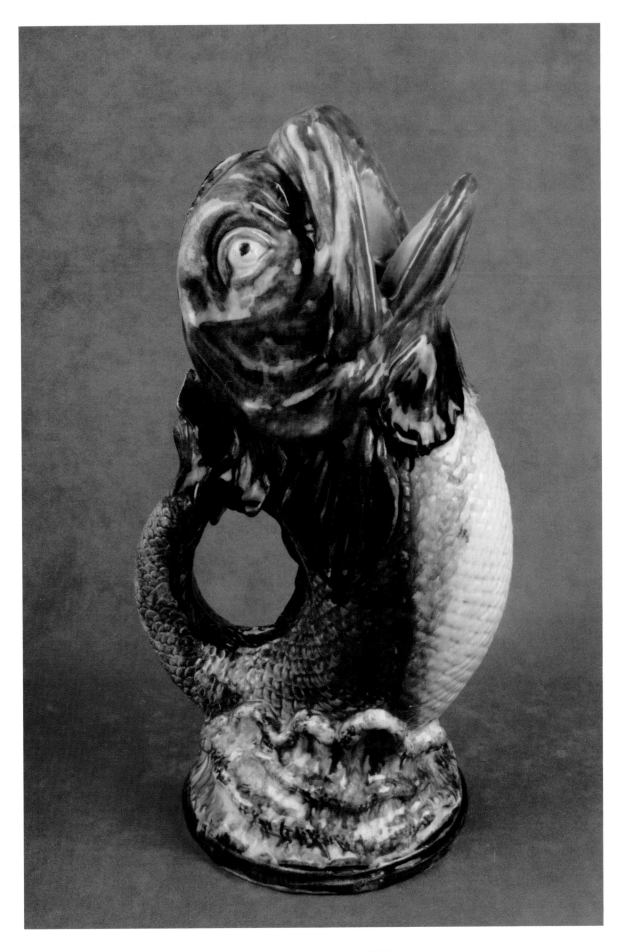

An unmarked fish vase, 14.5" high.
Courtesy of John Tribble, Atlanta

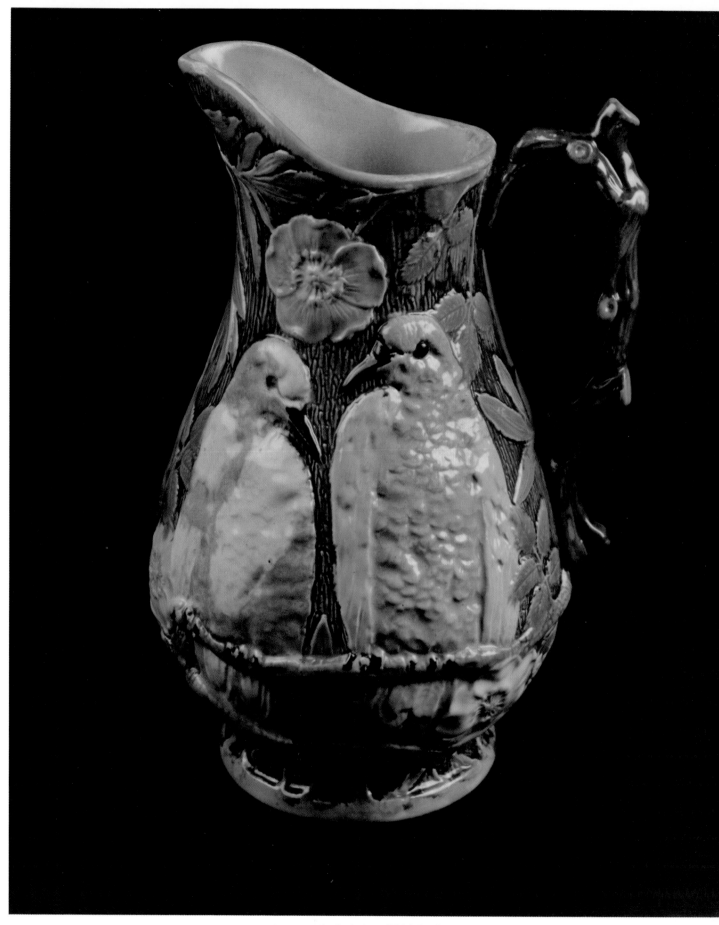

An unmarked pitcher, 9" high. Courtesy
of Dearing Antiques, Miami Circle,
Atlanta

10.5" platter with a swan and wicker pattern. Courtesy of Dearing Antiques, Miami Circle, Atlanta

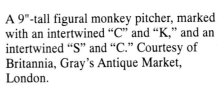

A 9"-tall figural monkey pitcher, marked with an intertwined "C" and "K," and an intertwined "S" and "C." Courtesy of Britannia, Gray's Antique Market, London.

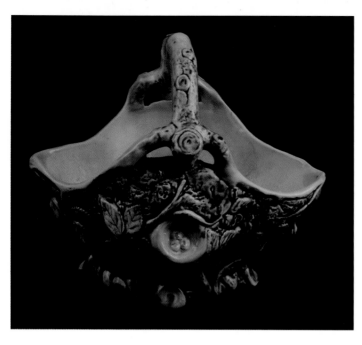

A 8.5"-high basket, English, c. 1860. Courtesy of Dearing Antiques, Miami Circle, Atlanta

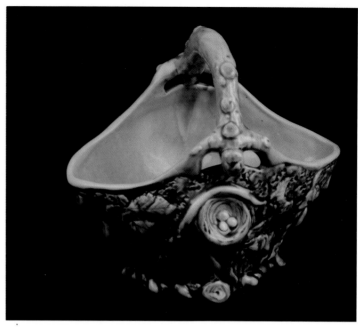

The same basket in a different color scheme. Courtesy of Joseph Conrad Antiques, Atlanta

6.5" columbine plate. Courtesy of Dearing Antiques, Miami Circle, Atlanta

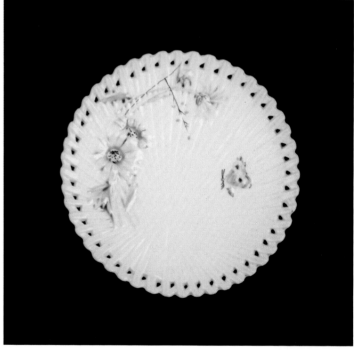

This plate was also produced in a fully-colored version. As majolica's popularity waned, more items were manufactured with less overall glazing: cheaper, and more appealing to the taste of the day. 8.5" plate, white. Courtesy of Dearing Antiques, Miami Circle, Atlanta

1875: "The amateur collector who wishes to indulge a little traffic with his friends need not be ashamed of dabbling in the business of the bric-à-brac merchant. Very aristocratic individuals have dealt in such merchandise...When once a man becomes a collector, he can hardly escape becoming a seller."[153]

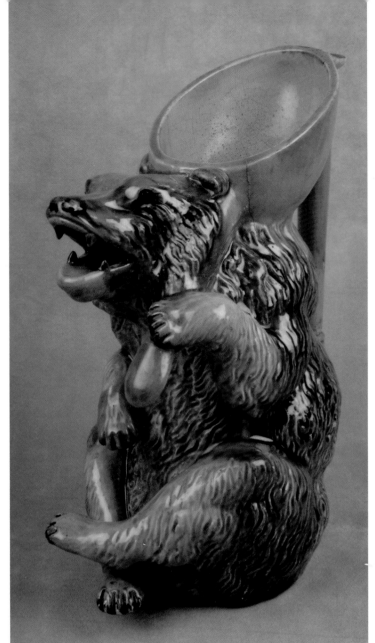

A bear figurine by Holdcroft, 9.5" high, unmarked. Courtesy of John Tribble, Atlanta

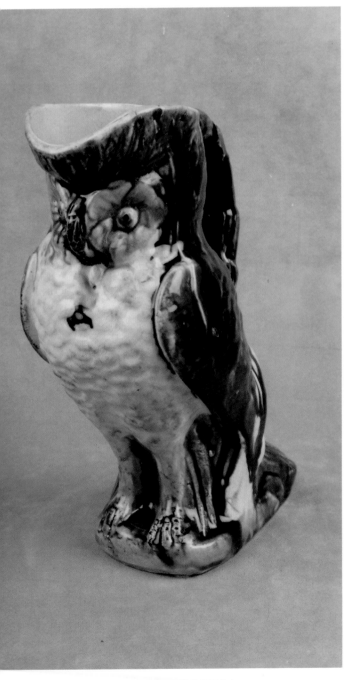

An unmarked English owl, 10" high. Courtesy of Joseph Conrad Antiques, Atlanta

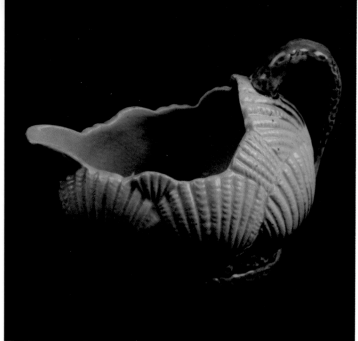

A scallop-shell creamer, 5" wide.
Courtesy of Dearing Antiques, Miami
Circle, Atlanta

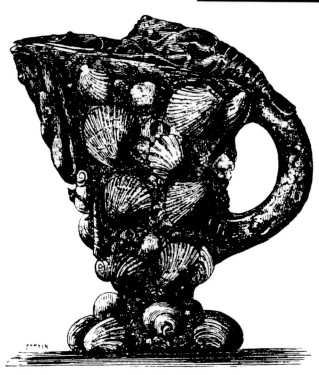

GOBLET ORNAMENTED WITH FOSSIL SHELLS.
(Louvre Museum.)

A tall pitcher modeled snake handles, c.
1860, England. The body of the pitcher
shows a bull and a matador, obscured by
badly running glaze. Courtesy of Joseph
Conrad Antiques, Atlanta

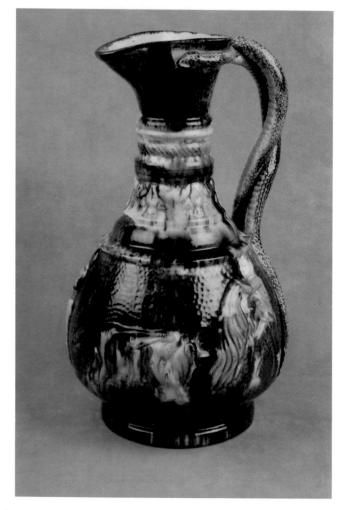

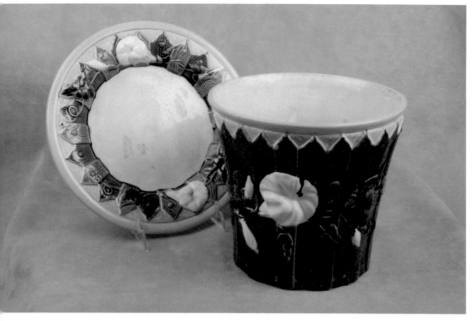

A two-piece morning glory cachepot, English, c. 1860. Courtesy of Joseph Conrad Antiques, Atlanta

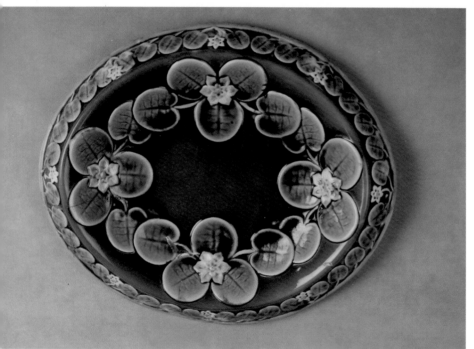

An unmarked bread plate, 13.5" x 11", made in England, c. 1860. Courtesy of Britannia, Gray's Antique Market, London.

A 6" saucer in a lily pad design, un-marked. Courtesy of Britannia, Gray's Antique Market, London.

A delicate Minton bowl, 7" diam. Courtesy of Britannia, Gray's Antique Market, London.

8.5", English, c. 1880, unmarked. Note the stilt marks on the face of the plate, a sure sign that this product was originally marketed on the low end. Courtesy of Joseph Conrad Antiques, Atlanta

An 8" unmarked dish. Courtesy of Dearing Antiques, Miami Circle, Atlanta

An 11" bread plate bearing the motto "Waste Not, Want Not," English, c. 1880. Courtesy of Joseph Conrad Antiques, Atlanta

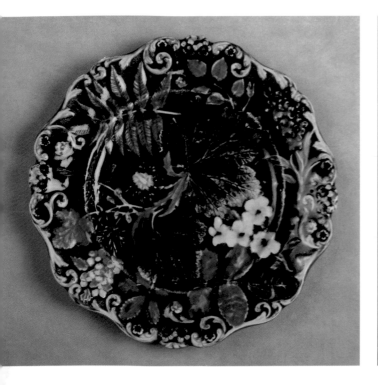

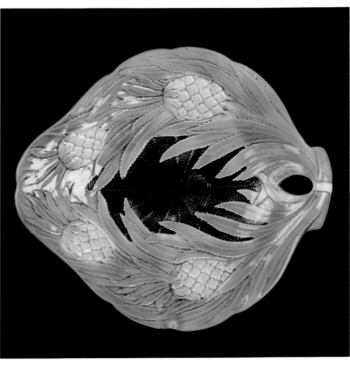

A wildly colorful plate, 9.25", unmarked.
Courtesy of John Tribble, Atlanta

An 11" unmarked pineapple piece.
Courtesy of Dearing Antiques, Miami
Circle, Atlanta

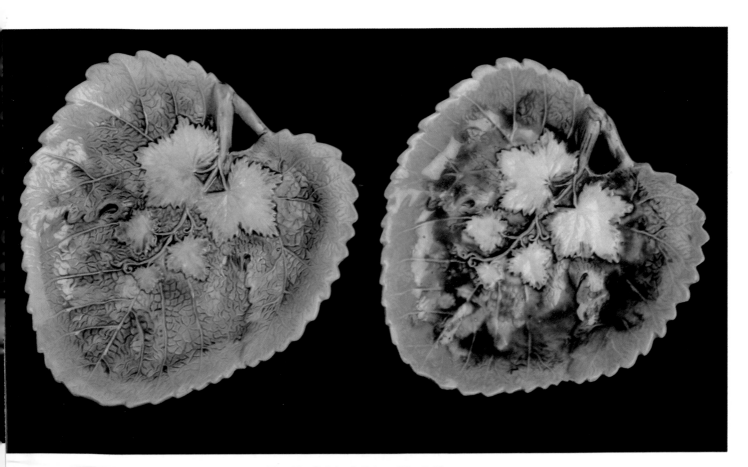

Two English leaf dishes, 8" x 7.5",
unmarked, c. 1860. Courtesy of Britan-
nia, Gray's Antique Market, London.

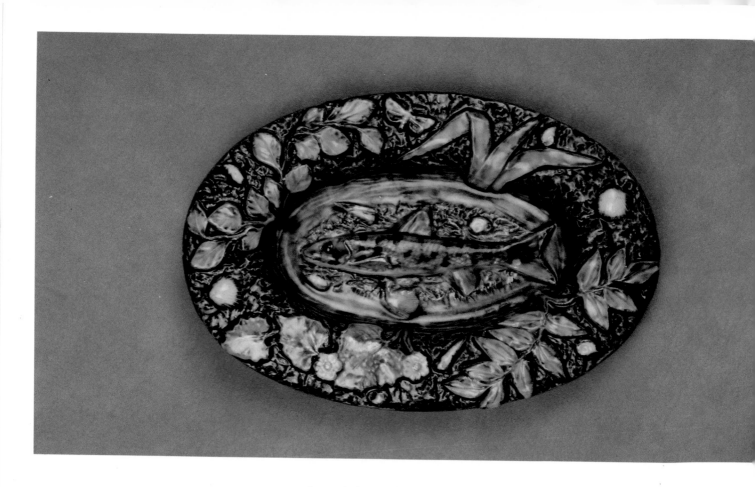

An oval platter with a fish center, 8" x
5.5", unmarked. Courtesy of Britannia,
Gray's Antique Market, London.

A very large crab platter from the
Angouléme Pottery, 17" x 14". A script
inscription on the back reading "A.
Remoleau" indicates that Alfred
Remouleau may have made the piece.
Courtesy of Britannia, Gray's Antique
Market, London.

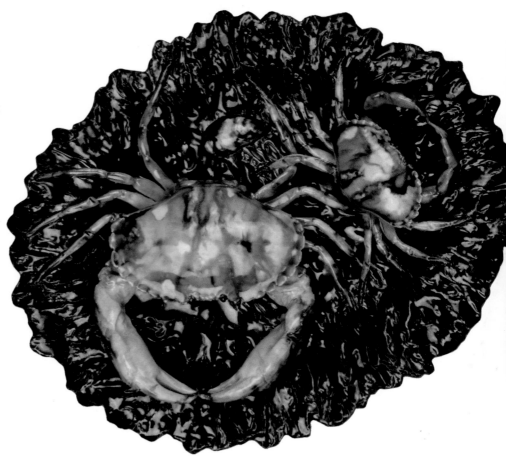

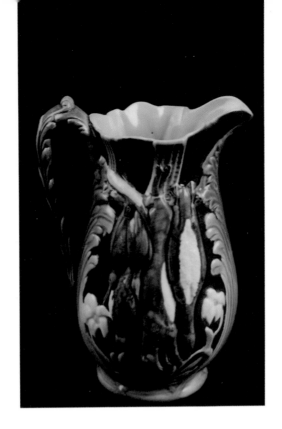

A cobalt pitcher by Joseph Holdcroft, 8"
high. Courtesy of Dearing Antiques,
Miami Circle, Atlanta

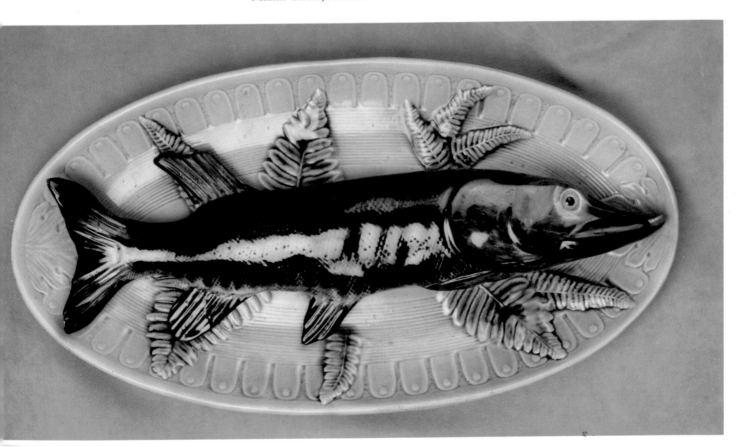

A platter with a three-dimensional fish,
18" x 9.5", unmarked. Courtesy of
Britannia, Gray's Antique Market,
London.

Two figural match holders, unmarked, 6.5" high. Courtesy of Byron Hamilton, Atlanta

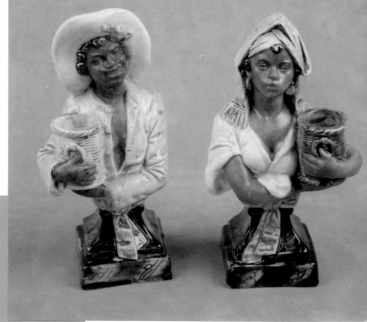

An unmarked smoking companion, 6" long. Courtesy of Byron Hamilton, Atlanta

A figure, possibly Minton. Courtesy of Britannia, Gray's Antique Market, London.

1875: "As regards the...dealers....although there are unquestionably men of the highest respectability, integrity, and knowledge, who probably commenced their career as art dealers with some capital...there are hundreds, at home and abroad, who have commenced the trade as did my friend, with a majolica vase, or a Dresden teapot."[155]

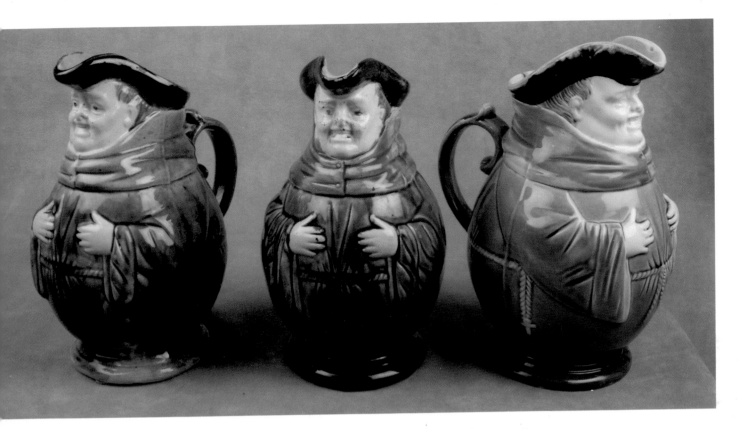

Three monk pitchers. Courtesy of
Britannia, Gray's Antique Market,
London.

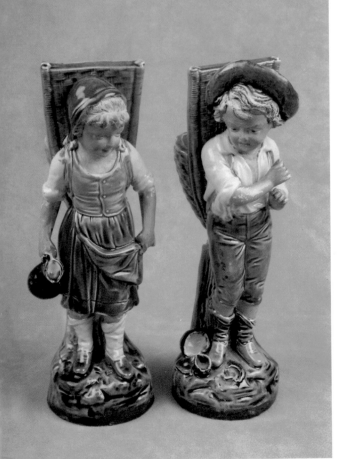

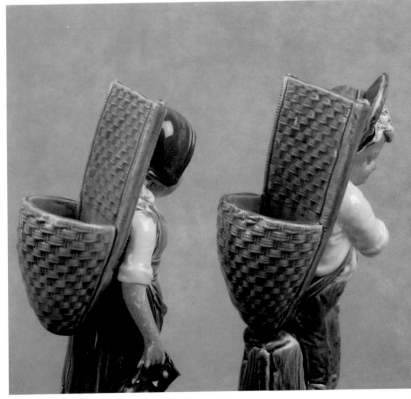

English figurines, c. 1860, unmarked.
Courtesy of Joseph Conrad Antiques,
Atlanta

MAKERS & MARKS

The correct affectation with connoisseurs in ceramics
is to reverse the plate set before them, and study
the marks subscribed, with an air of inscrutable wisdom.
But avoid the catastrophe which befell an absent-minded man
not long ago, who, forgetting that he had just been helped,
turned over his plate, bestowing a
"bouchée a` la reine" ['a royal mouthful'!]
upon the satin lap of the lady next to him.[156]

John Adams & Company
English, 1864-1873
Hanley, Staffordshire
Marks "J. ADAMS & CO." and
 "ADAMS & CO."
Became Adams & Bromley Pottery,
 1873-1886.

W. & J. A. Bailey
Scottish, 1790-1908
Alloa, near Glasgow, Scotland
Majolica production began c. 1860,
 continued at least through 1881.
Marks may include "W. & J. A. Baily
 / ALLOA."

Banks & Thorley
English, 1873-
Hanley, Staffordshire
Became Banks & Co. in 1887, then
 Edward Banks in 1888-9. Most
 identifiable majolica was
 registered in mid- to late 1880s.
 Known patterns are Bamboo &
 Basketweave, and Fern, Floral &
 Bow.
Pieces generally unmarked except for
 British Registry marks, from
 which they can be attributed to the
 firm.

Adams & Bromley
English, 1873-1886
Hanley, Staffordshire
Marks "ADAMS & BROMLEY,"
 "A. & B." and "A. & B. /
 SHELTON."

Samuel Alcock & Co.
English, 1828-1859
Burslem, Staffordshire
Marked their rare majolica pieces "S.
 Alcock & Co."

Arabia Pottery
Finland, 1874-
Often produced large, functional
 pieces in an Art Nouveau style.
"ARABIA" impressed mark indicates
 1874-1930 manufacture.

Arsenal Pottery
American, pre-1877 to 1899
Trenton, New Jersey
Used several names, including Mayer
 Brothers between 1880-1884.
Exhibited majolica at Chicago
 World's Fair, 1893.
Wares were unmarked.

Avalon (*see Chesapeake Pottery*)

Banks & Thorley
English, 1873-1887
Hanley, Staffordshire
No manufacturer's mark; registry
 marks start mid- to late 1880s.
Known patterns: "Bamboo &
 Basketweave" and "Fern, Floral,
 & Bow."
Became Banks & Company in 1887,
 and Edward Banks in 1888.

A. M. Beck
American, 1882-1884
Evansville, Indiana
A small three-kiln operation, with the
 distinction of producing majolica
 at the westernmost point in the
 United States.
Majolica wares were unmarked.

The Bennett Pottery
American, 1848-1937
Baltimore, Maryland
In 1856, the company was renamed
 the Edwin Bennett Pottery. Wares
 produced by this firm in the early
 1850s are thought to qualify as
 majolica by some, but many others
 feel that Bennett's majolica
 production did not start until the
 1870s, continuing through the
 apex of American majolica
 popularity.
The most common mark appearing on
 majolica is "BENNETT'S" in an
 arch above a patent date and the
 word "PATENT" or "COPY-
 RIGHT" in an arch below.

Bowman Company
American
Trenton, New Jersey
In 1904, bought old "Lettuce Leaf"
 molds from Wannopee, and
 produced a heavier version,
 marked "LETTUCE LEAF" (in
 quotation marks) with "TRADE"
 above and "MARK" below.

T. C. Brown-Westhead, Moore & Co.
English, 1862-1904
Hanley, Staffordshire
A limited line of excellent-quality
 majolica was produced in 1870s
 and 1880s.
Marks include the full company
 name, "B.W.M & Co.," and
 "B.W.M."

William Brownfield
English, 1860-1891
Cobridge, Staffordshire
Majolica produced by early 1870s.
Marks include (1850-1891) a
 Staffordshire knot with the initials
 W and B, (1871-1891) "W. B. &
 S.," (until 1871) the impressed
 "BROWNFIELD['S]," and (1876-
 1891) "BROWNFIELD & SON"
 in banner over two slightly
 overlapping globes.

Brownhills Pottery Company
1871-1896
Tunstall, Staffordshire
The company mark was "B.P.Co."

Burmantofts
English, 1880-1904
Leeds, England
Impressed marks include
 "BURMANTOFTS / FAIENCE"
 and "BF" in a monogram.

Ulisse Cantagalli
Italian, 1878-1901
Florence, Italy
Designs reflect Italian Renaissance
 maiolica.
Marks include "CANTAGAL
 FIRENZE."

James Carr (*see New York City
Pottery*)

The Chesapeake Pottery Co.
American, majolica production 1882-
 1910
Baltimore, Maryland
Two different types of majolica were
 produced: Clifton (cream-colored
 background with simple natural
 decorations in several colors) and
 Avalon Faience (an ivory
 background with single-color
 naturalistic designs and a gold
 trim)
Marks read "CLIFTON / DECOR B"
 or "AVALON / FAIENCE /
 BALT," both surrounding the
 monogram DFH.

Choisy-le-Roi
French, 1804-1933
Majolica was produced from the
 1860s through 1910, and was
 granted exhibition medals from
 1867-1889. It is quite delicate and
 ranks in quality near Minton and

Wedgwood. Careful glazing and
 naturalism are typical.
Those pieces that are marked read
 "Choisy-le-Roi," "Choisy," or the
 initials "HB" (sometimes in
 monogram) for the director,
 Hippolyte Boulanger.

W. T. Copeland & Sons
English, 1776-
Stoke-on-Trent, Staffordshire
Majolica generally has fine modeling.
 A tricorn eagle vase was produced
 for display at the Philadelphia
 Centennial Exhibition in 1876.
A common majolica mark is
 "COPELAND," impressed, often
 with a British registry mark. Other
 marks exist.

Creil et Montereau
French, early 1800s-
Made wares including majolica
 dessert services.
Marked with the company name.

William DeMorgan
English, early 1870s
Merton
Mark was the initials "DM" above a
 tulip with two leaves.

James Ellis & Son
English, active 1869
Hanley, Staffordshire

Eureka Pottery
American, 1883-1887
Trenton, New Jersey
Bird & Fan and Owl & Fan are two
 Asian-inspired patterns.
Much of this firm's wares were
 marked "EUREKA POTTERY"
 arching over "TRENTON."

**The Faience Manufacturing
Company**
American, 1879-1892
Greenpoint, New York
Majolica made only in the early
 years.
Wares were marked with the incised
 monogram "FMCO."

S. Fielding & Company
English, 1870 through the 1880s
Stoke-on-Trent, Staffordshire
In 1879, name changed to S. Fielding
 & Son.

Not all Fielding majolica was marked, but look for "FIELDING" (c. 1879) and "SF & Co" (1880-1917).

Thomas Forester & Sons, Ltd.
English, 1877 through W.W.I
Longton, Staffordshire
Originally called the Church Street Majolica Works, then the Phoenix Works (1879-1883).
Known for salt-rolled majolica, three dimensional flowers "á la Barbotin," and gurgling fish pitchers.
Marks for the company include "TF & S LTD" and "Foresters England," but no piece of majolica so marked has ever been found.

Fontainbleau
French, late 1700s-
Rustic majolica, similar to Portuguese.
Marks read "FONTAINBLEAU," impressed.

Gien
French, majolica made 1864-present
After a modern facility was built in 1866, the company could produce nearly fifty thousand plates a day.
Good-quality wares were displayed at the Paris Exhibition in 1878.
Marks include a turreted-castle logo, with "GIEN" above it and "FRANCE" below, and the words "La Faiencerie de Gien" in an oval.

Glasgow Pottery
American, 1863-c. 1900
Trenton, New Jersey
One of only three American potteries to display majolica at the Centennial Exhibition.

Griffen, Smith & Company
American, majolica made from 1882 through mid-1890s
Phoenixville, Pennsylvania
Well-known wares include colored and Argenta (white) versions of the "Shell & Seaweed" pattern, and colorful begonia leaf dishes.
Four stamped and impressed marks were used—a "GSH" monogram, a monogram with the word "ETRUSCAN," a monogram in a double circle with "ETRUSCAN" above and "MAJOLICA" below, and a rare stamp reading simply "ETRUSCAN."

The Hampshire Pottery
American, 1871-1914
Keene, New Hampshire
Majolica production began in 1879, and included corn-pattern pieces.
Few pieces were marked, but look for "James S. Taft & Co., Keene, N.H.," "J.S.T. & Co., Keene, N.H.," and "Hampshire Pottery."

Joseph Holdcroft
English, 1870-
Longton, Staffordshire
Much majolica made for export to North America, South America, and Australia.

Marks include a small impressed JH monogram in a circle, the name "HOLDCROFT," or simply the initial J.

George Jones
English, 1861-
Stoke-on-Trent
Became George Jones & Sons in 1874.
Well-designed and beautifully produced majolica in useful forms, reminiscent of Minton's quality.
Bases are often mottled, with a single unglazed spot left for scratching or painting in a design number. The monogram GJ in a circle is common, with "& SONS" added in 1874. This may appear in a raised cartouche seal.

Keller et Guerin (see Luneville)

Samuel Lear
English, c. 1877-1886
Hanley, Staffordshire
Majolica production began in 1882, with lightweight ware such as "Sunflower & Urn," "Pond Lily & Rope," and "Lily of the Valley."
Most Lear ware was unmarked; only one known piece of majolica bears the impression "LEAR."

Lithgow Pottery
Australian, 1879-1896, 1905-1907
Wares with mottled glaze marketed as majolica c. 1882.
Marks include impressed "LITHGOW" and a number of circular marks with the firm's name and a kangaroo logo.

Longchamp
French, near Dijon
Made oyster plates, asparagus servers, and wall plaques.
Marks read "LONGCHAMP" and "TERRE DE FER."

Luneville
French, 1731-1914
Lorraine, France
In 1788, this factory was turned over to Keller et Guerin, who operated it through the 1800s. The factory first produced faience, and in the second half of the nineteenth century switched to majolica.
The firm's mark was an impressed "LUNEVILLE," sometimes with the addition of "KG" (Keller et Guerin) and "DEPOSE."

Mafra & Son
Portuguese, 1853-present
Caldas de Rainha, Portugal
Specialized in reproducing Wheildon ware and, especially, Palissy ware, of medium quality.
Twentieth-century pieces by Mafra, along Palissy-lines, are readily available (I have seen them on shelves in stores like T. J. Maxx and Marshalls!), and are easy to recognize as new.

Marks often include the name "MAFRA," along with "CALDAS" and "PORTUGAL."

The Manufacture Royale de Rato
Portuguese
Lisbon, Portugal

The Massier family
French, from Vallauris
Majolica, produced in the late 1800s, was brilliantly colored and artistically painted, ranging over a broad subject matter. Their work was a link between Victorian majolica and later pottery of the Art Nouveau era.
Marks include signatures of various family members.

Mayer Pottery Company
American, majolica made starting in 1881
Beaver Falls, Pennsylvania
Tiles known to have been produced, with the mark "MAYER."

Minton
English, 1793-
Stoke-on-Trent
First used the term "majolica" for Victorian earthenware at the Crystal Palace Exhibition in 1852, and generally accepted as the finest manufacturer of the ware through the 1890s.
Marks are the name "MINTON," changing to "MINTONS" in 1872.

Moore Brothers
English, 1872-1905
Longton, Staffordshire
Often produced Japanese-style designs.
Impressed or incised marks reading "MOORE" or "Moore"; painted marks reading "MOORE BROS." The mark of London distributor Thomas Goode may also appear.

George Morley & Company
American, c. 1879-1885
Wellsville and East Liverpool, OH
This company produced more majolica than any other U.S. pottery west of Pennsylvania. Significant lines include gurgling fish pitchers and other figural pitchers. Ceramic bodies tend to be heavier than most majolica; some is actually ironstone.
Marks read "MORLEY & CO. / MAJOLICA / WELLSVILLE, O." between 1879 and 1884, and thereafter "GEORGE MORLEY'S / MAJOLICA / EAST LIVERPOOL, O." The earlier mark sometimes reads "MAJOLLICA."

Moulins des Loups
French, late 1800s-
In 1928, this name united three French majolica producers near Onnaing: Orchies, Hamages, and St. Amand, each of which previously had used its own name to mark wares.

The New Milford Pottery
American, 1887-1892
New Milford, Connecticut
Later became the Wanopee Pottery, q.v.
Marks read "N.M.P.CO." inside a diamond.

The New York City Pottery
American, 1853-1888
New York City, New York
It is most likely that majolica production peaked in the 1870s, and continued through 1888. The pottery was one of only three American firms to exhibit majolica at the Centennial Exhibition, where they were initially overlooked. When the commission was asked to reevaluate their work, however, they won a gold medal! They were also honored at the Paris Exposition in 1878.
While some collectors hold that no marked wares have survived, others assert that the initials "J.C." (for proprietor and English immigrant James Carr) were used, in a monogram looking much like George Jones' "J.G."

Odell & Booth Brothers
American, 1878-1890
Tarrytown, New York
Infrequently marked, but look for a figural dog pitcher impressed "O & B.B."

Onnaing (La Faiencerie d')
French, majolica made 1870-1900
Wares are lighter than many other majolica companies', pieces were commercial or novelty wares, and colors were slightly sloppy. Some are humorously entertaining.
Marks show a crown over a shield with a radiant sunburst; "Frie" is to the left of this logo (abbreviation for faiencerie) and "O" is to the right (for Onnaing).

The Peekskill Pottery Company
American, c. 1882-1890
Peekskill, New York

The Philadelphia City Pottery
American, 1868-1890
Philadelphia, Pennsylvania
Produced some fantastic large-scale pieces, including a twenty-gallon teapot for the Centennial Exhibition, where they were one of only three American firms showing majolica.
Wares were unmarked.

Rafael Bordalo Pinheiro
Portuguese, b. 1846-1905
Caldas da Rainha, Portugal
This remarkably talented ceramist made wares inspired by Mafra and by Palissy, and after the 1889 Paris exhibition, by Minton and French wares as well. He made large pieces and tiles.

The Portland Stone Ware Company
American, 1850s-1969
Portland, Maine
Majolica production began in 1878, and is believed to have ceased by the mid-1880s.
No identifying marks.

The Prestonpans Pottery
Scottish, majolica made c. 1875-1900
One one attributable piece, the mark "Belfield & Co." on a ribbon appears.

Georges Pull
German, b. 1810-d. 1889
Working in Paris beginning in 1856, this potter made Palissy wares that are sometimes confused with the originals. There are more delicate and better-painted than English or Portuguese imitations.
Marks include "Pull" and "PULL."

Rörstrand
Swedish, majolica made 1860s-
Near Stockholm
Majolica wares by this firm were shown at the Philadelphia Centennial Exhibition in 1876.

J. Roth
English, known active 1879-1881
London, England
Marks may include "J.R. / L" (J. Roth / London) in an octagon.

Saint Clément
French, 1758-
Lorraine, France
Majolica was produced from the 1860s through the early 20th century. Their pieces are known for subtle glazing effects. Owned by Keller and Guerin, who also operated Luneville. St. Clément's colors were the more restrained of the two.
Wares were marked with an impressed "SAINT CLÉMENT," sometimes with "KG" added.

Sandford Pottery
English, 1859-
Wareham, Dorset
Manufacturer's mark was "SANDFORD / POTTERY" incised on raised pads.

Salins
French, destroyed in Franco-Prussian War.
Best-known wares are asparagus pieces, well modeled and glazed.
Marks read "SALINS," impressed.

Sarreguemines
French/German, 1770s-early 20th century
Majolica was produced after 1860 and into this century. Ceramic bodies were dense and heavy, and quality is said to be exceeded only by Minton. Originally located in France, border changes of the Franco-Prussian war put the company in German territory.

A much-used mark is the impressed "SARREGUEMINES." Another mark is "U & C" (Utschneider & Company), sometimes over an "S", in an octagon or circle.

Wilhelm Schiller & Sons
Czechoslovakia, 1829-1895
Bodenbach, Bohemia
Excellent modeling and glazing details.
Marks read "W. S. & S."

Shorter & Boulton
English
Stoke-on-Trent, Staffordshire
Began manufacturing majolica in 1879 for the Australian and American markets. Patterns included the popular Bird & Fan design. Patent registrations ceased in 1882.
No name mark was used, but British registry marks often were.

Societá Ceramica Richard
Italian, majolica made 1842-1860.
Marks read "GINORI."

Star Pottery
Scottish, 1880-1907
Glasgow, Scotland
Marks include a five-pointed star above the word "STAR."

Edward Steele
English, 1875-1900
Hanley, Staffordshire
No manufacturer's mark used.

Daniel Sutherland & Sons
English, 1863- c. 1883
Fenton, Staffordshire
No marked majolica has yet been found, but the company's mark on other wares is "S & S."

Tenuous Majolica
American, no dates known
No location known
While the identity of this pottery remains anonymous to history, pieces similar to Griffen, Smith & Company patterns have been found with an impressed circular mark, reading "TENUOUS" above and "MAJOLICA" below. A letter "H" appears in the center of the circle.

The Trenton Potteries *see Arsenal, Eureka, Glasgow, and Willets*

Victoria Pottery Company
English, 1882-
Stoke, Staffordshire
Mark "VP / C" inside a triangle of swords, impressed.

Villeroy & Boch
German, 1748-present
Many locations, with majolica made at Mettlach andSchramberg.
Majolica is high-quality, often with pierced rims, Art Nouveau styling.
Marks for Schramberg include a sheild with the company name, or "SMF" (Schramberg Majolika Fabrik) in a monogram.

Wannopee Pottery Company
American, 1892-1904
New Milford, Connecticut
Formerly the New Milford Pottery Company.
Specialized in "Lettuce Leaf" patterns; see Bowman Company.
Marks included an incised "W" in a sunburst, sometimes with "NEW MILFORD" as well. Also look for "WANNOPEE POTTERY CO."

Wardle & Company
English, majolica production 1871-1910.
Hanley, Staffordshire
Patterns include the Bird & Fan design and the Fern & Bamboo design.
Wardle's designs bear the English registry mark and an impressed "WARDLE."

Warrilow & Cope
English, 1880-1894
Longton, Staffordshire

Wedgwood
English, majolica production from 1862 through the first quarter of the twentieth century
Stoke-on-Trent, Staffordshire
High-quality wares, generally of a more delicate, classical, and refined bent than Minton's.
Most wares were marked, initially "WEDGWOOD," in 1892 adding "ENGLAND," and in 1911 "MADE IN ENGLAND." The letter M was used to designate majolica from 1873 to 1888, and K was used until 1920. Majolica-glazed tiles were designated with the letter Q from c. 1884. In 1860 a code system was established to record potting dates (month and year) using a set of three impressed letters. The first letter was the month of potting; the second was the potter's mark. The third letter indicated the year, beginning with letter O in 1860 and re-cycling from A in 1872, and again in 1898.

Willets Manufacturing Company
American, 1879-
Trenton, New Jersey
No marked majolica has been found.

Winton Pottery
English, 1886-1889
Stoke, Staffordshire
Became Grimwades Ltd. in 1890

James Woodward
English, majolica production 1860-1888
Swadlincote, Derbyshire
Wares marked with a anchor and cable forming the monogram "J. W."

Worcester Porcelain Works
English, 1751-
Bristol, England
Majolica with an unusually refined body, delicate modeling, and subdued coloration was produced at least during the 1880s.

From 1862, wares marked with a "C" surrounded by a rosette of four intertwined "W"s.

BIBLIOGRAPHY

Ames, Kenneth L. et al. 1986. *Accumulation & Display: Mass Marketing Household Goods in America, 1880-1920.* Wilmington, DE: The Henry Francis du Pont Winterthur Museum.

Bergesen, Victoria. Ever Green. *Country Living Magazine.*

Collard, Elizabeth. 1967. *Nineteenth-Century Pottery and Porcelain in Canada.* Montreal: McGill University Press.

Blackmore, Lyn. 1992. A Palissy-Type Vessel from Blackfriars, London. *Everyday and Exotic Pottery from Europe c. 650-1900: Studies in Honor of John G. Hurst.* Oxford: Oxbow Books.

Bockol, Leslie, and Jeffrey B. Snyder. 1994. *Majolica: American & European Wares.* Atglen, PA: Schiffer Publishing Ltd.

Bray, Marsha S. 1992. The Power of Home: St. Louis Victorian Interiors. *Gateway Heritage,* Spring.

Burty, Phillipe. 1869. *Chefs-D'Oeuvre of the Industrial Arts.* London: Chapman & Hall.

Byng Hall, Major H. 1875. *The Bric-A-Brac Hunter, or, Chapters on Chinamania.* Philadelphia: J. B. Lippincott & Co.

Conway, M. D. 1874-1875. Decorative Art and Architecture in England (First Paper, Second Paper, and Third Paper). *Harper's Magazine* 49.

Cooper, H. J. 1881. *The Art of Furnishing on Rational and Aesthetic Principles.* New York: Henry Holt & Co.

Dawes, Nicholas M. 1990. *Majolica.* New York: Crown Publishers.

Dudson, Audrey M. 1993. *Cheese Dishes.* Stoke-on-Trent: Dudson Publications, Ltd.

Edwards, Ralph, and L. G. G. Ramsey, eds. 1968. *The Connoisseur's Complete Period Guides.* New York: Bonanza Books.

Fortnum, C. Drury E. 1876. *South Kensington Museum of Art Handbook No. 4.* New York: Scribner, Welford & Armstron.

Garrett, Rhoda and Agnes; John Hullah; and Mrs. Oliphant. 1879. *Art at Home: A Collection of Papers on House Decorations, Music, Dress, Etc.* Philadelphia: Porter & Coates.

Gates, William C. Jr., and Dana E. Ormerod. 1982. The East Liverpool, Ohio, Pottery District: Identification of Manufacturers and Marks. *Historical Archaeology: The Journal for the Society of Historical Archaeology* 16(1-2).

1871. A Glimpse at the Potteries. *Leisure Hour.*

Guthrie, Hugh, ed. 1968. *Late Victorian Decor.* American Life Foundation.

Harrison, Constance Cary. 1882. *Woman's Handiwork in Modern Homes.* New York: Charles Scribner's Sons.

Hayden, Arthur. 1904. *Chats on English China.* New York: Frederick A. Stokes Co., Publishers.

Hooker, Francis Hopkins. 1896. *Afternoons with Ceramics.* Syracuse: The Portfolio Club.

James, Arthur E. 1945. *The Potters and Potteries of Chester County, Pennsylvania.* West Chester, PA: Chester County Historical Society.

Jervis, Simon. 1983. *High Victorian Design.* Suffolk, England: The Boydell Press.

Jervis, W.P. Date unknown; late 1800s. *Rough Notes on Pottery.* Newark, NJ.

Karmason, Marilyn G. and Joan B. Stacke. 1989. *Majolica: A Complete History and Illustrated Survey.* New York: Harry N. Abrams.

Klein, Terry H. 1991. Nineteenth Century Ceramics and Models of Consumer Behavior. *Historical Archaeology* 25(2).

Labart, M. Jules, trans. 1855. *Handbook of the Arts of the Middle Ages and Renaissance: As Applied to the Decoration of Furniture, Arms, Jewels, &c. &c.* London: John Murray.

Lancaster, Osbert. 1953. *Homes Sweet Homes.* London: John Murray Ltd.

Larkin, Jack. 1989. *The Reshaping of Everyday Life, 1790-1840.* New York: Harper & Row Publishers.

Murphy, Lady Blanche. 1876. The Age of Knickknacks. *Lippincott's Magazine* 18.

1865. *Once a Week: an Illustrated Miscellany of Literature, Art, Science, & Popular Information* XIII, June-December. London: Bradbury & Evans.

Panton, J. E. 1898. *From Kitchen to Garret: Hints for Young Householders.* London, Ward & Downey.

1879. *Potter's American Monthly Illustrated Magazine* XII (January). Philadelphia: John E. Potter & Company.

1879. Pottery & Porcelain at the Paris Exposition. *Lippincott's Magazine* 23.

1876. Pottery at the Centennial. *Atlantic Monthly* 38.

Schreiber, Lady Charlotte. 1911. *Lady Charlotte Schreiber's Journals: Confidences of a Collector of Ceramics & Antiques . . . from the Year 1869 to 1885, vol. 1.* London: John Lane.

Swinney, H. J. 1975. The Reassuring Quality of Victorian Adornment. *A Scene of Adornment: decoration in the Victorian home (from the collections of the Margaret Woodbury Strong Museum).* Rochester, NY: The Memorial Art Gallery of the University of Rochester.

ENDNOTES

1. Kenneth L. Ames, 1986, 10
2. Audrey M. Dudson, 1993, 42
3. Audrey M. Dudson, 1993, 42
4. Nicholas M. Dawes, 1990, 108
5. W. P. Jervis, date unknown (late 1800s), 74
6. Marilyn Karmason, Joan Stacke, 1989, 17
7. W. P. Jervis, date unknown (late 1800s), 74
8. Lady Blanche Murphy, 1876, 205
9. Marilyn Karmason, Joan Stacke, 1989, 17
10. Phillipe Burty, 1869, 60
11. Rhoda and Agnes Garrett, Mrs. Oliphant, and John Hullah, 1879, 85
12. Phillipe Burty, 1869, 40
13. Phillipe Burty, 1869, 67
14. Pottery at the Centennial, 1876, 571
15. Pottery & Porcelain at the Paris Exposition, 1879, 316
16. W. P. Jervis, date unknown (late 1800s), 20
17. Phillipe Burty, 1869, 68
18. Phillipe Burty, 1869, 68
19. Audrey M. Dudson, 1993, 42
20. W. P. Jervis, date unknown (late 1800s), 6
21. W. P. Jervis, date unknown (late 1800s), 52
22. M. Jules Labarte, 1855, 303
23. Phillipe Burty, 1869, 83-85
24. Lyn Blackmore, 1992, 378
25. Lyn Blackmore, 1992, 371
26. Lady Blanche Murphy, 1976, 710
27. Jonathan Spence, 1993, 38
28. Audrey M. Dudson, 1993, 17
29. Pottery & Porcelain at the Paris Exposition, 1879, 324
30. Osbert Lancaster, 1953, 46
31. Pottery & Porcelain at the Paris Exposition, 1879, 318
32. Constance Cary Harrison, 1882, 185
33. Osbert Lancaster, 1953, 44
34. Potters American Monthly, 295
35. Marilyn Karmason, Joan Stacke, 1989, 32
36. Marilyn Karmason, Joan Stacke, 1989, 157
37. Leslie Bockol, Jeffrey Snyder, 1994, 113

38. A Glimpse at the Potteries, 1871, 94
39. Marilyn Karmason, Joan Stacke, 1989, 24
40. Marilyn Karmason, Joan Stacke, 1989, 40
41. Marilyn Karmason, Joan Stacke, 1989, 15
42. Marilyn Karmason, Joan Stacke, 1989, 24-25
43. Marilyn Karmason, Joan Stacke, 1989, 25
44. W. P. Jervis, date unknown (late 1800s), 50
45. W. P. Jervis, date unknown (late 1800s), 50
46. A Glimpse at the Potteries, 1871, 94
47. M. D. Conway, First Paper, 1874, 617
48. A Glimpse at the Potteries, 1871, 94-96
49. Marilyn Karmason, Joan Stacke, 1989, 202
50. W. P. Jervis, date unknown (late 1800s), 50
51. Marilyn Karmason, Joan Stacke, 1989, 202
52. A Glimpse at the Potteries, 1871, 96
53. A Glimpse at the Potteries, 1871, 95
54. A Glimpse at the Potteries, 1871, 157
55. A Glimpse at the Potteries, 1871, 94
56. A Glimpse at the Potteries, 1871, 96
57. A Glimpse at the Potteries, 1871, 95
58. W. P. Jervis, date unknown (late 1800s), 50
59. A Glimpse at the Potteries, 1871, -2 157
60. A Glimpse at the Potteries, 1871, 96
61. M. D. Conway, Second Paper, 1874, 786
62. M. D. Conway, Second Paper, 1874, 784
63. Lady Blanche Murphy, 1876, 197-198
64. M. D. Conway, Second Paper, 1874, 786
65. Lady Blanche Murphy, 1876, 206
66. M. D. Conway, Third Paper, 1874, 40
67. Marsha S. Bray, 1992, 43
68. Osbert Lancaster, 1953, 36
69. Osbert Lancaster, 1953, 44-46
70. W. P. Jervis, date unknown (late 1800s), 21
71. W. P. Jervis, date unknown (late 1800s), 19
72. Nicholas M. Dawes, 1990, 3
73. Marilyn Karmason, Joan Stacke, 1989, 38
74. Pot. & Porc. at the Paris Expo, 1879, 324
75. Arthur Hayden, 1904, 181
76. Phillipe Burty, 1869, 67
77. Major H. Byng Hall, 1875, 190
78. Phillipe Burty, 1869, 68

79. Nicholas M. Dawes, 1990, 4
80. Marilyn Karmason, Joan Stacke, 1989, 68
81. W. P. Jervis, (late 1800s), 18-19
82. Marilyn Karmason, Joan Stacke, 1989, 69
83. Marilyn Karmason, Joan Stacke, 1989, 71
84. Marilyn Karmason, Joan Stacke, 1989, 72
85. Audrey M. Dudson, 1993, 45
86. Marilyn Karmason, Joan Stacke, 1989, 104
87. Marilyn Karmason, Joan Stacke, 1989, 68
88. H. J. Swinney, 1975, 4
89. Kenneth L. Ames, 1986, 7
90. H. J. Swinney, 1975, 4
91. Kenneth L. Ames, 1986, 15
92. H. J. Swinney, 1975, 4
93. Kenneth L. Ames, 1986, 7
94. Kenneth L. Ames, 1986, 10
95. Pottery at the Centennial, 1976, 571
96. Pottery at the Centennial, 1976, 571
97. Gates Ormorod 9-10
98. Kenneth L. Ames, 1986, 86
99. Major H. Byng Hall, 1875, 239
100. Pottery at the Centennial, 1976, 572
101. Kenneth L. Ames, 1986, 11
102. Leslie Bockol, Jeffrey Snyder, 1994, 127
103. Marilyn Karmason, Joan Stacke, 1989, 68
104. Elizabeth Collard, 1967, 155
105. Elizabeth Collard, 1967, 319
106. Elizabeth Collard, 1967, 157
107. Elizabeth Collard, 1967, 160
108. Elizabeth Collard, 1967, 159
109. Elizabeth Collard, 1967, 249
110. Elizabeth Collard, 1967, 249
111. Francis Hopkins Hooker, 1896, 133
112. M. D. Conway, Second Paper, 1874, 784
113. A Glimpse at the Potteries, 1871, 95
114. A Glimpse at the Potteries, 1871, -2 57
115. Francis Hopkins Hooker, 1896, 133
116. A Glimpse at the Potteries, 1871, 95
117. Leslie Bockol, Jeffrey Snyder, 1994, 70
118. Terry H. Klein, 1991, 78-79
119. Leslie Bockol, Jeffrey Snyder, 1994, 73

120. Glimpse at the Potteries, 1871, 157-158
121. Jack Larkin, 1989, 24
122. Marilyn Karmason, Joan Stacke, 1989, 28
123. Once A Week, 1865, 9
124. Victoria Bergesen, 187-188; Marilyn Karmason and Joan Stacke, 1989, 28
125. Victoria Bergesen, 188
126. Marilyn Karmason, Joan Stacke, 1989, 28
127. Marilyn Karmason, Joan Stacke, 1989, 28
128. Ralph Edwards, L. Ramsay, 1968, 1401
129. Victoria Bergesen, 187
130. Victoria Bergesen, 188
131. Nicholas M. Dawes, 1990, 11
132. Nicholas M. Dawes, 1990, 17
133. *Late Victorian Decor,* 1968, 20
134. Elizabeth Collard, 1967, 159
135. Marilyn Karmason, Joan Stacke, 1989, 32
136. *Late Victorian Decor,* 1968, 80
137. Marilyn Karmason, Joan Stacke, 1989, 32
138. W. P. Jervis, date unknown (late 1800s), 18
139. Elizabeth Collard, 1967, 159
140. Elizabeth Collard, 1967, 160
141. Nicholas M. Dawes, 1990, 17
142. Nicholas M. Dawes, 1990, 12
143. Elizabeth Collard, 1967, 159
144. Elizabeth Collard, 1967, 160
145. Elizabeth Collard, 1967, 159
146. Constance Cary Harrison, 1882, 112
147. M. D. Conway, Third Paper, 1874, 36
148. W. P. Jervis, date unknown (late 1800s), 6
149. Lady Blanche Murphy, 1876, 202-204
150. Pottery & Porcelain at the Paris Exposition, 1879, 313
151. Constance Cary Harrison, 1882, 213
152. Constance Cary Harrison, 1882, 213
153. Major H. Byng Hall, 1875, 8
154. Major H. Byng Hall, 1875, 213
155. Major H. Byng Hall, 1875, 268
156. Constance Cary Harrison, 1882, 22
157. Major H. Byng Hall, 1875, 12
158. H. J. Cooper, 1881, 109

PRICE GUIDE

"To the wholly ignorant amateur," wrote a nineteenth-century collector, "no book ever published, however valuable or correct it may be, is of much avail."[157] The same might be said today about value guides; purchasing antiques is a risky financial investment, just as it was in previous centuries. When you use this price guide (with evaluations in U.S. dollars), call liberally upon your own judgement; acquire as much field experience as you can. Spend time in shops, auctions, flea markets, and the occasional museum. Examine, admire, and handle majolica as much as you can, and talk with dealers and other collectors. Nag the curators. Become familiar with manufacturers' marks; learn to appreciate the look and feel of high-quality workmanship even in unmarked pieces.

While you're at it, familiarize yourself with different marketplaces. Majolica values in recent years have increased rapidly, but there are huge discrepancies between the asking prices at fine galleries, auctions, and hole-in-the-wall shops with a piece or two hidden on a bottom shelf. In addition, different regions value certain styles and makers more than others.

Another nineteenth-century writer, in discussing the mania for antiquities faced by his own contemporaries, advised them thus:

> Now there are springing up here and there men of intelligence and spirit, who are stimulating the genius of the country in producing useful and ornamental ware of a very high artistic order, and we recommend those who have neither the time nor inclination to study ceramic trade-marks, to confine their purchases to these modern specimens, and thus avoid the risk of being duped or ruined.[158]

If only it were as simple as knowing the trademarks! Investing in majolica requires a commitment to learning how to evaluate this fantastic pottery on its own merits—on excellent design, spectacular color, and intrinsic creativity, which give majolica a special appeal that only you can judge!

page	item	value ($U.S.)	page	item	value	page	item	value	page	item	value
7	platter	$3080	63	tazza	$2600	110	plate	$110	155	oyster plate (left)	$245
8	teapot	$1975		mug	$1975	117	tazza	$260		oyster plate (right)	$610
	small pitcher	$760	67	pitcher	$1975	118	plate (left)	$195	156	sardine box (left)	$920
	large pitcher	$1550	68	pitcher	$1975	119	plates	$125 ea.	157	sardine box (right)	$1075
9	pitcher	$850		jardiniere	$3080	120	plate (left)	$125	158	sardine box	$1400
10	fish pitchers	$400 ea.	69	pitcher	$760	121	plate (left)	$155	159	sardine box	$1550
21	pedestal plate	$1400	70	platter	$3080		plate (right)	$60	160	sardine box	$1975
22	pitcher	$1900		plates (restored)	$195 ea.	122	plates	$200–300 ea.	161	sardine box	$1400
23	platter	$4600	71	plate	$495				163	tile (top)	$40
	pedestal plate	$450	72	dish	$295	123	plate (left)	$250	164	tile	$155
	plate	$1075	73	teapot	$1075		plate (right)	$195	165	cake plate	$1550
26	canister	$300	74	game pie dish	$4600	124	plate (multicolor)	$425	167	bread platter	$450
27	tray (top)	$450	76	tazzas, each	$4600	125	tazza	$895		fish plate	$345
	tray (bottom)	$1450	77	game pie dish	$9320	126	plate (left)	$85	168	fish basket	$495
28	pitcher	$1400		lidded pitcher	$2925		plate (right)	$35		fish (center)	$195
	jardiniere (top)	$1400	78	George Jones piece	$1600	127	plate	$80		fish (right)	$130
	jardiniere (bottom)	$3080	79	plate (top)	$300	128	plate (left)	$265	170	pitcher	$1250
29	jardiniere (top)	$3080		plates (middle, restored)	$195 ea.		plate (right)	$125	171	platter	$210
30	plate (top)	$390	81	plate (top)	$420	129	plate (left)	$145		monkey pitcher	$920
	plate (bottom)	$150		plate (bottom)	$445		plate (right)	$125	172	basket (left)	$550
31	jardiniere	$1450	84	pitcher	$3150	130	dish	$100		basket (right)	$500
32	tray (restored)	$345	86	plate	$195	132	strawberry server	$6150		plate (bottom)	$95
	tea set	$1300	87	tazza	$930	133	sugar bowl	$4150	173	owl pitcher	$400
33	dishes	$145 ea.		begonia leaf (large)	$210	134	server (bottom)	$2300	174	creamer	$210
41	vase	$795		begonia leaf (small, right)	$170	135	strawberry server	$4600		pitcher	$450
	pitcher	$1975		begonia leaf (small, left)	$145	136	strawberry plate	$125	175	cachepot	$1095
42	desk set (restored)	$600	88	sardine box	$1100		strawberry platter	$850		bread plate	$355
	dish	$295		teapot	$1800	137	strawberry server	$1950		saucer	$125
43	platter	$370		sugar bowl	$650	138	strawberry dish	$595	176	oval dish	$250
	George Jones server	$1250		coffee pot	$300	139	strawberry dish	$250		11" bread plate	$295
44	Forrester vase	$645	90	teapot	$200	140	asparagus server	$760	177	pineapple platter	$395
	Worcester vase	$1995	91	teapot	$180	141	asparagus server	$750		dish (lower left, restored)	$1150
45	vase	$2695	94	pitcher	$920	142	asparagus pot	$760		dish (bottom right)	$390
46	jardiniere	$995	95	pedestal jardiniere		143	plate (middle)	$260	178	syrup pitcher	$395
	frog pitcher	$920		This amazing piece was priced in			plate (bottom)	$275		corn vase	$395
47	small pitcher	$760		the realm of $35,000 in 1993!		144	plate (left)	$260		vase (right)	$380
	medium pitcher	$920	96	centerpiece	$2750		plate (right)	$200	179	planter	$800
	large pitcher	$920	98	yellow dish	$220	145	plate (left)	$1150		eggcup holder	$1395
48	jardiniere	$3750		Palissy-style dish	$450		plate (right)	$260		creamer	$250
49	putti	$2925	99	Palissy-style dish	$1150	146	plate (top)	$290	180	candlestick	$225
	serving dish	$735	100	vase	$2700		plate (bottom)	$325		grasshopper	$920
	Christmas platter	$1975	101	planter	$3250	147	plate	$370	181	small disk	$2150
54	pitcher	$1195	102	pitcher	$1050	148	plate	$370		large plate	$1075
55	jardiniere (restored)	$1000	103	figurine	$625	149	platter	$150	182	oval platter	$1235
56	jardiniere	$2135	104	centerpiece	$4750	151	asparagus server	$1295		crab platter	$1975
58	urn	$2135	108	fish	$2150	152	server (left)	$795	183	pitcher	$1250
61	game pie dish	$3080		floral plate	$1150		server (right)	$1500		platter	$1550
	fish server	$6160	109	sunflower platter	$445	153	asparagus server	$895	185	figurines	$600 pr.
62	pitcher	$1550		Gerber plate	$235	154	oyster plate (right)	$155			

INDEX